# Wildlife
# Photographer
# of the Year
## Portfolio 21

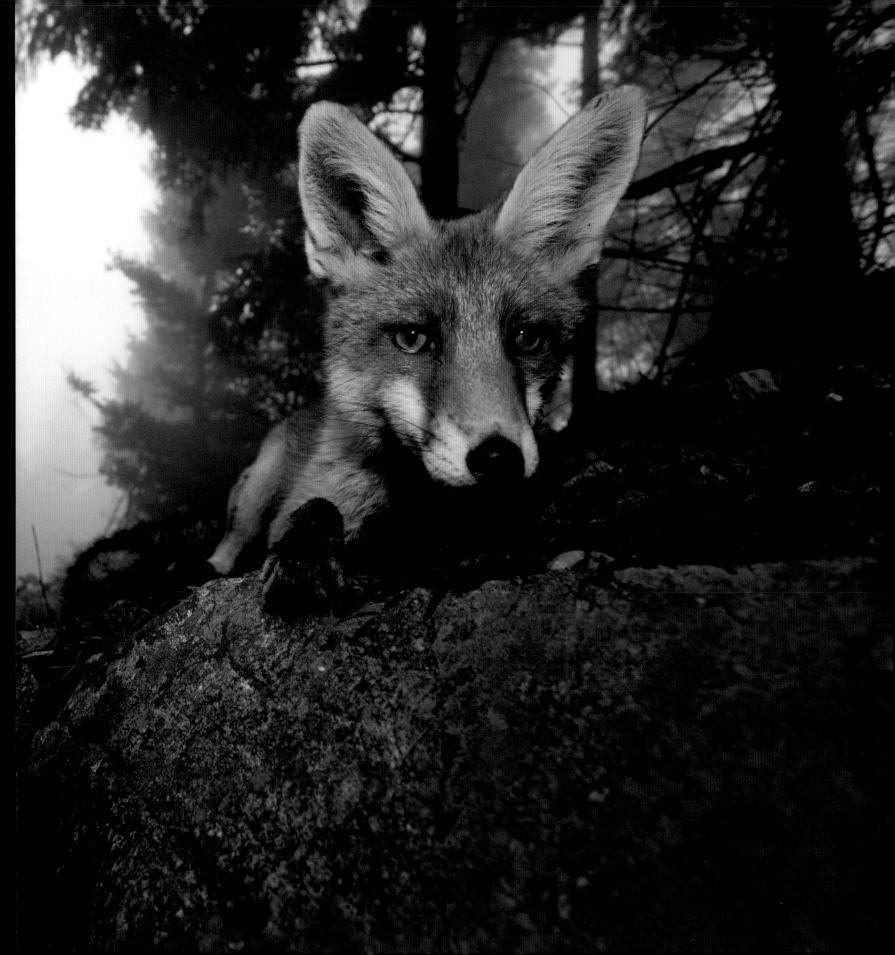

# Wildlife
# Photographer
# of the Year
# Portfolio 21

Published by the Natural History Museum, London

First published by the Natural History Museum,
Cromwell Road, London SW7 5BD
© Natural History Museum, London, 2011
Photography © the individual photographers 2011

ISBN 978-0-565-09298-6

A catalogue record for this book is available from the
British Library.

**Editor** Rosamund Kidman Cox
**Designer** Bobby Birchall, Bobby&Co Design
**Caption writers** Rachel Ashton and Tamsin Constable
**Colour reproduction by** HiFi ColorStudio d.o.o.
**Printing by** Toppan Leefung Printing Limited

# Contents

# Foreword

Dedication, resilience, courage, resourcefulness, cunning – essential survival attributes of many wild animals. Nature photographers, too, need such attributes. You only have to look at the work of those photographing in the wild to understand that the parallels are real. Learning to sense the quality of light is also an essential skill. Tuning in, feeling the air and making best use of the light is common practice among the best nature photographers. In the language of photography, light is the most elusive and misunderstood ingredient of successful expression.

Each year advances in technology encourage more radical approaches to what can be photographed, central to which is the ability of cameras to work in lower light levels. But technology cannot be a substitute for sensitivity to the feeling and atmosphere of light. Excessive Photoshopping certainly isn't.

The oldest manifestations of our uniquely human visual culture are petroglyphs and cave paintings, and the themes in this art are invariably animals and hunting. Through history we have made images of animals, and today, our prolific output is through photography. Our pictures are records, reflections and distillations of what we see, how we feel and even what we believe. Linking photography with the artistic expression of our distant ancestors is a reminder that our passion for nature has endured across hundreds of generations.

The Wildlife Photographer of the Year competition is the greatest gathering of images celebrating the wild world. It is also an opportunity to reflect on the meaning of what we do as photographers, on our love of nature and of our place within it. From the outset, the competition sets out its stall, asking all photographers to abide by a code of conduct, central to which is the welfare of wild creatures.

Any hint that animals have been harmed or distressed by the photographer will receive short shrift from an experienced panel of judges. Digital technology makes it all too easy to manipulate the facts, and so rigorous standards allow only images that are a fair and true reflection of the photographer's role as eyewitness.

Many categories encourage photographers to think about how they interpret what they see. This helps showcase a diversity of images and a wealth of vision with which to delight and inspire the public. The competition also disseminates stories about the natural world. The biggest story, of course, is the degradation of ecosystems. Bit by bit, extinction of species undermines the robustness of the webs of life on which we humans depend. We will only halt that destruction if we understand we are part of nature, not apart from it. Photographers have a unique opportunity to help that happen. It is almost an instinct to rejoice in the mystery, majesty, beauty – and abundance – of life. Our photographic stories may speak of the robustness, or fragility, of ecosystems, but their most powerful message is of the beauty of nature, and how impoverished we are in its absence.

While we will never be quite as connected as our cave-painting ancestors, a nature photographer learns, or relearns, an inherent connection with the wild – to cope with its discomforts, to absorb its wealth of sensations, to wonder at it. In this way, photography gives us a deeper sense of who and what we are. Success in this competition is a rewarding outcome, but anyone who has participated is already winning through being in the outdoors with a camera. Discovering a sense of wonder in the wild is the greatest prize of all.

**JOE CORNISH**
Photographer and Wildlife Photographer of the Year judge

# The Competition

Displayed in this book are more than 100 of the best images of wildlife and the natural environment you are likely to see this year – a distillation from nearly 41,000 pictures entered in the competition by photographers from 95 countries. It's a competition open to all, and so the roll call is a wonderful mix of amateurs and professionals, the young and the famous.

The owners are two UK institutions that pride themselves on championing the diversity of life: the Natural History Museum and *BBC Wildlife* Magazine. The competition has its origins back in the 1960s (when conservation wasn't a public issue), transforming into its current form in the early 1980s. Since then, most of the great names in wildlife photography have competed in the competition at some point in their careers, and winning a place continues to be an aspiration for wildlife photographers worldwide. Through it, they gain international coverage and recognition.

Taking a winning picture requires a mixture of vision, aesthetics, camera literacy, knowledge of nature – and luck. That luck has to be planned for – to know where an animal might be, what it might be doing, when the light might be just right. But to make the most of such serendipity requires being able to see the magic of a moment.

The judges look for pictures with outstanding creativity, originality and photographic excellence, taking them beyond mere representations of nature. But digital manipulation of the content is not allowed, the welfare of the subjects is considered paramount, and pictures must be taken under wild and free conditions.

The Wildlife Photographer of the Year's aims also go beyond those of a normal competition. It seeks to:

- use its collection of inspirational photographs to make people, worldwide, wonder at the splendour, drama and variety of life on Earth;

- be the world's most respected forum for wildlife photographic art, showcasing the very best images of nature to a worldwide audience;

- raise the status of wildlife photography of into that of mainstream art.

Today, through the exhibition in its many travelling forms, the international editions of this portfolio book and the pages of *BBC Wildlife*, together with international publicity, the pictures travel the world, inspiring and illuminating. As a result, they are seen by many millions of people.

The final aim of the competition is to

- inspire a new generation of photographic artists to produce visionary and expressive interpretations of nature.

The Eric Hosking Award and the categories for young photographers exist to encourage and promote new talent – talent that will provide the winners of future years. This year, a 90 per cent increase in the number of young photographers entering is proof that a new generation has taken up the banner.

## The Judges

**Michael AW**
marine photographer, publisher and author (Australia)

**Mark Carwardine** (Chair)
zoologist, writer and photographer (UK)

**Joe Cornish**
landscape photographer (UK)

**Colin Finlay**
Head of Image Resources,
Natural History Museum, London (UK)

**Pål Hermansen**
photographer and author (Norway)

**Anders Geidemark**
wildlife photographer and writer (Sweden)

**Rosamund Kidman Cox**
editor and writer (UK)

**Erik Sampers**
Picture Director, *Terre Sauvage* magazine (France)

**Sophie Stafford**
Editor, *BBC Wildlife* Magazine (UK)

**Markus Varesvuo**
wildlife photographer (Finland)

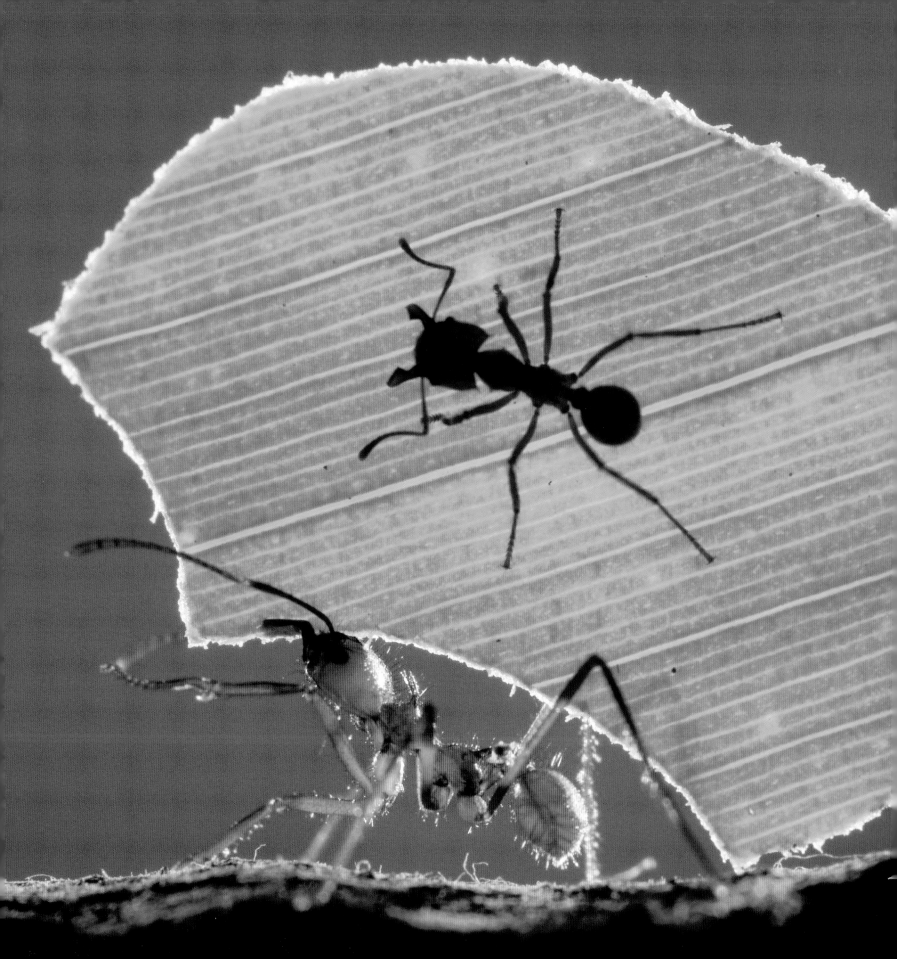

# The Organizers

The competition is owned by the Natural History Museum
and *BBC Wildlife* Magazine, and is sponsored by Veolia Environnement.

Wildlife Photographer of the Year is one of the Museum's most successful and long-running exhibitions. Together with *BBC Wildlife* Magazine, the Museum has made it the most prestigious, innovative photographic competition of its kind and an international leader in the artistic representation of the natural world.

The annual exhibition of award-winning images continues to raise the bar of wildlife photography and excite its loyal fans, as well as a growing new audience. People come to the Museum and tour venues across the UK and around the world to see the photographs and gain an insight into the diversity of the natural world – an issue at the heart of our work.

Open to visitors since 1881, the Natural History Museum looks after a world-class collection of 70 million specimens. It is also a leading scientific-research institution, with groundbreaking projects in more than 68 countries. About 300 scientists work at the Museum, researching the valuable collection to better understand life on Earth, its ecosystems and the threats it faces.

Last year, more than four million visitors were welcomed through the Museum's doors to enjoy the many galleries and exhibitions that celebrate the beauty and meaning of the natural world, encouraging us to see the environment around us with new eyes.

**Visit www.nhm.ac.uk for what's on at the Museum.**
You can also call +44 (0)20 7942 5000
email information@nhm.ac.uk
or write to us at:
Information Enquiries
Natural History Museum
Cromwell Road
London SW7 5BD

The images that grace the magazine's pages – spectacular, intimate, powerful, thought-provoking and moving – represent the very best of wildlife photography.

*BBC Wildlife* Magazine is proud to have launched the forerunner of this competition in the1960s and to have nurtured its development into a showcase for the brightest talents in natural-history photography.

The same love of wildlife and wonder at the natural world inspire the magazine.

Every month, *BBC Wildlife* showcases beautiful images, compelling stories and fascinating facts. Covering everything from animal behaviour to British wildlife, the latest conservation issues to inspirational adventures, our writers are all experts in their fields.

Our award-winning features are illustrated with the world's finest photography – images captured by photographers recognized in this competition.

We publish all of the winning images from the Veolia Environnement Wildlife Photographer of the Year competition in our glossy and gorgeous guide, free with the November issue.

**Visit www.discoverwildlife.com to subscribe to**
***BBC Wildlife***, read amazing articles and enjoy stunning photo galleries.
You can also call +44 (0)117 927 9009
or email wildlifemagazine@bbcmagazines.com

We are extremely proud to be title sponsor of the 2011 Veolia Environnement Wildlife Photographer of the Year competition, and this year, for the first time, we are also sponsors of the Wildlife Photographer of the Year UK touring exhibition.

Providing the right environmental services is our core business, and preserving natural habitats and animal species is essential to our present and future. The competition embodies the corporate values held by our company, such as our commitment to sustainable development, the preservation of natural resources and the very real need to inspire people of all ages.

This competition features the best of wildlife photography from across the world, highlighting the richness and diversity of nature, which is our collective responsibility to protect.

**Jean-Dominique Mallet**
Chief Executive Officer
Veolia Environmental Services (UK) Plc
www.veolia.co.uk

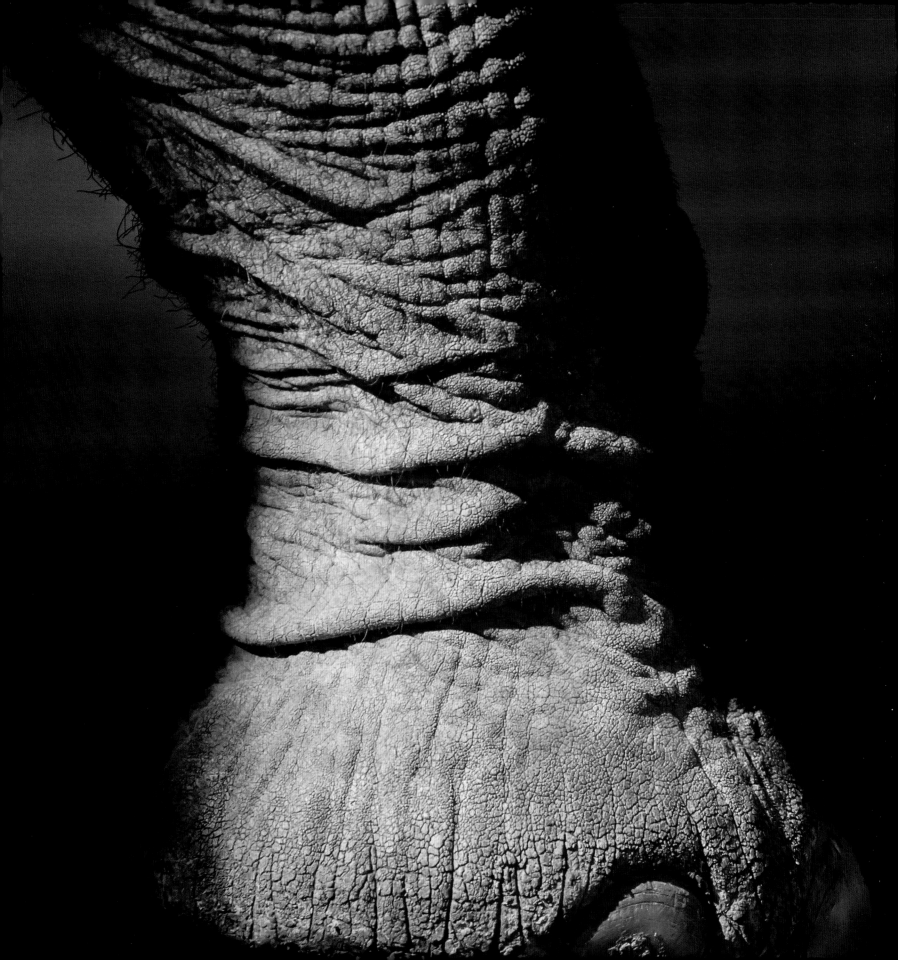

# The Veolia Environnement
# Wildlife Photographer of the Year Award

# The Veolia Environnement
# Wildlife Photographer of the Year

The Veolia Environnement Wildlife Photographer of the Year Award goes to Daniel Beltrá,
whose picture has been chosen as the most striking and memorable of all the entries in the competition.

## Daniel Beltrá

A Spanish photojournalist based in Seattle, USA, Daniel specializes in environmental and conservation stories. He started his career working for the Spanish national news agency EFE and then became a freelance photojournalist, working regularly for Greenpeace. Daniel has won two World Press Photo awards for his environmental coverage, the inaugural Global Vision Award of the Pictures of the Year International in 2008 and the Prince's Rainforests Project Award in 2009. He is a fellow of the International League of Conservation Photographers (ILCP). Daniel's aim is to use his work to bring greater respect for his subjects and to inspire people to take action.

## Still life in oil

Crude oil trickles off the feathers of the rescued brown pelicans, turning the white lining sheets into a sticky, stinking mess. The pelicans are going through the first stage of cleaning at a temporary bird-rescue facility in Fort Jackson, Louisiana. They've already been sprayed with a light oil to break up the heavy crude trapped in their feathers, which has turned their normally pale heads orange and their brown and grey feathers mahogany.

The oil is from BP's Deepwater Horizon wellhead, which blew up in the Gulf of Mexico on 20 April 2010. By November, around 6,000 dead birds had been collected. Of the 2,000 oiled birds rescued alive, 1,250 were later released. 'The birds that made it here were under serious stress,' says Daniel. Such was the urgency of the rescue operation that Daniel had to work around the volunteers. Every so often, one of them would open the pen to move a pelican in or out. Daniel then had no more than 10 seconds to get into position and photograph the pelicans through the crack before the door swung shut again. He wanted to portray not just tragedy but also a sense of compassion through the pelicans' innate, almost prehistoric elegance. 'For me, this image is an icon of the disaster.'

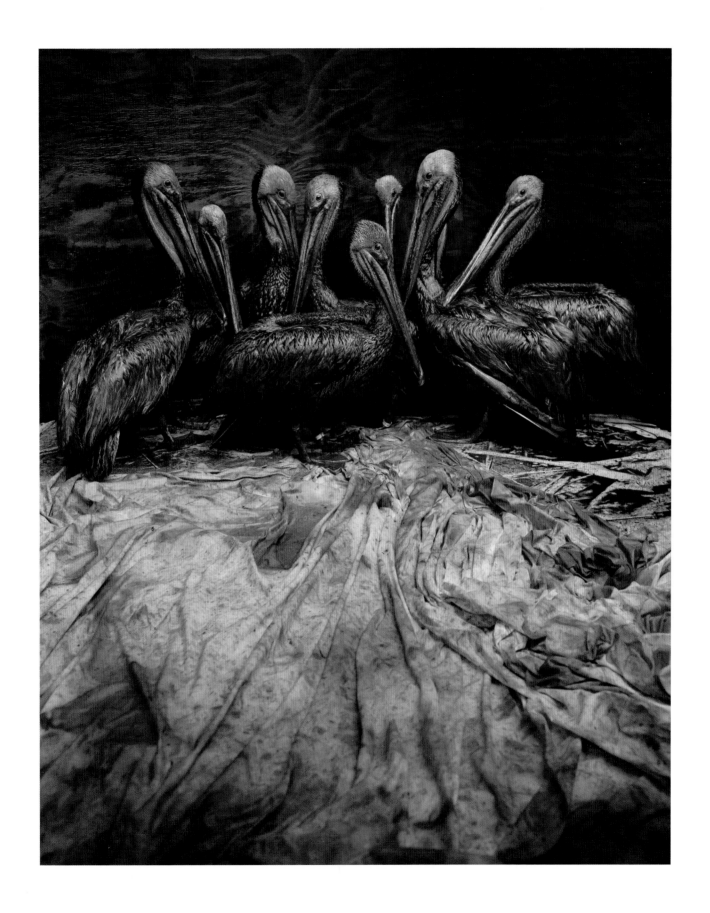

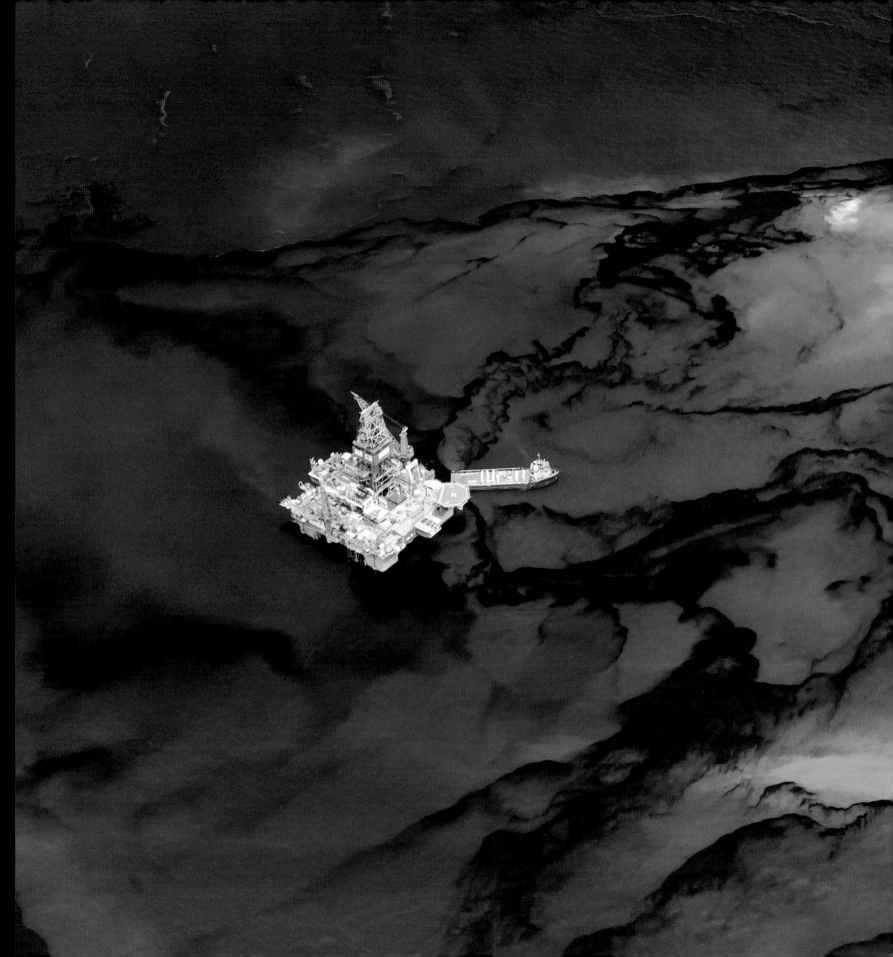

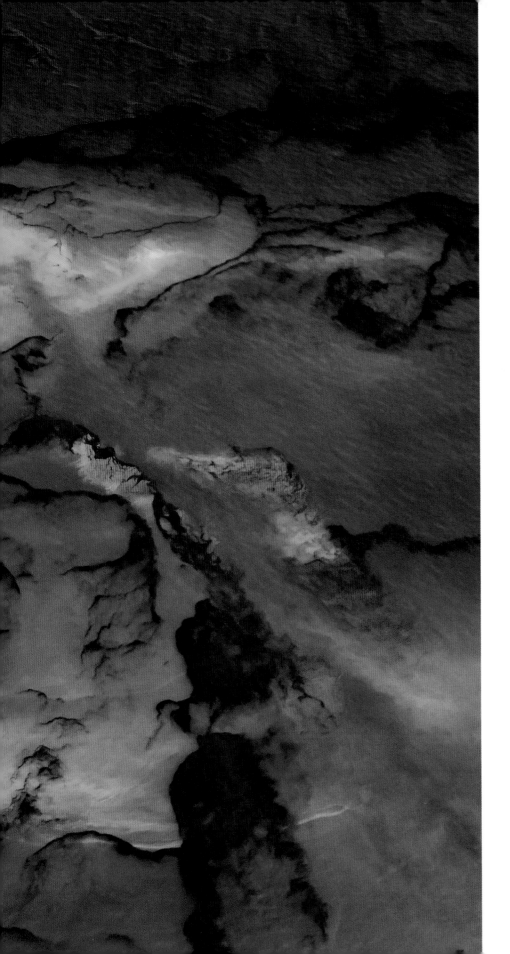

# The Wildlife Photojournalist of the Year Award

This award is given to a sequence of six pictures that tells a memorable story, whether about behaviour or an environmental issue.
The sequence should work without the aid of words and is judged on picture quality as well as the power of the story itself.

**WINNER**

## Daniel Beltrá

SPAIN

## THE PRICE OF OIL

On 20 April 2010, off the coast of Louisiana, BP's Deepwater Horizon wellhead suffered a blowout, releasing an estimated 4.9 million barrels of crude oil into the Gulf of Mexico. The wellhead was finally shut down on 19 September 2010. It was one of the worst oil spills in history. Daniel's photographs show the oil seeping into an already challenged and complex ocean ecosystem.

## Beneath the surface

Oil gushes to the surface near one of the relief wells, brought in to attempt to cap the damaged Deepwater Horizon wellhead, which had already sunk. 'This was a crazy day,' says Daniel. 'A lot of work was going on, with helicopters constantly landing and taking off from the boat's helipad.' He says he 'was blown away by the insane colours' – possibly the result of underwater work or some kind of chemical interaction with the dispersants being used. 'Flying over the disaster makes you grasp the immensity of the problem and the scale of the task.'

Canon EOS 5D Mark II + 24-70mm f2.8 at 54mm; 1/1000 sec at f4 (-0.7 e/v); polarizing filter; ISO 320.

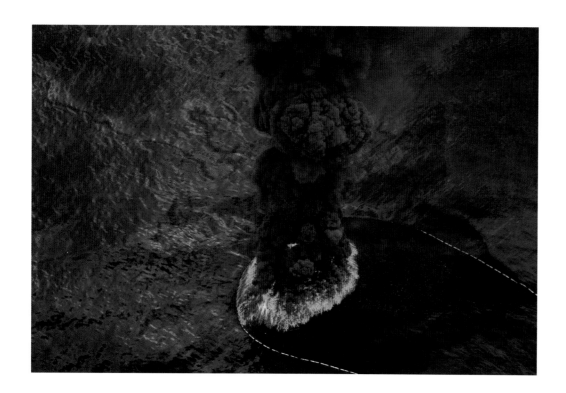

## From sea to air

One way to try to get rid of the oil was to burn it. After take-off one day, Daniel and his pilot spotted plumes of black smoke on the horizon. A cloud ceiling meant they had permission to fly a little lower, and so Daniel had a rare opportunity to take photographs a little closer. It also meant inhaling acrid smoke. In total, 411 controlled burns took place. Some 5,300 hired vessels helped with the clean-up by, for example, tugging booms to contain the oil.

**Canon EOS 5D Mark II + 100-400mm lens at 350mm; 1/1250 sec at f6.3 (-0.7 e/v); ISO 400.**

## Toxic beauty

'This is what the oil spill mostly looked like, for miles and miles, from one corner to the other,' says Daniel. 'Visually, the textures, hues and patterns of the oil were striking.' Asked why he made images of the oil spill that look beautiful, he answers, 'It was not my original intention, but photographs of disasters are often harsh. This set of images wouldn't look out of place in an art gallery, where families could look at them and discuss them. It's a route to understanding that doesn't depend on shock. I think it helps get the message to a wider audience, because if the image is aesthetically appealing, people are more likely to stop and read the caption.'

**Canon EOS 5D Mark II + 35mm f1.4 lens at 35mm; 1/1000 sec at f5.6 (-0.7 e/v); ISO 250.**

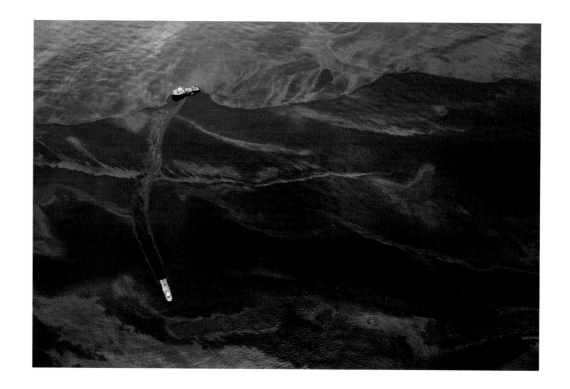

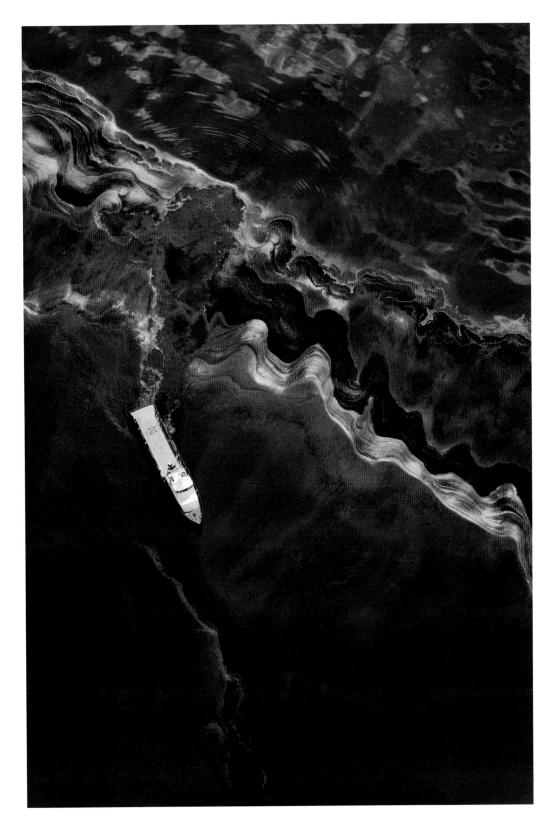

## Crimson crude

Gentle waves nudge bands of thick crude oil into curves of orange, red and burgundy. These were the heaviest oil slicks Daniel saw in the month he spent photographing the spill. They were also the most impressive. But he knew that, 'without a reference point, you could be looking at a splash of oil in a puddle.' Eventually, towards the end of the flight, one of the many boats involved in the clean-up motored in, perhaps to take samples, disturbing the gruesome pattern. Surface oil like this would end up washing ashore on the Alabama, Mississippi, Louisiana and Florida coastlines. How much remained below the surface is unknown.

**Canon EOS 5D Mark II +100-400mm lens at 170mm; 1/800 sec at f5; ISO 500.**

## Still life in oil

Oiled brown pelicans awaiting a second bout of cleaning – for Daniel, 'an icon of the disaster'.

**Canon EOS 5D Mark II + 35mm f1.4 lens at 35mm; 1/30 sec at f4 (-0.7 e/v); ISO 800.**

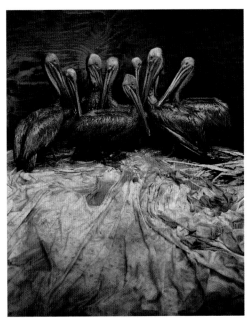

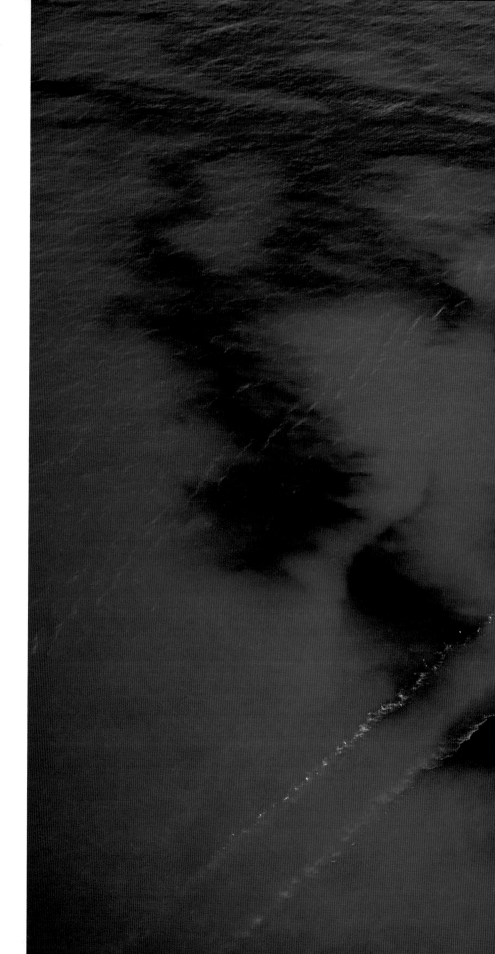

## Oil print

Criss-crossing the patches of black oil are paths
of clean water, the tracks left by boats involved
in attempts to cap the well. It's not clear what
caused the flashes of fluorescent orange.
They may have been a reaction caused by the
propellers churning up toxic chemical dispersants –
Corexit 9,500 and 9,527 – 9 million litres
(2 million gallons) of which were poured onto
the oil in an attempt to break it up. Whatever
the cause, the visual effect lasted only a few
moments. Here, the boat passed from top right
to bottom left, and the orange lights at the top
are already fading. As always, Daniel had to work
fast and intuitively, photographing from the open
window of the plane.

**Canon EOS 5D Mark II + 24-70mm f2.8 lens at 51mm;
1/1000 sec at f2.8; polarizing filter; ISO 400.**

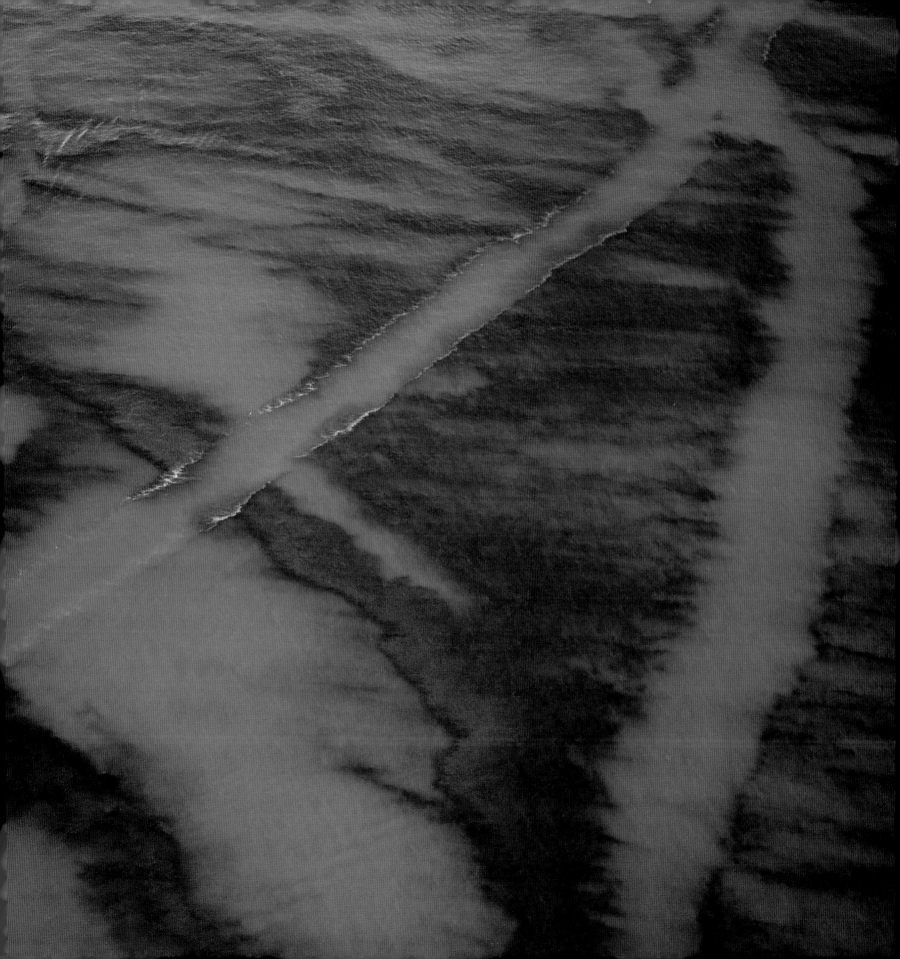

# Creative Visions of Nature

This category is for conceptual pictures – original and surprising views of nature, whether figurative or abstract – which are judged purely on their artistic merits.

## Illusion

**WINNER**

## Stefano Unterthiner

ITALY

The winter gathering of whoopers on Lake Kussharo, on Hokkaido, Japan, was a picture of chaos. The swans were constantly standing up, sitting down, heading off, interacting and calling. 'I suddenly saw that this could be the key to a completely different kind of image – one that shows the rhythms of a flock's movements,' says Stefano. He started to imagine the group of swans as one, flowing over the ice, seen at different points in time and space, and he set out to create the illusion. The swan enters lower right, wanders around a bit, sits down a few times, and exits top right – a single shot of continuous time and motion.

**Nikon D700 + 24-70mm lens; 1/320 sec at f16; ISO 1000.**

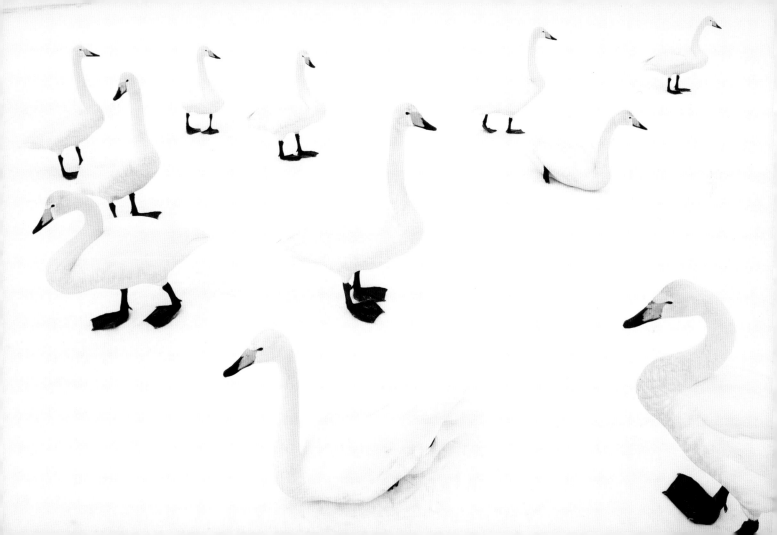

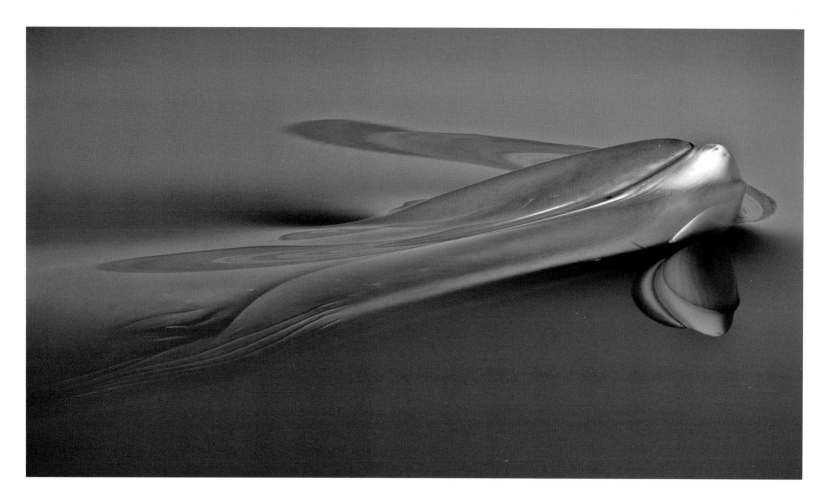

# Curious whale

**JOINT RUNNER-UP**

## Robert Cave

UK

It was first thing in the morning, just off Santa Catalina, when the call
'whale nine o'clock' came over the tannoy. Robert rushed on deck.
He was on a whale-watching holiday in Baja California, Mexico, and had
already had incredible encounters with humpbacks, blues, fins and greys.
So he was primed and ready with his camera. Slicing through the velvet-smooth
water towards the boat was a minke, which was not what they had expected.
Minkes are uncommon in the region. Even more surprising, she seemed to
want to make contact with the whale-watchers. For more than an hour,
she played around the boat, sometimes rolling onto her side and looking up
at the people craning over the side or going under the boat to dazzle them
with underwater and surface blows. It was an unforgettable experience,
crystallized in this photo, which reflects the grace and beauty of a mammal
completely adapted to its marine environment.

**Nikon D3S + 200-400mm f4 lens; 1/2500 sec at f8; ISO 3200.**

# Midnight tern

**JOINT RUNNER-UP**

## Ole Jørgen Liodden

NORWAY

Having led many trips to Norway's Svalbard archipelago, Ole knows exactly where to go for wildlife. When on location, he sleeps in the day and photographs at night, always carrying two cameras, ready for the moment. On this occasion, he was near Longyearbyen on the island of Spitzbergen. It was midnight when the light appeared, penetrating through the clouds and illuminating the valley up ahead. 'Midnight light is like a long-lasting, beautiful sunset,' he says. This time, though, it was so overwhelmingly beautiful that Ole started to walk towards it 'as though entranced'. And then the Arctic tern appeared. Pure magic. Ole adjusted his shutter speed to blur the background and tracked the tern – symbol of the Arctic – as it flew over the tundra alongside him.

**Nikon D3S + 600mm f4 lens; 1/8 sec at f13; ISO 100**.

# A spectrum of silk

**HIGHLY COMMENDED**

## Antti Partanen

FINLAND

The setting was a bog in Siikainen, Finland. Draped over the plants were dew-drenched spiderwebs, sparkling in the early morning sun. But it was only when Antti looked at the dew drops through his viewfinder that the transformation happened. If he moved the focus a little behind or in front of the droplets, rainbow colours became visible. To bring out the colours clearly in the photograph, he had to focus on the dew, use long shutter times and move the camera during the exposure. He took nearly 200 shots in an attempt to capture the effect, but few of the photographs satisfied him. Finally, the following summer, he got pictures that he felt did justice to the phenomenon.

**Pentax K10D + Tamron SP 90mm f2.8 macro lens; 1/10 sec at f25; ISO 125.**

# Migaloo the Magnificent

**SPECIALLY COMMENDED**

## Marc McCormack

AUSTRALIA

'There can't be many more exhilarating wildlife experiences,' says, Marc, 'than to hang in the air looking down on the emergence and submergence of such a magnificent animal.' Marc got his shot over the Great Barrier Reef, off Queensland, hanging by a harness from the open door of a helicopter. As the all-white Migaloo – the only known albino humpback – took deep breaths at the surface, he glowed like an iceberg. But as he dived, he turned aquamarine, leaving in his wake a 'footprint' – a smooth patch of water caused by the upward thrust of his tail flukes. Migaloo visits Australia annually, and seeing him is a whale-watching highlight. He is part of a humpback population that in winter migrates from feeding grounds in Antarctica to the subtropical waters off Australia to breed.

**Canon EOS-1D Mark III + 600mm f4 lens; 1/1600 sec at f13; ISO 250.**

## The coming

**HIGHLY COMMENDED**

## Sven Začek

ESTONIA

From time to time, Sven returns to his childhood home in Võrumaa, south Estonia, to photograph the very first subject he took pictures of – roe deer. The past two winters in Estonia have been very severe, and Sven wanted to illustrate the harsh conditions the deer have had to endure.
On this day, he located a small herd sheltering at the bottom of a hill during a fall of snow, dug himself a snow hide and sat tight to watch. It was already well below freezing and getting dark. But the strange light was what Sven wanted, giving the scene an almost mystical feel.
Hearing the crunch of snow of an approaching animal, he focused on the horizon, catching the moment that the stranger appeared over the hill.

**Nikon D3S + 400mm f2.8 lens + TC-14E II converter; 1/250 sec at f4; ISO 2000; Gitzo tripod + Wimberley head.**

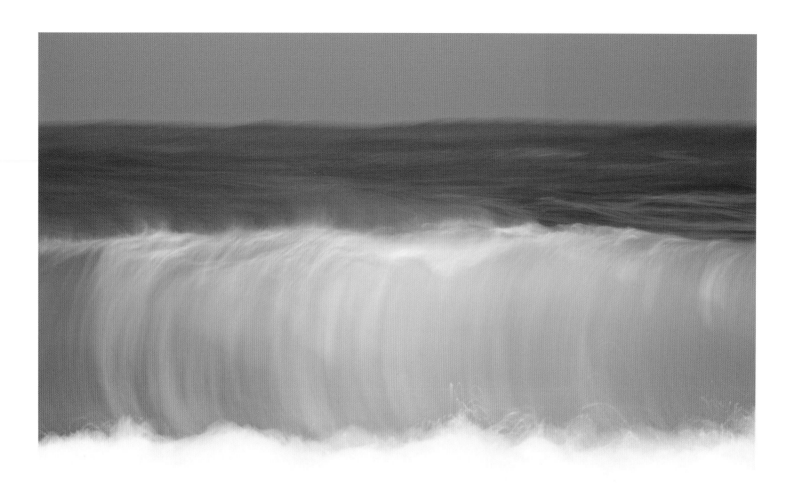

## Ocean abstraction

**HIGHLY COMMENDED**

## Laurence Norton

USA

A storm was heading for Kauai's north shore in Hawaii, and the coastguard warning was of dangerously high waves. For Laurence, it was the news he had been waiting for. 'For my entire life, I've been mesmerized by the ocean . . . and I went to Hawaii specifically to photograph the winter storm waves.' Under a bright midday sun, Laurence set up his tripod on dunes overlooking a beach where high surf was expected. As the storm approached and the waves slammed onto the beach, 'I could feel the impact in my chest,' he says. Using a long lens to achieve a compression of the space between the waves and the ocean behind, a slow speed to soften the motion and filters to adjust the light and colour, he achieved his objective: to create an abstraction of the contrast between the power of ocean waves and the serenity of the ocean itself.

**Nikon D3X + 28-300mm f3.5-5.6 lens + two-stop circular polarizer + three-stop ND filter; 0.6 sec at f20; ISO 50.**

# Snow and geese

**HIGHLY COMMENDED**

## Arthur Morris

USA

Huge numbers of migratory birds, including snow geese and white-fronted geese, refuel at the Lower Klamath National Wildlife Reserve in California on their migration south. In turn, the spectacle attracts hundreds of birdwatchers and photographers. Arthur was one of them. 'Every so often a mass of them would take off, for no obvious reason, but perhaps scared by a coyote or eagle,' he says. 'The noise of the blast-off was incredibly loud, like honking jet engines.' Suddenly, a heavy snowfall hit. Arthur would normally have opted for a slow shutter speed to blur the movement, but this time, with the wind behind him and the birds flying towards him, he chose to use a fast speed to capture the extraordinary pattern of legs and wings. 'I love the way their feet all dangle down and the strange perspective caused by the birds in front being less obstructed by the snowflakes than those above and behind.'

**Canon EOS-1D Mark IV + 800mm lens; 1/640 sec at f6.3 (+ 2.3 e/v); ISO 400.**

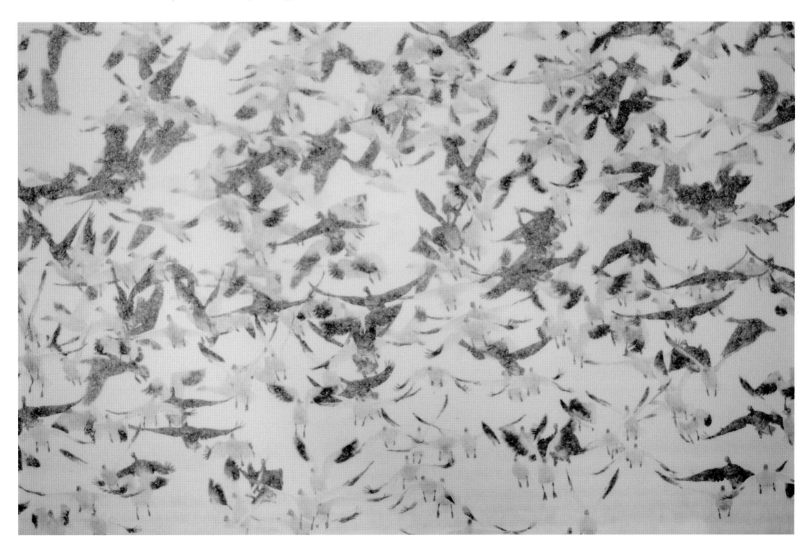

# Behaviour Birds

In this category, it's not enough for the picture to have aesthetic appeal. The subjects must also be doing something interesting or dramatic.

## The assassin

**WINNER**

## Steve Mills

UK

A severe freeze in December 2010 caused major problems for British birds, especially those needing to feed in mud. Even secretive birds were forced into the open. Knowing any snow-free area was a precious resource, Steve located a tiny patch of exposed grass near where he lives in Whitby, North Yorkshire, and waited. Eventually a snipe emerged and began feeding frantically. 'I was only a few metres away,' says Steve. 'In normal conditions, a snipe would be more cautious.' Within a few moments, though, it had paid the ultimate price. A merlin swooped in fast and low and grabbed it in a flurry of snow. The struggle was short. The merlin pinioned the snipe, stared briefly at Steve and then killed its prey with a series of rapid blows to the head. 'The attack was so unexpected, so dramatic and so close,' says Steve, 'that I was overjoyed to find I had captured the moment, but I also felt great sympathy for the loser.'

**Canon EOS 50D + 500mm f4 lens; 1/500 sec at f5 (+1.7 e/v); ISO 400.**

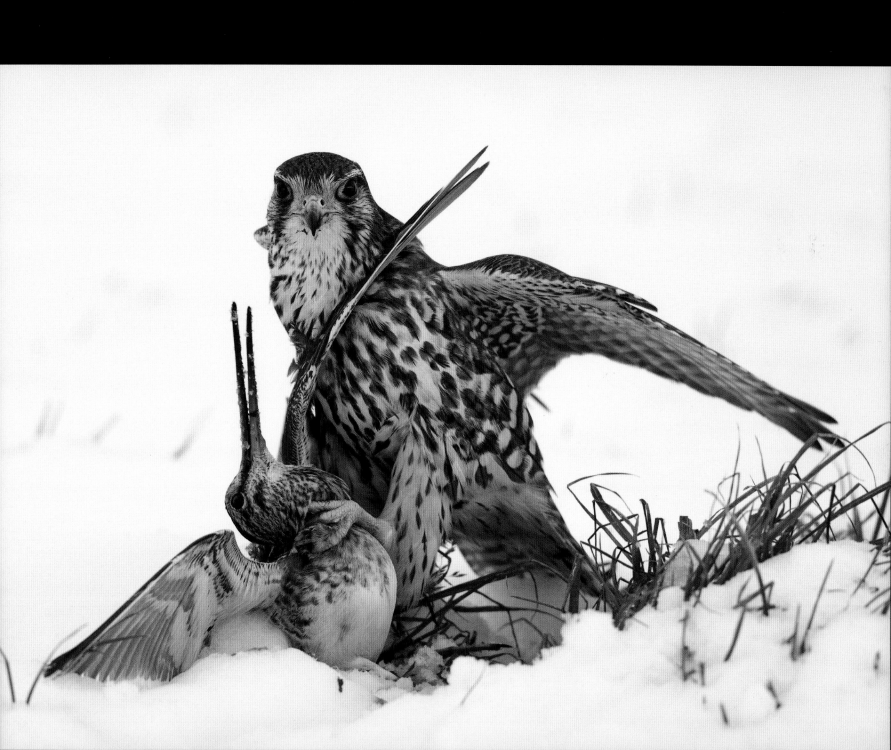

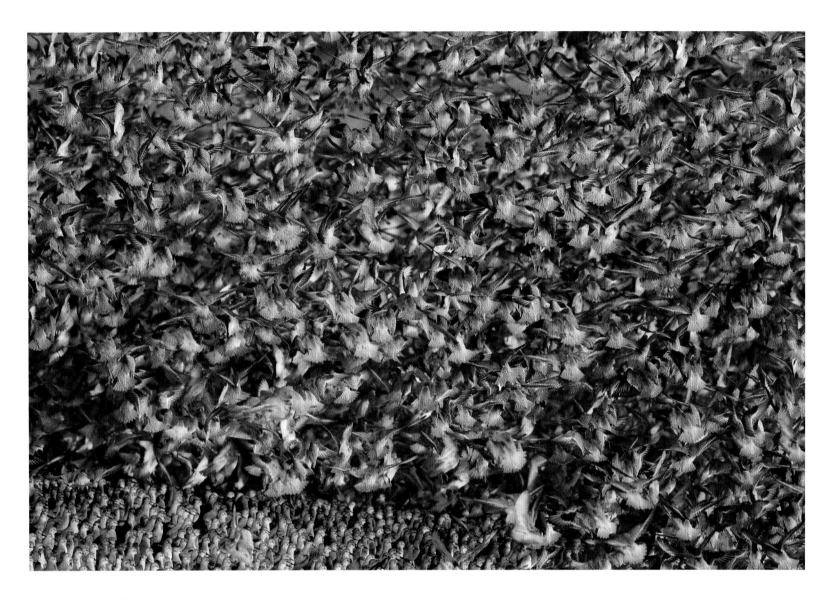

# Knot lift-off

**SPECIALLY COMMENDED**

## Thomas Hanahoe

UK

The bleak mudflats of the Wash Estuary in Norfolk provide an enormous feeding table for waders. As the tide comes in, the flocks are flushed inland. To catch the spectacle, Thom set up on Snettisham beach just before dawn. 'I watched as, in the distance, hundreds of thousands of wading birds took to the air, swirling in unison before swooping low over the shore to settle on the beach,' he says. Tens of thousands of knots roosted together, 'their heads aligned like spectators at a sports event'. But with the arrival of a marsh harrier, all hell let loose. 'The knots erupted into a wall of wings, and the air filled with an intense crescendo of calls. As the wave of birds started to ascend, I pressed the shutter.'

**Canon EOS-1D Mark IV + 500mm f4 lens + 1.4x extender at 700mm; 1/2500 sec at f5.6; ISO 1600.**

# Wings of a gull

**RUNNER-UP**

## Jan van der Greef

THE NETHERLANDS

Jan first went to Flatanger in northern Norway to photograph white-tailed eagles. But he became captivated by the herring gulls wheeling around the boat. When he planned his next trip, he knew the picture he wanted to get. He crouched down low in the boat and concentrated on a single bird, waiting until it took off and panning his camera up with the gull, using a slow speed to capture the wing dynamics. 'The sublime, soft lighting,' says Jan, 'the gull's wonderful wing motion and the shimmering stream of water from its legs – for me, symbolizing the transition from floating on water to the freedom of the moment in the air – combined to create the ethereal image I had hoped for.'

**Canon EOS-1D Mark IV + 70-200mm f2.8 lens at 115mm + 1.4x extender; 1/6 sec at f14; ISO 200.**

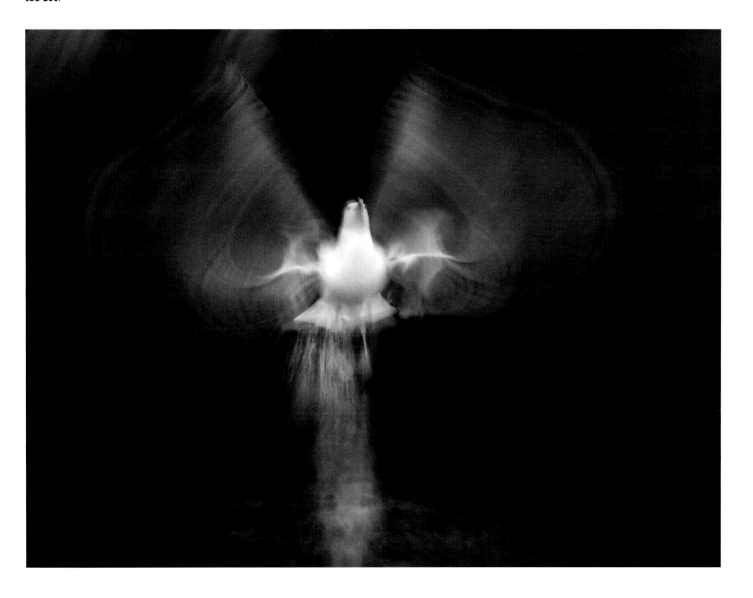

# Racket-tail in the rain

**HIGHLY COMMENDED**

## Petr Simon

CZECH REPUBLIC

Petr has become addicted to hummingbirds. One of his favourite species is the booted racket-tail – tiny, quick and a real challenge to photograph. He recently spent more than two weeks at a lodge in Ecuador watching hummingbirds, obsessed with getting the quintessential image. Each day, he watched the birds feeding, getting to know their routines – which bird feeders and flowers they visited and when. Muted light gave the best results, and this shot of a male booted racket-tail feeding at a bromeliad was taken in the late afternoon. Petr used flashes to highlight the bird's dazzling plumage and a fast shutter speed to slow its rapid wing-beat. The soft rain added a sparkling touch to the scene.

**Nikon D3S + 400mm f2.8 lens; 1/800 sec at f5.6; ISO 3200; two Nikon SB-900 flash units.**

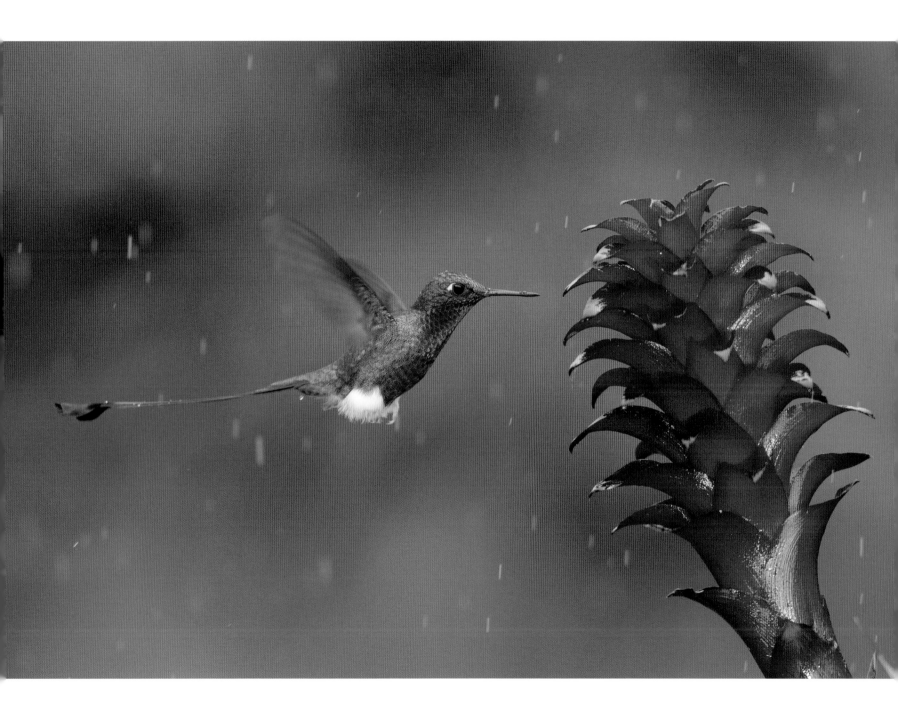

# The paper-clip suitor

HIGHLY COMMENDED

## Tim Laman

USA

Male bowerbirds are famous for collecting various random items to tempt a prospective mate with. Few, though, match the great bowerbird's eclectic taste. Living in northern Australia, the male accumulates artifacts as diverse as pebbles, snail shells, vertebrae, rifle shells, CDs and, in this instance, a pretty pink paper clip. Not only do the males use their stash to impress the females, but they will also boost their haul by stealing from each other. After enticing a female to enter his bower – a 'bivouac' of twigs – a male will choose one of his prized decorations and strut back and forth in front of the entrance, showing off to her. Tim photographed this bower in a surprisingly public place, the campus of James Cook University, Queensland, and got down low to get a bowerbird's perspective of the display. 'This,' he says, 'is the female's view from inside the bower, with the eager male, mid-strut, peering back at her.'

Canon EOS-1D + 300mm f2.8 lens + 1.4x extender; 1/45 sec at f8; ISO 640; flash fill.

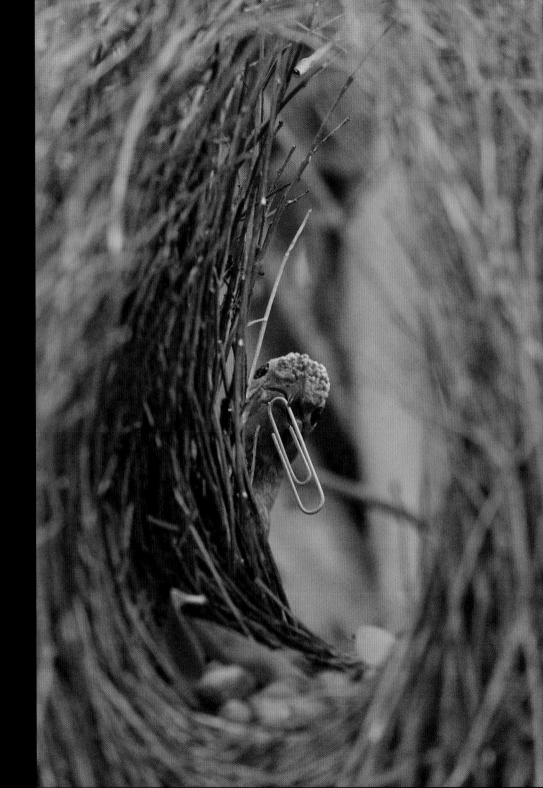

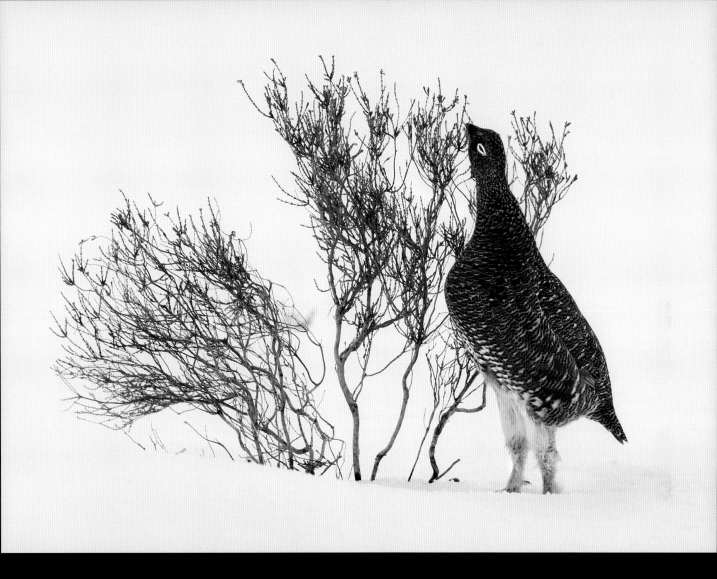

## Extreme foraging

**HIGHLY COMMENDED**

## Ron McCombe

UK

'We were into our third week of snow,' says Ron. 'This is unusual for the Scottish Borders,' and the snow had forced the red grouse down from the high moor to the lower slopes of the Lammermuir Hills in an attempt to find exposed vegetation. But the temperature here wasn't much better, with a bitter east wind bringing it down to -10˚C (14˚F). From the roadside, Ron watched this female searching for food. 'She had to stand on tiptoe to pick the seeds at the top of the heather. It looked so elegant, even though the situation was so harsh. It's hard to imagine how they find enough food to survive such a winter.'

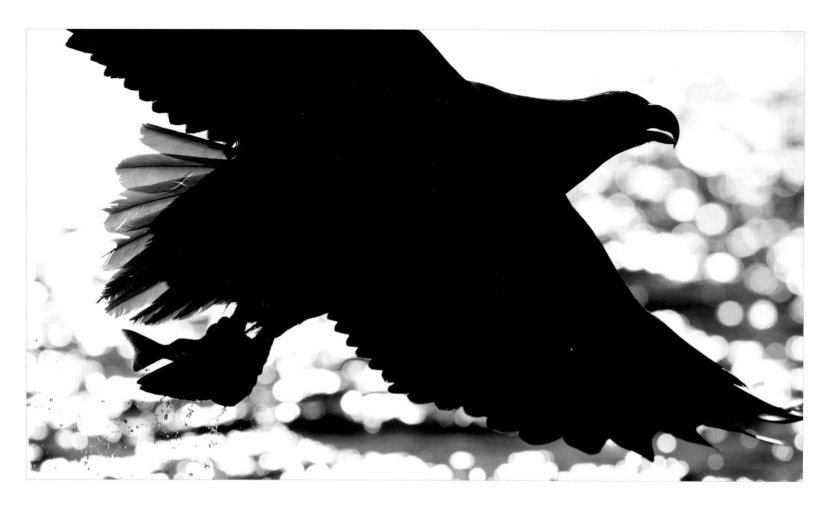

## Swoop of the sea scavenger

**HIGHLY COMMENDED**

### Roy Mangersnes

NORWAY

Roy has taken many pictures of white-tailed eagles fishing off the coast of
Norway, but on this trip, he set out to shoot an image that would convey
the sheer size and power of the bird. These eagles are among the largest flying
birds in Europe, with a wingspan of 2.2 metres (7 feet). In Norway, they are
found mainly around the coast. Here fish form a large part of their diet, but
much of it is scavenged from the leftovers of fisheries, seabirds and otters
and also by stealing from other birds. Roy took the shot from a boat in a fjord
in Flatanger, northern Norway, using fish bait. 'I chose a long lens even though
I knew the eagle would be very close,' says Roy, the plan being to try for
a silhouette. The challenge was to hold the heavy 500mm lens steady on
a rocking boat and to follow the swooping bird with such a tight frame.
But the result is a striking portrait.

**Nikon D3S + 500mm f4 lens; 1/3200 sec at f8; ISO 500.**

# Taking flight

**HIGHLY COMMENDED**

## Paul Goldstein

UK

Paul arrived very early on the shores of Lake Nakuru, Kenya, before the rising sun had burnt off the mist. He had returned to photograph the greater and lesser flamingos and used shade, shadows and silhouettes to create drama, rather than sunlight to emphasize their vivid colours. He was helped by a combination of circumstances: rain during the night, a rapidly clearing sky, enough time for the cold air to form mist over the alkaline waters and a hyena hunting for young or infirm birds along the far shore of the soda lake.

The predator set up a wave of panic, with those closest to it taking flight and those nearest to Paul standing alert. Ten minutes later, not only had the whole flock lifted up, but the mist had also burnt off, completely changing the scene.

**Canon EOS-1D Mark 4 + 500mm f4 IS lens; 1/5000 sec at f10 (-1.7 e/v); ISO 200; beanbag.**

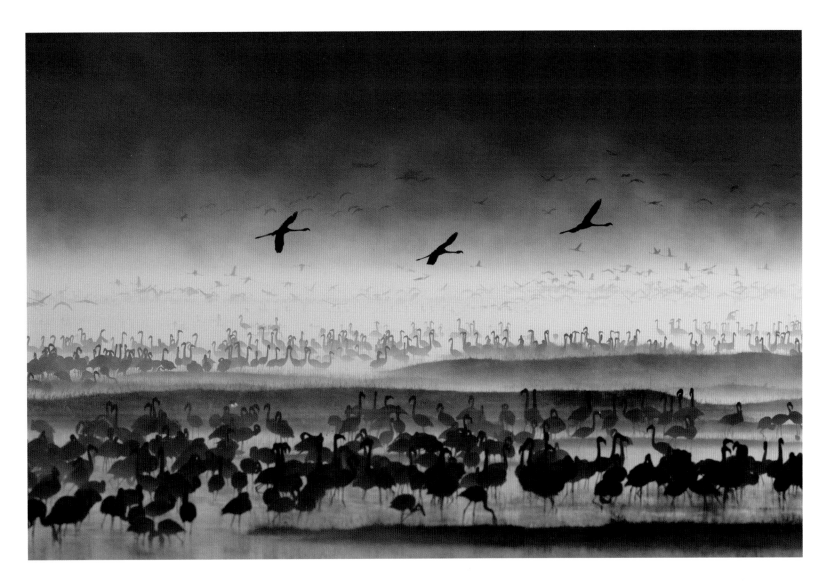

# Fire flying

**HIGHLY COMMENDED**

## Nilanjan Das

INDIA

'The heat was unbearable,' says Nilanjan, 'and that was from where I stood, some 30 metres [100 feet] away from the fire.' The black drongos, on the other hand, swooped close to the flames, picking off insects fleeing the blaze. The conflagration happened in late February, in Kaziranga National Park, Assam. But it was a deliberate fire lit by the Indian forest department to burn off the elephant grass and encourage new growth, and so Nilanjan had time to position himself with a clear view of the fire. The heat haze played havoc with his camera's auto-focus, but luckily he had switched to manual focus moments before the birds appeared. The drongos hunted for just 10 seconds in front of the wall of flames, seemingly unaffected by the heat, and then vanished.

Nikon D700 + 200-400mm lens at 400mm; 1/2500 sec at f5.6; ISO 800.

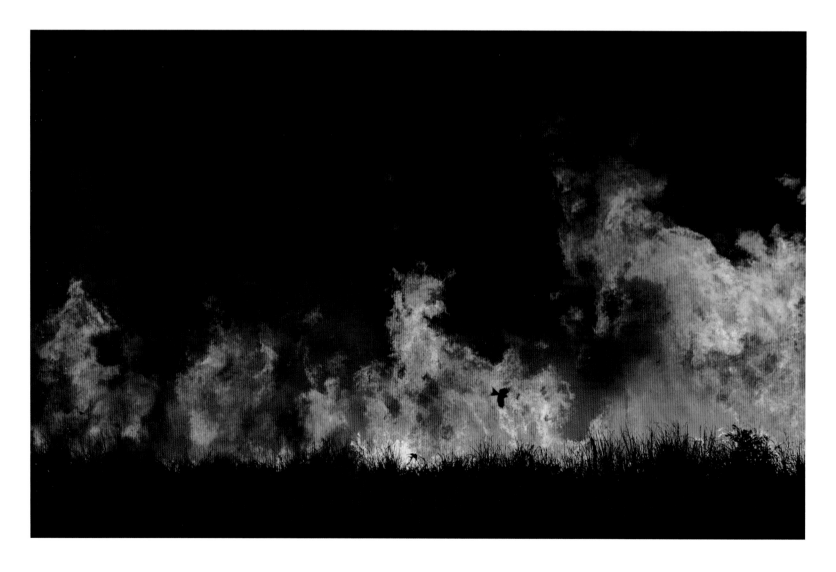

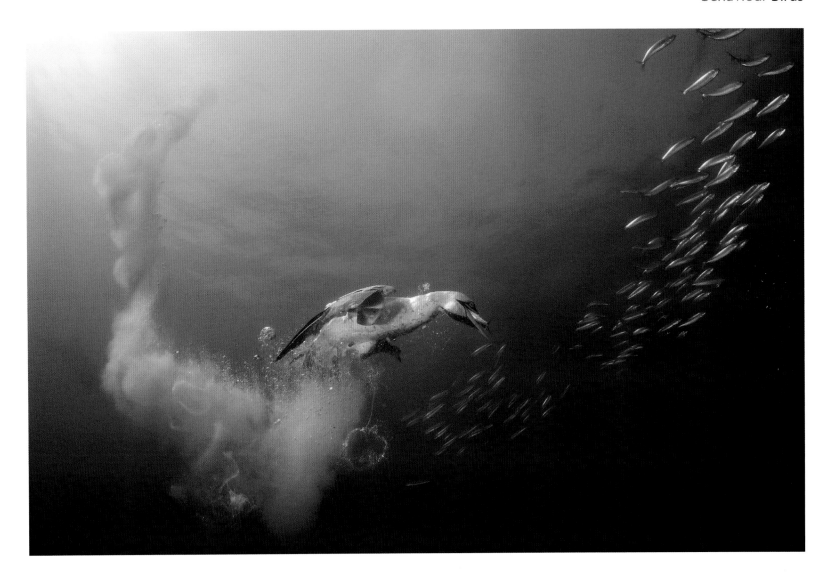

# High-dive precision

**HIGHLY COMMENDED**

## Gennady Fedorenko

RUSSIA

This is the moment that the Cape gannet gets its fish. The corkscrew bubble-trail and fleeing sardines reveal the trajectory of the bird's 10-metre (33-foot) dive from 30 metres (100 feet) above the water off the coast of Port St Johns, South Africa. The annual 'sardine run' along the southeastern coast of southern Africa is one of the world's great migration events. Sharks, dolphins, whales, seabirds and, in this instance, Fedorenko join in the hunt. 'The gannets were mesmerizing to watch,' says Fedorenko, 'and as graceful below water as they are in the air.' But their dives are so fast and the action is over so quickly that 'getting this shot is as much luck as skill,' says Fedorenko, modestly.

**Canon EOS-1Ds + 15mm f2.8 lens; 1/160 sec at f18; ISO 640; Sea & Sea MDX Mark III housing; Inon Z240 strobes.**

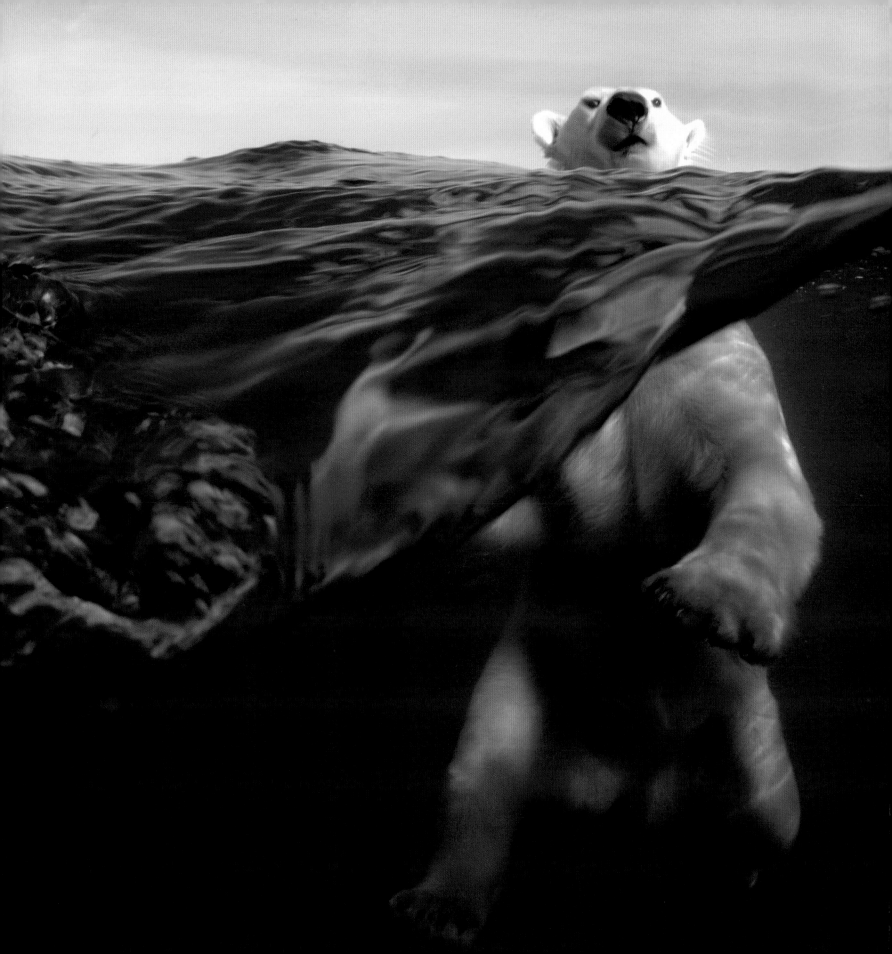

# Behaviour
# Mammals

In this category, the pictures are chosen
for their action and interest value
as well as for their aesthetic appeal.

## Polar power

WINNER

### Joe Bunni

FRANCE

After three days on a small boat looking for polar
bears in Repulse Bay, Nunavut, Canada, Joe finally
got lucky. 'We cruised at a distance, so we didn't
disturb the bear. Then, once we were sure it was
relaxed with our presence, I slipped quietly into
the water with just a mask and fins, attached to
the boat by a rope.' The polar bear now started
to swim towards the boat, powering itself with
its front legs, the toes of its huge paws spread
wide. It didn't appear to notice Joe, and for
20 minutes he was able to take photographs from
the water. But then the bear caught sight of its
own reflection in the dome port and swam up to
Joe. 'It's amazing when a huge, powerful animal
comes beside you.' It came so close that its nose
touched the housing, startling it. The second after
Joseph took this shot, the bear reached out and
touched the dome with its paw. Then it turned
and swam away, leaving Joe with an unforgettable
split-level image of a swimming polar bear –
symbolic, he says, 'of the power and elegance
of a wonderful creature struggling to survive in
a fast-changing climate.'

**Nikon D2X + 10.5mm f2.8 fisheye lens; 1/320 sec at f12;
ISO 400; Aquatica housing.**

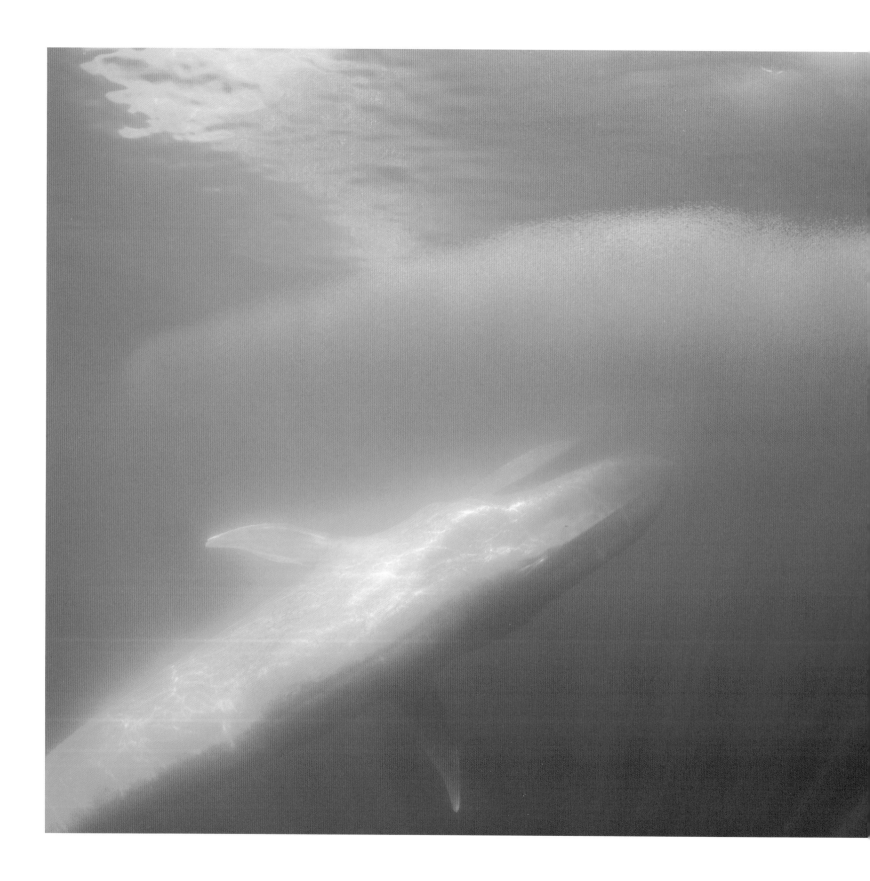

# Big blue mouthful

**RUNNER-UP**

## Richard Herrmann

USA

When news reached Richard that a mass of animals, including blue whales, were feeding on krill near the Los Coronados Islands in Baja California, Mexico, he dropped everything and set off from San Diego in his buddy's skiff. That same day, he was in the water with the animals. On his first dive, wearing just a snorkel and mask so as not to cause disturbance, he started photographing a school of market squid feeding on a krill ball. Then, suddenly, he became aware of a huge shape to his left, moving fast towards another great ball of krill near the surface. It was an adult blue whale, probably about 20 metres (70 feet) long. As it approached the krill, it began to open its mouth, ready to lunge through the ball. 'Opportunities like this with blue whales are very rare. I knew exactly the timing and distance I needed,' says Richard, 'and was excited but calm. I just had to swim as hard as I could to get in position and trust my skills to get it right.' He managed six shots before the whale disappeared into the krill. 'Charging through the ball on its side, with its throat pleats expanded, the huge whale then gently collapsed them [to expel the water] and swallowed its meal.'

**Canon EOS 5D + 15mm fisheye lens; 1/200 sec at f9; ISO 400; Sea & Sea housing.**

# The charge

**HIGHLY COMMENDED**

## Eric Pierre

FRANCE

Eric had been tracking Arctic wolves on Victoria Island, Canada, when his guide spotted a herd of muskoxen some 5 kilometres (3 miles) away. Approaching, Eric could see that the herd was nervous, probably because wolves were also on its trail. So he made a detour and stopped about 1 kilometre (half a mile) away upwind. Suddenly, he realized that the herd was now running towards them, oblivious of them. 'I've seen muskoxen run away,' says Eric. 'I've seen them react to a threat by forming a circle, and I've even seen a male charge. But I've never seen a herd spread out into a charging line like this. I could hear the thundering of their hooves. It was one of those situations where it really mattered that I made the right choice between technical accuracy, aesthetics – and security.'

**Nikon D700 + 500mm f4 lens; 1/2000 sec at f8; ISO 400; Gitzo carbon tripod + carbon Eki head.**

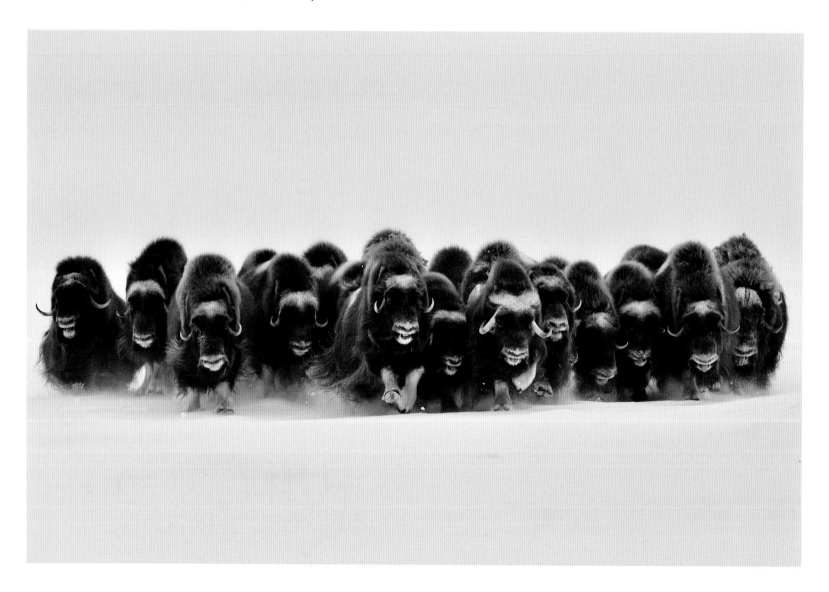

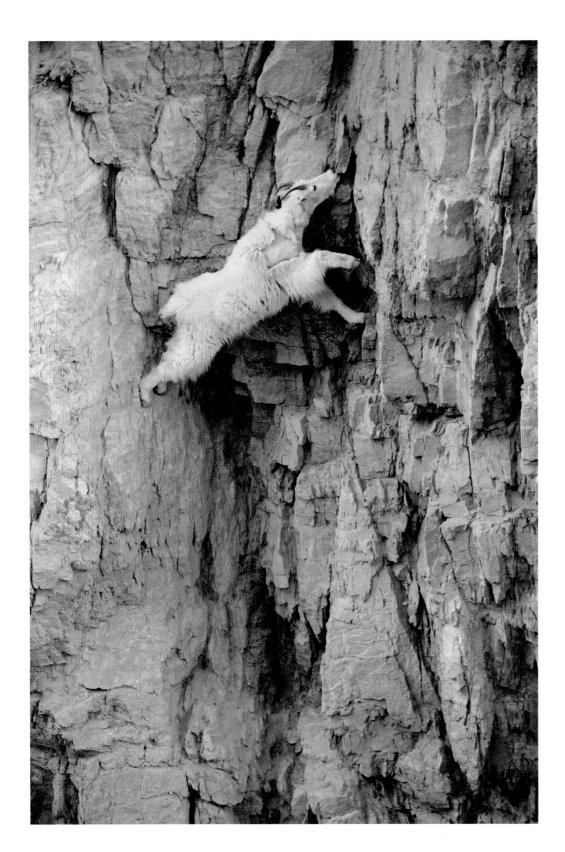

## Balancing act

**HIGHLY COMMENDED**

Joel Sartore

USA

In a death-defying manoeuvre, a mountain goat stretches to reach a mineral lick. Joel knew it was a favourite lick and had stationed himself at the other side of the gorge in Glacier National Park, Montana. When this female arrived, he watched as, slowly and methodically, she first balanced on all four feet on a single, tiny ledge and then pushed out with her front legs and wedged herself into the crevice, her rubbery hooves spread out for maximum grip. 'They never rush,' says Joel. 'They have to be so careful about where they put their feet, testing each foothold, because every step could be their last.' When she'd finished, the mountain goat reversed the move, carefully balancing again on the tiny ledge and then slowly turning around so that she could climb back up the mountain face and rejoin the rest of the herd.

**Nikon D3 + 200-400mm f4 lens; 1/500 sec at f4 (-1.3 e/v); ISO 2000.**

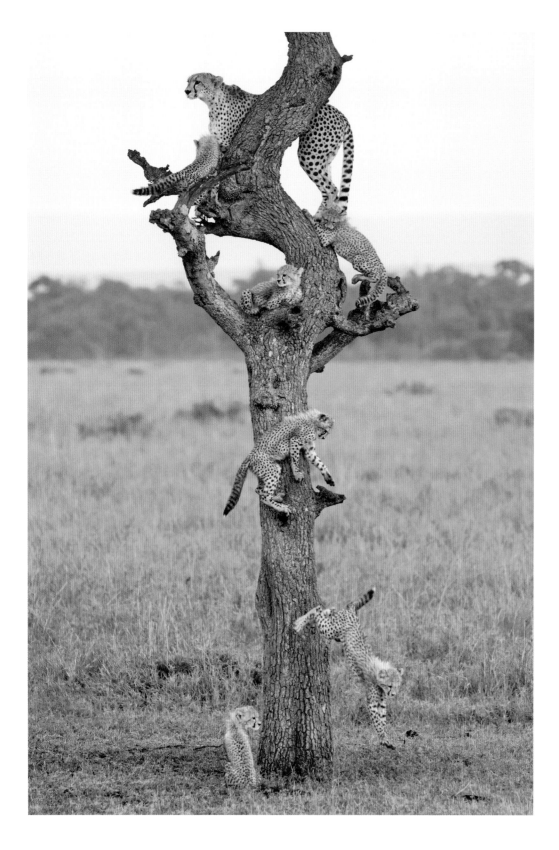

## Family tree

**HIGHLY COMMENDED**

## Paul Goldstein

UK

Paul caught up with this cheetah female and her six nine-week-old cubs just before sunrise. He had been following the family in Kenya's Masai Mara for the past two weeks. While the lively siblings played around a balanites tree, circling and leaping, he took a series of backlit shots. Occasionally, one would use its sharp, young claws to scramble up the tree and then down again. Then, just as the sun clouded over, something unexpected happened. 'Five out of the six cubs ended up in the tree at the same time,' says Paul. 'Then the mother, her belly concave with hunger, suddenly leapt up, too. She paused just below the crown and looked around, scanning the plain for breakfast. I love the way the postures are all different – and the indifference of the cub on the ground. Over the past 20 years, I have probably spent more time with cheetahs than any other animal, but I've never seen a scene like this before.'

**Canon EOS-1D Mark IV + 70-200mm lens; 1/640 sec at f4 (-0.3 e/v); ISO 400; beanbag.**

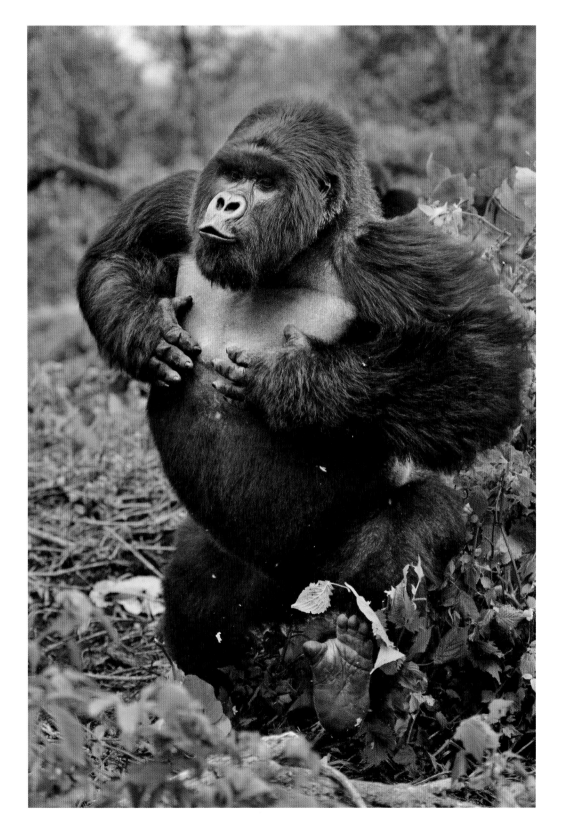

## Making an impression

**HIGHLY COMMENDED**

### Andy Rouse

UK

This is the moment that Akarevuro, a young male mountain gorilla, charged at Andy and his companions in Volcanoes National Park, Rwanda. It had taken a couple of hours' trekking to reach the gorilla band, which is led by Akarevuro's father, Kwitonda. 'The group was very chilled', recalls Andy. 'Kwitonda ate peacefully, and Akarevuro was hanging out with some females in a clearing.' With hormones raging, Akarevuro suddenly rushed towards the group of humans. 'Dense vegetation prevented us from moving back,' says Andy. 'Akarevuro stopped a few metres away from us, squatted on all fours and remained like that for several minutes to make his point.' Andy sat still, avoided eye contact and waited for the moment to pass. 'Akarevuro was simply out to impress one of the receptive females,' concludes Andy. 'And it worked – a little later, we saw him mating.'

**Nikon D3S + 70-200mm f2.8 lens; 1/3200 sec at f4; ISO 800.**

# Behaviour
# All Other Animals

This is a category for pictures of animals that are not mammals or birds –
in other words, the majority of animals on Earth. Most of them behave
in ways that are seldom witnessed and little known or understood.
So this category offers plenty of scope for fascinating behaviour.

## Cold embrace

**HIGHLY COMMENDED**

### Cyril Ruoso

FRANCE

Cyril couldn't believe his ears. Here he was,
some 2,000 metres (6,500 feet) up in the French
Alps, beside a lake covered with ice, but he could
hear a frog chorus. Cyril had visited the spot the
previous year and knew that hundreds of common
frogs would shortly be emerging from hibernation,
but he didn't expect them to start their mating
rituals while still under the ice. But he could hear
them singing away, presumably in the gap of air
between the ice and the water. Ten days later,
the ice began to melt, and the first choristers
appeared. Cyril says, 'The males jump on anything
that moves – even on my equipment,' holding
on with the aid of the dark 'nuptial pads' on their
thumbs. Here, one male is holding onto another
as they both wait for a female to show up. Cyril
positioned his hide on the bank and carefully set
up his camera and split-level lens half in the water,
together with both underwater and above-water
flashes and a cable linking the camera to his
monitor. 'I wanted to portray everything about
this extraordinary habitat – the mountains,
the ice, the water and the cold – and create a shot
which would show that even the most common
species is extraordinary.'

**Canon EOS 5D + Sigma 14mm f2.8 HSM lens; 1/160 sec
at f20; ISO 200; custom-made housing; Inon D2000 S
+ Canon 580EXII + Nikon SB-24 strobes; hide.**

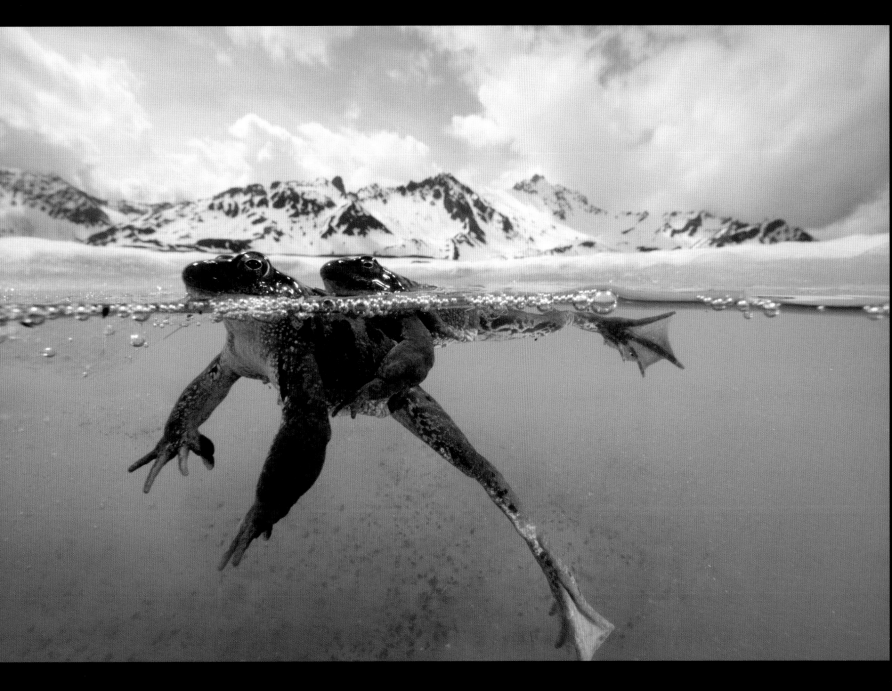

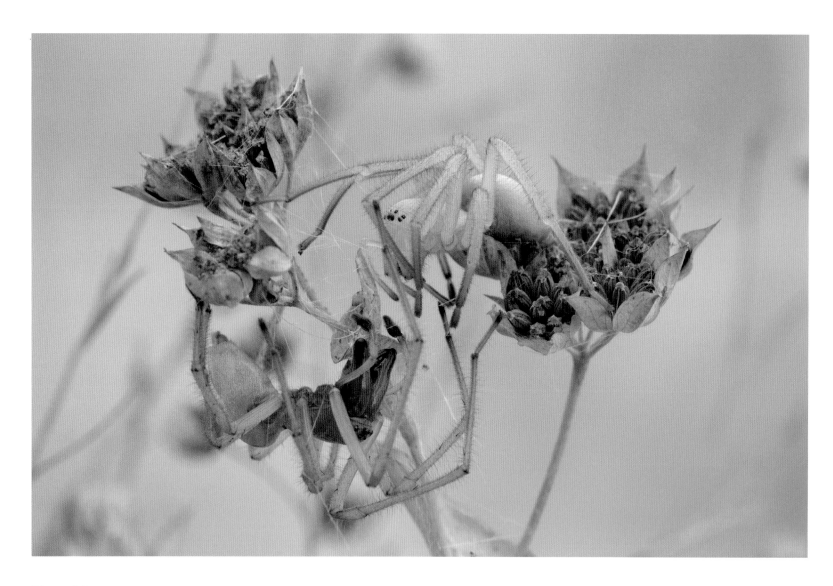

## Touching romance

**HIGHLY COMMENDED**

## Dmitry Monastyrskiy

RUSSIA

'It took me a long time to find these spiders and almost as long to take their picture,' says Dmitry. The location was a meadow on the outskirts of the city of Rostov-on-Don in southwest Russia, and the yellow-sac spiders were racing around the seedheads, stopping only briefly to touch legs. Here the male is under the female, waving his black palps (the appendages that transfer sperm to a female), presumably signalling his romantic intentions. Dmitry never did see them mate. If they did, the female would have built a sac-like nest for her eggs and guarded the eggs until they hatched. The species is one of the few in Europe with fangs that can penetrate human skin, but the bite isn't dangerous.

**Canon EOS 40D + 100mm 2.8 lens; 1/3 sec at f11; ISO 100; wireless shutter release; Manfrotto 190XPROB tripod; reflector.**

# A stack of suitors

**HIGHLY COMMENDED**

## Marcel Gubern

SPAIN

Sipadan Island, off the east coast of Sabah, Borneo, is renowned for its relatively pristine coral reefs and rich marine life. It's also a hotspot for sea turtles, which gather there to mate and nest. And it was turtles that Marcel was after. As he returned to his boat at the end of the very last dive of his trip, after several days searching for a mating pair, Marcel noticed a green turtle floating nearby. 'As I watched,' he says, 'I realized it was being pushed out of the water by something underneath. This was the moment I'd been waiting for.' He grabbed his snorkel, mask and camera and plunged back in. 'I couldn't believe my luck when I discovered it wasn't just two but a stack of turtles mating.' They didn't appear bothered by Marcel's presence, and while he was photographing the cooperative female and her suitors, other males drifted in to join the party. Female green turtles may have multiple matings and produce eggs sired by different males, but they can also be choosy about whose sperm they use and are capable of storing sperm in their oviducts for long periods.

**Nikon D200 + 12-24mm lens at 19mm; 1/100 sec at f7.1; ISO 200; Subal ND20 housing.**

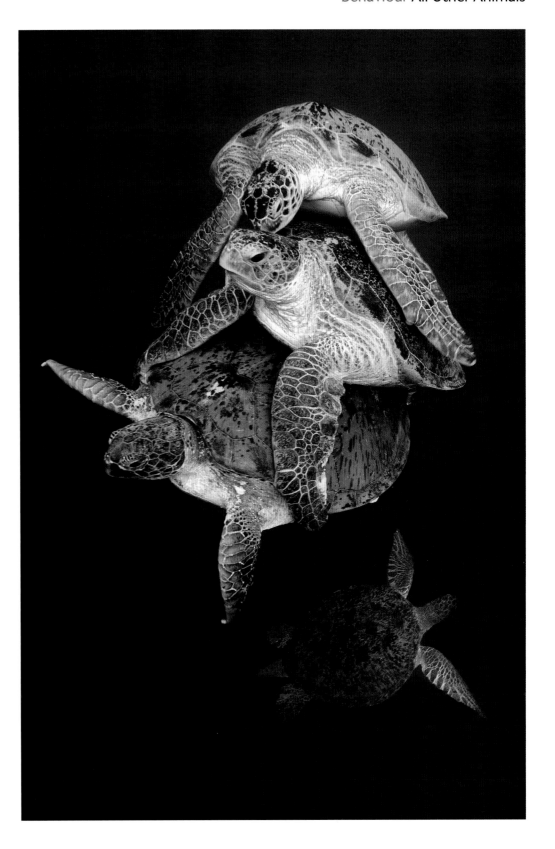

# Love under the lens

**HIGHLY COMMENDED**

## András Mészáros

HUNGARY

A new macro lens has opened up another world for András. 'Since I've had it, I use every opportunity to catch a glimpse of the lives of tiny insects,' he says. When he found these two snail-killing flies, each little more than half a centimetre long, mating on a grass stem, what struck him was not only 'their beautiful markings but also the female's seeming attitude of surprise to find another insect on her back.' Little is known about the lifestyle of this particular Central European species, but it almost certainly behaves like its close relatives, either laying its eggs on leaves in the vicinity of snails or directly onto snail shells. The resulting larvae then feed on snails, possibly even pupating in their shells.

**Canon EOS 5D + MP-E 65mm lens + extension tube + mirror lock-up; 1/200 sec at f10; ISO 200; Canon MT-24EX twin flash; Manfrotto ballhead; Gitzo tripod.**

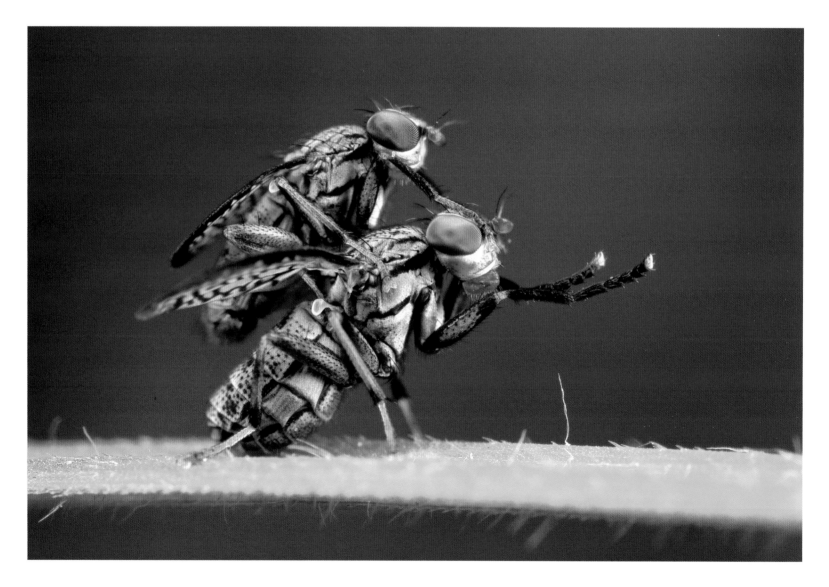

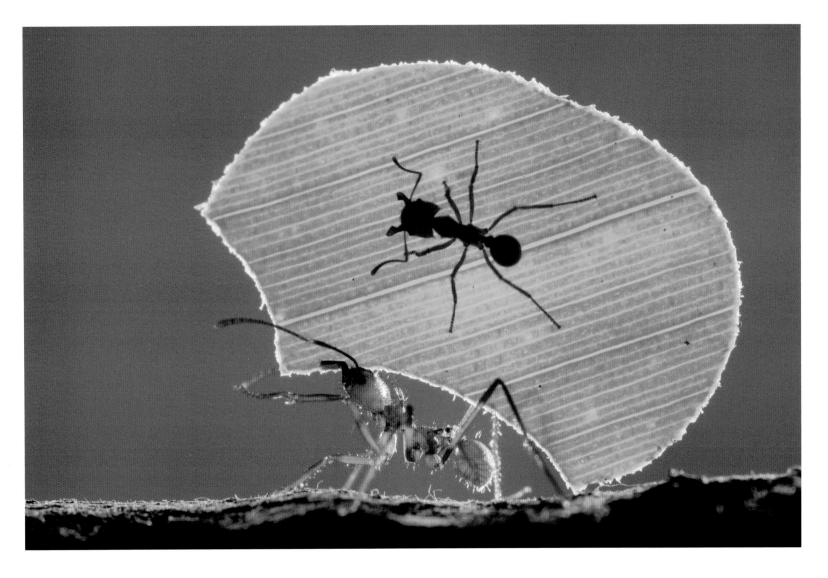

# Ant rider

**HIGHLY COMMENDED**

## Bence Máté

HUNGARY

The lives of most worker leaf-cutter ants – all of them females – are spent carrying bits of leaves back to their nest, to be used as compost to grow fungus for food. The result is a constant trail of ants to and from the nest. To photograph antwork up close, Bence chose to work at night in the Costa Rican rainforest, which is when the ants are most busy. To get an ant's-eye view, he lay belly-down, with two flashes lighting the branch 'road' being used by the workers and two flashes behind to backlight the ants. Here one of the smaller ants, referred to as a minor, is hitching a lift. But it has a job to do, too. Parasitic flies patrol the workers' lines, trying to lay their eggs on the ants, and it is the minor's job to protect her larger sister against the danger.

**Nikon D300 + 28-105mm lens; 1/250 sec at f16; ISO 200; four linked SB-800 flashes; Gizo tripod.**

# Nature in Black and White

Any wild landscape, plant or animal can be the subject, but what pictures must display is skilful and artistic use of the black-and-white medium.

## Big foot

**WINNER**

## Peter Delaney

IRELAND

Peter's day didn't start well. It was cold. He was sitting in a hide near a waterhole in South Africa's Mapungubwe Game Reserve, Limpopo, and he had forgotten not only his short lens but also his coffee flask. 'To say I was a little irritated would be an understatement,' he says, an irritation magnified when a huge herd of elephants came to within 20 metres (65 feet) of the hide. 'The elephants were playing and bathing, but the only thing I could do was shoot close-ups.' Soon, though, Peter became so engrossed in the detail of texture, tone and light that nothing else mattered. 'It made me realize that sometimes we can be spoilt by too much choice of equipment, and how creativity can often emerge from constraint.'

**Nikon D2Xs + 600mm lens; 1/350 sec at f8; ISO 640; beanbag.**

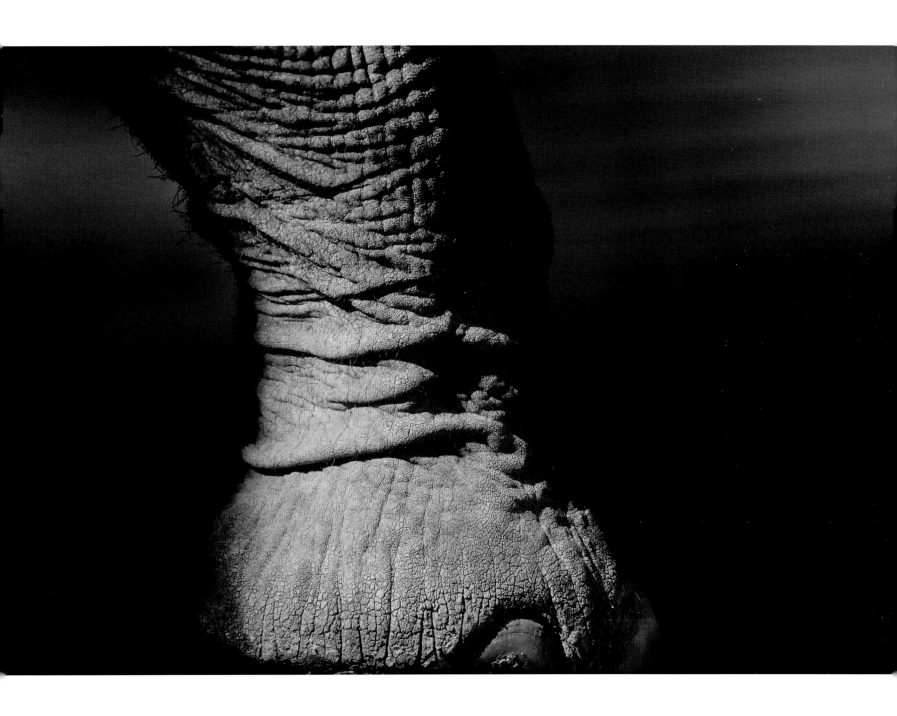

# Chachalacascape

**HIGHLY COMMENDED**

## Gregory Basco

USA

Though common enough in Costa Rica, the relatively drab gray-headed chachalaca is a bird that tends to be overlooked, says Gregory. Indeed, he had never bothered to photograph one. The loud *cha-cha-laca* calls of groups of the chicken-sized birds are, however, a familiar noise in the forest. One morning, exploring the grounds of an eco-lodge in Turrialba with the intention of photographing hummingbirds, a chachalaca was revealed to Gregory in a new light. Looking up into the forest trees, he saw a single bird. Silhouetted against the overcast sky, it had become one with the architecture of the cecropia tree, creating a picture not to be missed. Seconds later, the bird flew off to rejoin its flock nearby.

**Canon EOS 5D + 300mm f2.8 lens; 1/80 sec at f5.6; ISO 100; Manfrotto tripod + Really Right Stuff ballhead + Wimberley Sidekick.**

# In the flick of a tail

**SPECIALLY COMMENDED**

## David Lloyd

NEW ZEALAND

Photographers generally agree that giraffes, though easy enough to find, are tricky to photograph. 'They're so big that you either have to be far back, in which case you run the risk of background clutter, or you have to close in on detail,' says David. He saw the potential of the latter option when, in Kenya's Masai Mara, he encountered a giraffe at close quarters, and saw a second one on the horizon. He got himself into position and lifted his heavy lens to compose the image. What he waited for, though, was something that would inject life into the scene: a tail flick. 'I didn't expect that I would have to wait as long as I did. I was begging the giraffe in the distance not to move out of view and begging the one near me to flick its tail. My arms were aching from hand-holding the lens and were at the point of giving up when it finally did so.'

**Nikon D700 + 200-400mm lens; 1/3000 sec at f4; ISO 400.**

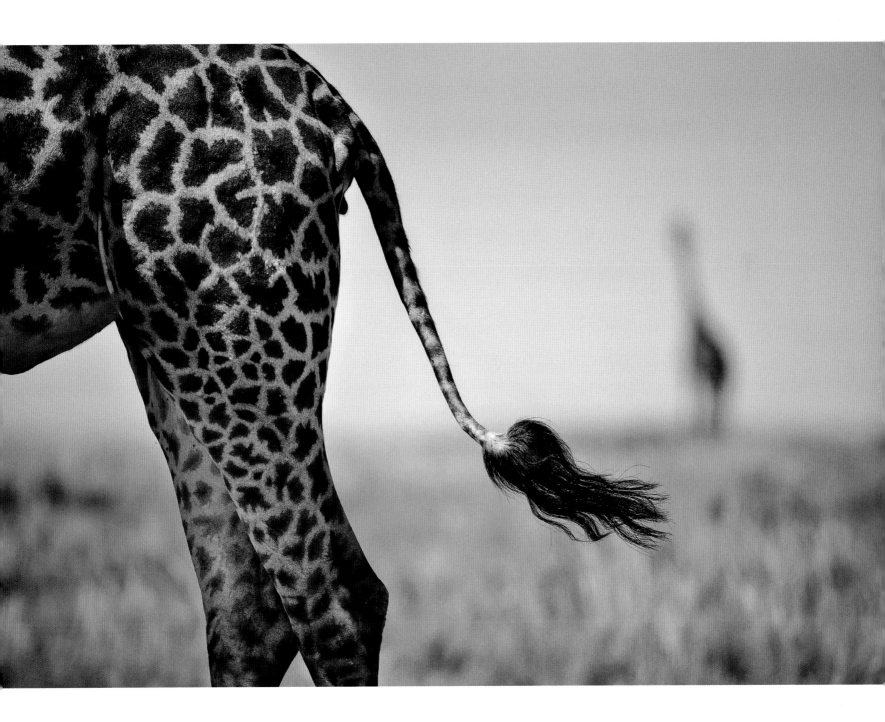

# Rhino in charge

HIGHLY COMMENDED

## Wim van den Heever

SOUTH AFRICA

The white rhino was clearly feeling a bit edgy.
He was the dominant male in this area of the
Sabi Sands Game Reserve and well known for
his unpredictable temperament when in female
company. Several females were nearby.
So Wim's driver stopped a good 100 metres
(330 feet) or so away. Then, without warning,
the rhino charged. 'I focused on it thundering
towards us,' says Wim, 'but then realized
the driver was struggling to start the engine.'
Wim's priorities changed. The rhino pulled up
at the last minute, just 3 metres (10 feet) away,
snorted and kicked up a dust storm. Having made
his point, he started running back, his head held
high. 'For a second he stopped, turned round,
and looked at me,' says Wim, 'just long enough
for me to get the shot.'

**Nikon D3X + 200-400mm f4 lens; 1/320 sec at f7.1;
ISO 400.**

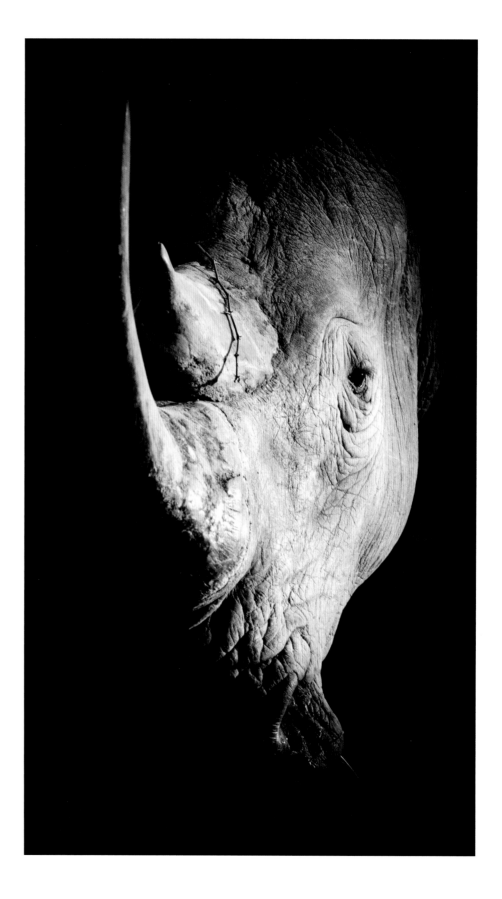

## Dream trees

**HIGHLY COMMENDED**

### Kevin Barry

USA

Kevin's original idea on a trip to south Florida's Big Cypress National Preserve had been to take landscape shots. When he got there, though, he was seduced by his favourite trees, pond cypresses. 'I came upon this beautiful grouping and decided to experiment with multiple exposures to try to capture the effect of being in among them,' says Kevin. Key to the effect was orienting the cypresses in the centre of the shot so that they appeared to recede. All that remained was to convert the image to black and white and adjust the exposure a little.

**Nikon D300 + 12-24mm lens; 1/6 sec at f22; ISO 400.**

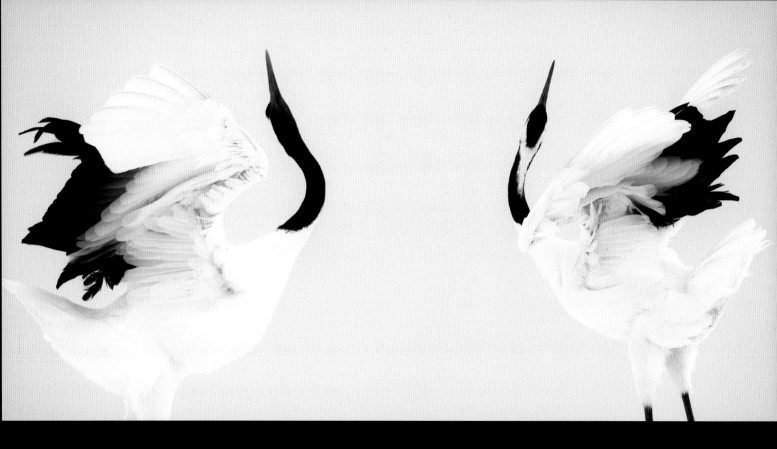

# Crane perfection

**HIGHLY COMMENDED**

## Stefano Unterthiner

ITALY

Even though Japanese cranes are endangered, photographing them on
Hokkaido is easy. The birds turn up every day at the same time and can be
relied on to perform their courtship dances in front of hundreds of cameras.
So today, photographs of dancing Japanese cranes are commonplace.
To create something original, Stefano set out with specific criteria in mind.
First, he wanted perfect 'white-out' conditions, so that the image would be
clean and elegant. Second, the photograph had to be close enough to show
the delicate detail of their feathers. Third, he wanted a sense of movement –
a hint of that famous delicate, leaping choreography. And finally, there had to
be synchronicity. The shot he ended up with did all that. But for him, the real joy

# Andrew George

THE NETHERLANDS

Early winter in 2010 was one of the coldest The Netherlands had experienced in years, and the lake in Andrew's local park in Eindhoven was almost completely frozen. As he watched the coots foraging on the ice, he began to visualize the image he wanted. So when the next snowfall came, he went straight out and waited. The coots were already on the ice, polishing off scraps of bread people had thrown them. As soon as all the food was gone, the coots headed back towards the only remaining hole in the ice. 'It reminded me of a scene from the movie *March of the Penguins*,' Andrew says, 'even though I was in my local park, in the middle of a city.'

**Nikon D700 + 70-200mm f2.8 lens; 1/60 sec at f8; ISO 800.**

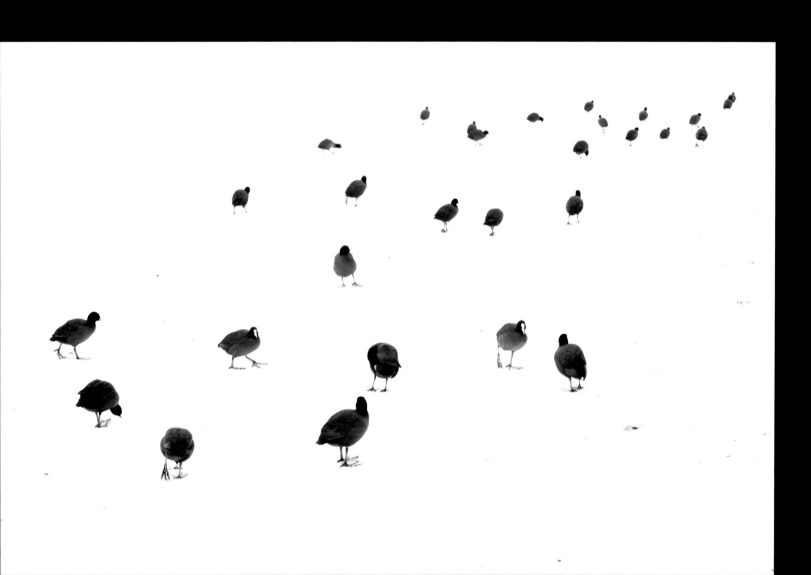

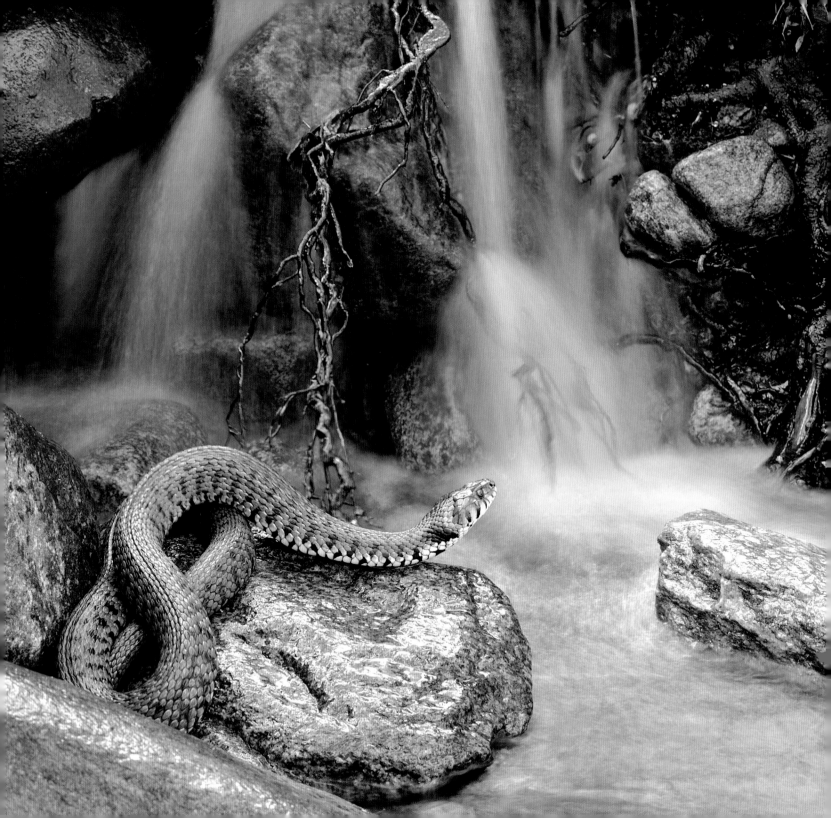

# Animal Portraits

This category invites portraits that capture the character or spirit of an animal in an imaginative way and convey a sense of intimacy. It is one of the most popular in the competition.

## Sinuousness

**WINNER**

### Marco Colombo

ITALY

Snakes can be difficult to find and even more difficult to photograph in an attractive setting. So when Marco found this female grass snake beside a beautiful stream in Lombardy, Italy, he knew he had struck gold. The snake stayed relaxed and motionless – her head held in profile – while Marco set up his tripod to take her portrait. She was probably watching for amphibians such as frogs (grass snakes can swim) and just didn't notice the human behind her. Marco took the decision to use a slow shutter speed to capture the movement of the water. 'I was enchanted by the scene,' he says. 'The beautiful reptile, the polished pebbles, the red roots and the flowing water created the image. I merely had to look in the viewfinder and press the shutter.'

Nikon D700 + 70-200mm f2.8 lens; 1.6 sec at f18; ISO 200; Manfrotto 190PROB tripod + 804CR2 head.

# Trust

**RUNNER-UP**

## Klaus Echle

GERMANY

On this special day, the vixen stayed beside Klaus for more than two hours. 'She was so relaxed that she lay down by my side,' says Klaus. He had gained her trust over several months, making a point of regularly walking in the part of the Black Forest, where he knew she hunted. The best time to see her, when she was most self-assured, was when the weather was bad and fewer people were around. But after six months, at the start of the mating season, she disappeared. 'I still miss seeing her,' says Klaus. 'I will never forget those very special moments. She came to trust me completely, and that's what I wanted to capture in this picture.'

**Canon EOS 5D Mark II + 17-40mm f4 lens; 1/60 sec at f7.1; ISO 160; flash.**

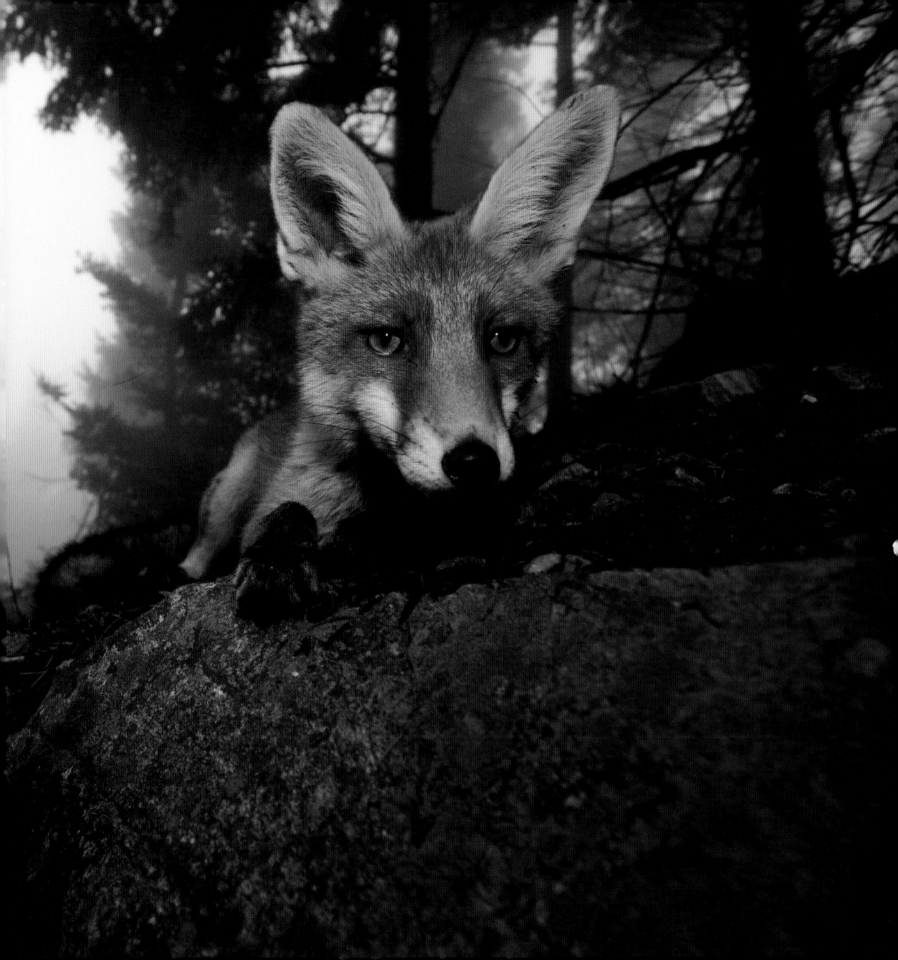

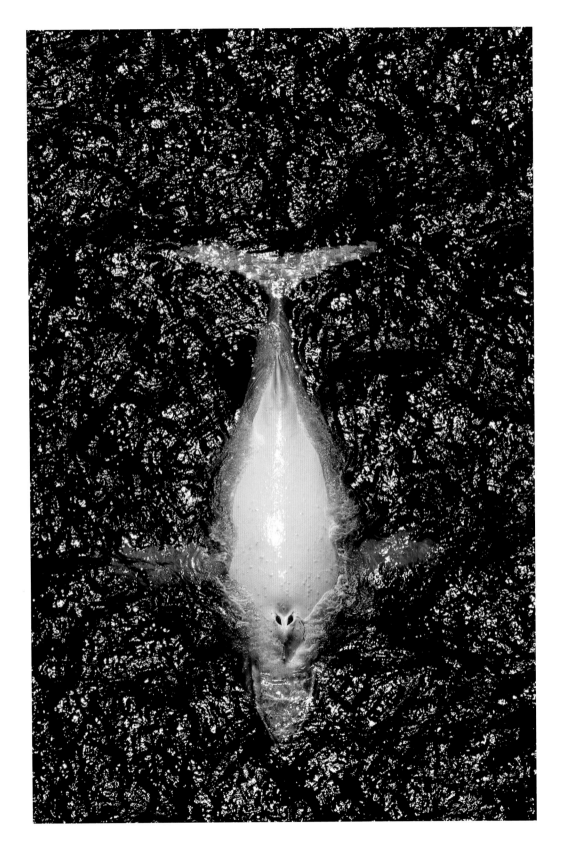

## White Fella

**HIGHLY COMMENDED**

## Marc McCormack

AUSTRALIA

Migaloo (Aboriginal for 'white fella') is the only known all-white humpback whale in the world. Marc had photographed him at sea level but knew that the way to get the perfect portrait would be from the air. He had already made three attempts, on days when the water was too rough to capture the white whale against the white-capped waves. On hearing that a tour boat had spotted Migaloo off Green Island, in the far north of Queensland, Marc chartered a helicopter to take him directly to the spot. 'On this day the water was almost smooth,' he says. 'I clicked the shutter as Migaloo took one last breath and disappeared like a giant ghost into the depths.' Migaloo belongs to the eastern Australian humpback population that is thought to total about 15,000 – still way below half the number that existed before commercial whaling began.

**Canon EOS-1D Mark III + 600mm f4 lens; 1/1600 sec at f13; ISO 250.**

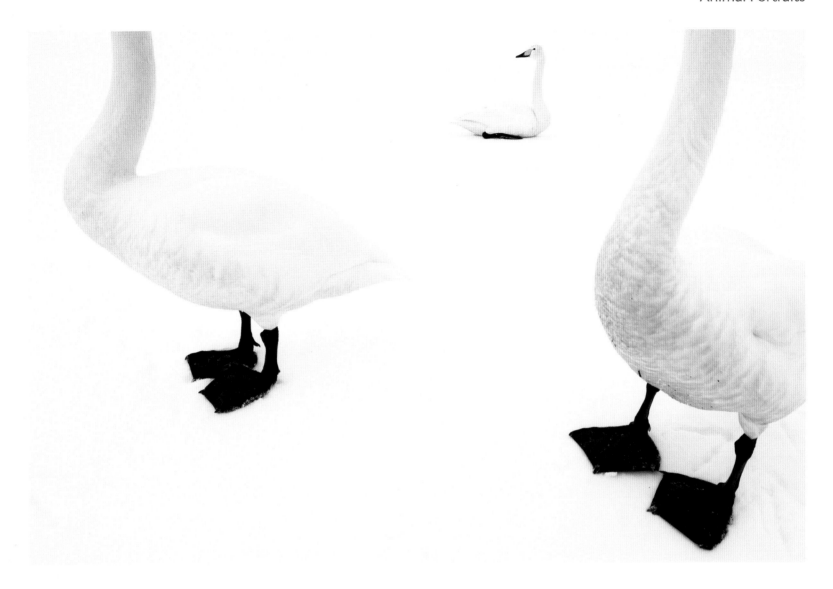

## Arrangement of swans

**SPECIALLY COMMENDED**

## Stefano Unterthiner

ITALY

Stefano spent six weeks at Lake Kussharo, in Hokkaido, Japan, before he found the perfect conditions to portray the winter gathering of whooper swans. One night, wind swept the snow across the surface of the frozen lake. The resulting snow crust was so hard that, though the 150 or so swans had walked all over it, their footprints could barely be seen. 'I wanted the swans to look as though they'd been "painted" on top of the snow,' says Stefano. Lying on the ice for several hours, he experimented with compositions using parts of their bodies against the white canvas as graphic elements. The final touch was to increase the contrast and brightness slightly during processing.

**Nikon D3 + 24-70mm lens; 1/320 sec at f16; ISO 1000.**

# Lunge feeding

**HIGHLY COMMENDED**

## Bence Máté

HUNGARY

Usually only fish get to see the inside of a Dalmatian pelican's beak at such an angle. But on Lake Kerkini in Greece, local fishermen feed the pelicans, which means part of the population is particularly bold and anticipates the meals of fish offal that are thrown to them. Bence planned his trip for February, when most of the pelicans are in their breeding plumage, which includes vibrant orange throat pouches. He constructed a special floating system that would enable him to take unusual perspectives using an underwater camera with a fish-eye lens, operated from a boat some 10 metres away. 'As the pelicans lined up for fish scraps from the fishermen,' says Bence, 'I couldn't believe my luck when they lunged forwards in unison, mouths wide open.'

**Nikon D300S + Tokina 10-17mm f3.5-4.5 lens; 1/320 sec at f16; ISO 500; Subal housing; three linked SB-800 flashes; floating remote-control system.**

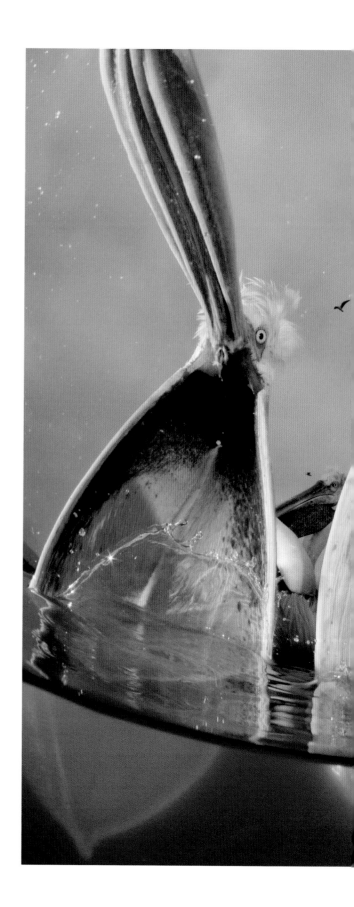

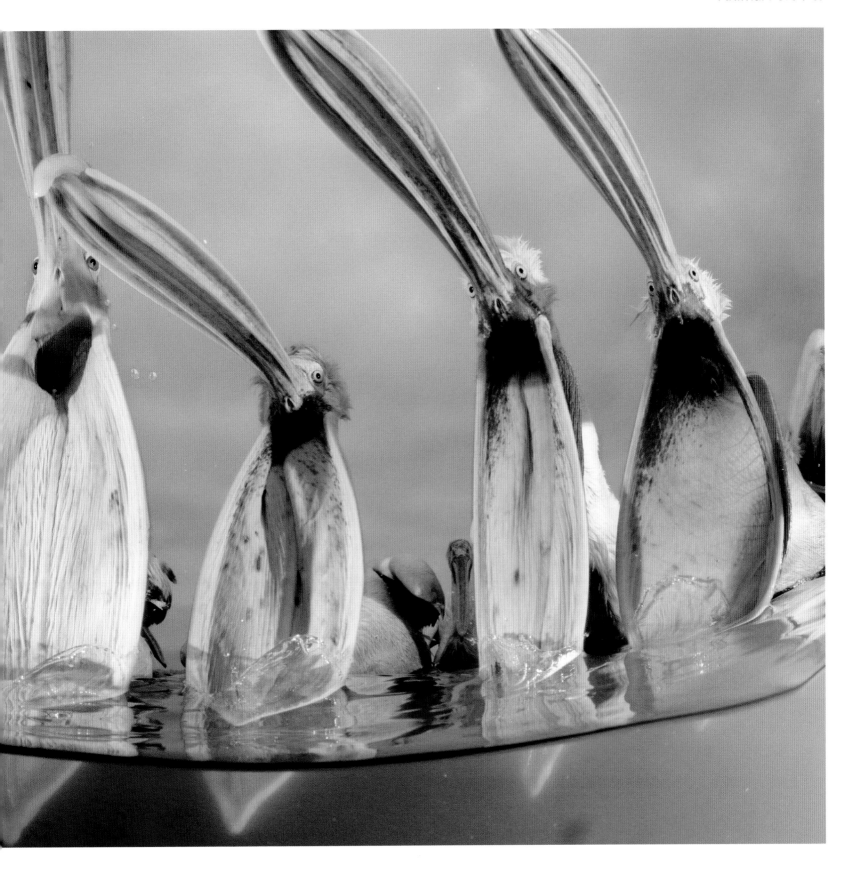

## Territorial strut

**HIGHLY COMMENDED**

## Ross Hoddinott

UK

Southern Britain experienced an unusually cold spell in December 2010, and Ross's Devon garden was covered in thick snow. 'The birds were feeding at my bird feeder and were very tolerant of me. So I didn't need a hide to photograph them,' he says. 'They had more to worry about than a human lying in the snow.' Ross stayed out for several hours at a time on each snowy day, and at one point noticed that there were up to eight robins in just one patch of the garden (some probably migrants from the Continent), which he notes must have been stressful for such a fiercely territorial bird. This individual is striking a warning pose, scattering snow in response to an approaching male. Ross captured the moment by setting his exposure meter so it wasn't fooled by the brightness of the snow and using a shutter speed fast enough to freeze the movement but slow enough to blur the motion of the scattering snow.

**Nikon D300 + 120-400mm lens at 400mm; 1/500 sec at f5.6; ISO 400.**

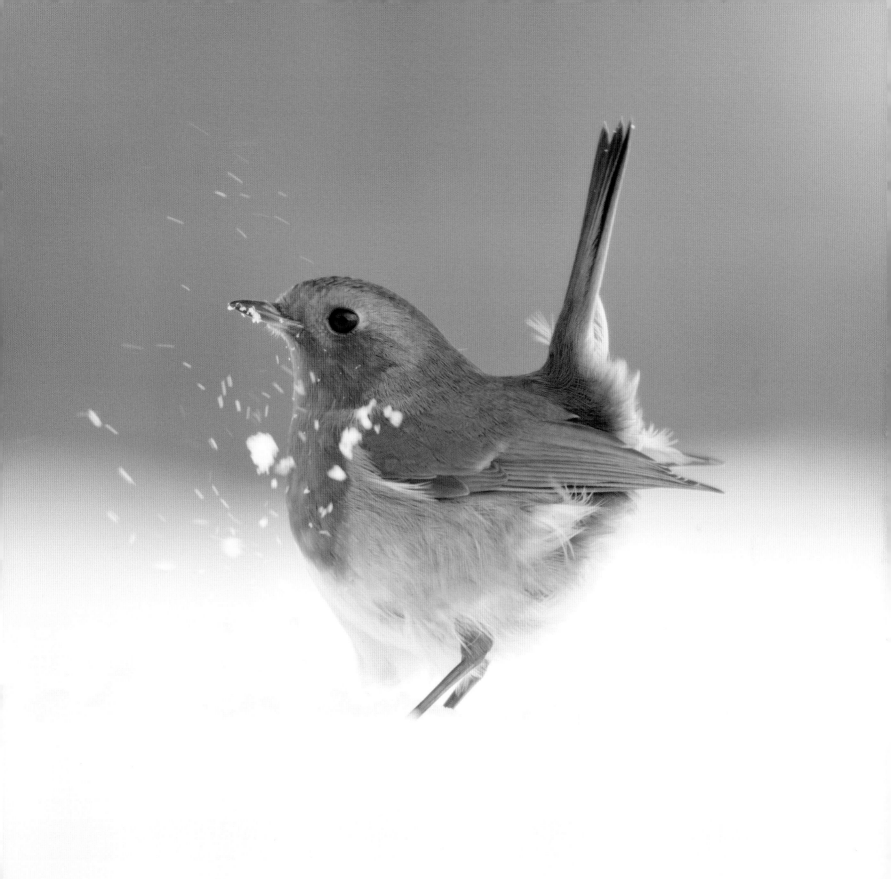

# Pool of hippos

**HIGHLY COMMENDED**

## David Fettes

UK

It was the end of the dry season, and David was lying belly-down at the edge of Long Pool in Mana Pools National Park, Zimbabwe. Hippopotamuses were arguing with each other as they vied for space – 'hurling water about', says David, 'and giving warning yawns to each other and to me.' As he watched through his lens, the evening light illuminated the scene, and one glowing hippo rose slowly from the water. 'I felt increasingly vulnerable,' says David, 'weighed down by a 500mm lens, conscious that lions or elephants could be approaching from behind to drink and aware that crocodiles were in the lake.' But though the hippo glared at him, David was outside its personal space, and the huge animal gradually sank back under the water.

**Canon EOS-1D Mark II N + 500mm f4 lens + 1.4x converter; 1/200 sec at f5.6; ISO 400.**

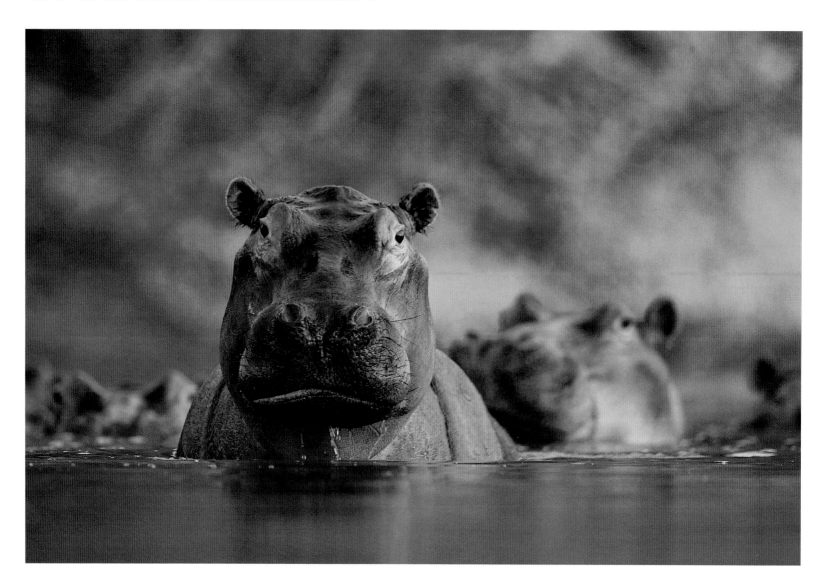

# Sleeping infant

**HIGHLY COMMENDED**

## Xavier Ortega

SPAIN

Trekking through the forests of Mahale Mountains National Park in Tanzania, Xavier could hear the small band of chimpanzees moving ahead through the trees. 'After a couple of hours,' says Xavier, 'I walked into a glade and there they all were.' He sat down, trying not to make any movement, so the group didn't feel threatened. Though they were used to researchers following them, they were not familiar with him. But they accepted his presence, and for the rest of the day he was able to observe their interactions. 'It was fascinating,' says Xavier, 'to see so many facial expressions and gestures, and hear them "speak".' He was particularly drawn to a mother with a small infant and took many pictures of her, his favourite being this most tender of moments.

**Nikon F90 + 400mm lens; 1/125 sec at f4; Fujichrome Provia 100.**

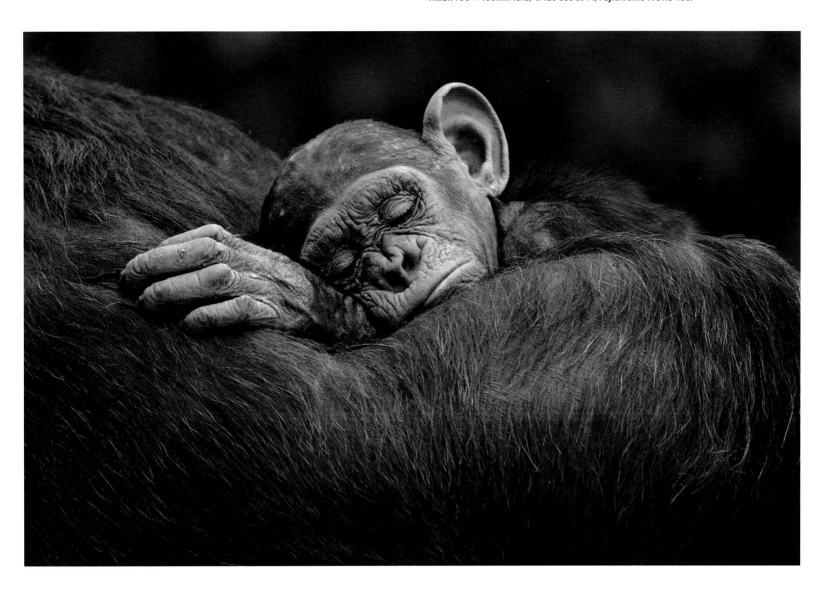

# Underwater World

The subjects in this category can be marine or freshwater species, but they must be featured under the water. The pictures themselves should be unforgettable, either because of the behaviour displayed or because of their aesthetic appeal – and, ideally, both.

## The grace of giants

**WINNER**

## Paul Souders

USA

'Even before I slid off the iceberg into the sea, my heart was racing and my lips were turning blue,' says Paul. 'I had no idea what to expect, other than that, under water, these huge masses of flesh and tusk would swim with grace and power. And that's what I wanted to show.' Paul had gone to Svalbard in Arctic Norway hoping to photograph walruses under water. He knew they could be dangerous, but he planned to appear as unthreatening as possible and hoped that the walruses would just be curious about him. The first sight of one approaching out of the gloom was the gleam of white tusk. Paul instinctively used the glass dome of his camera housing as a shield. The walrus investigated him, pressing up against the dome, while its giant herd-mates slowly circled Paul. 'Their curiosity satisfied,' says Paul, 'they moved off in search of something more entertaining than a hyperventilating photographer.' Walruses were hunted nearly to extinction for their ivory tusks, and they are still very wary of people. Though their numbers are slowly increasing, the biggest danger they face now is climate change.

Canon 1Ds II + 16-35mm lens; 1/160 at f6.3; Seacam housing.

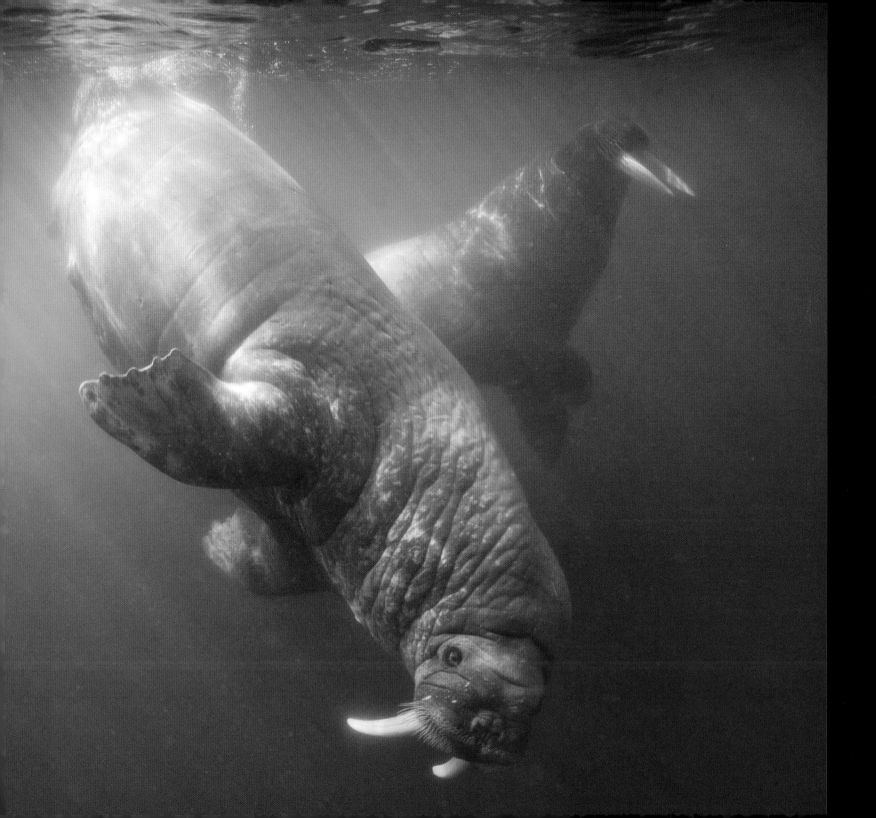

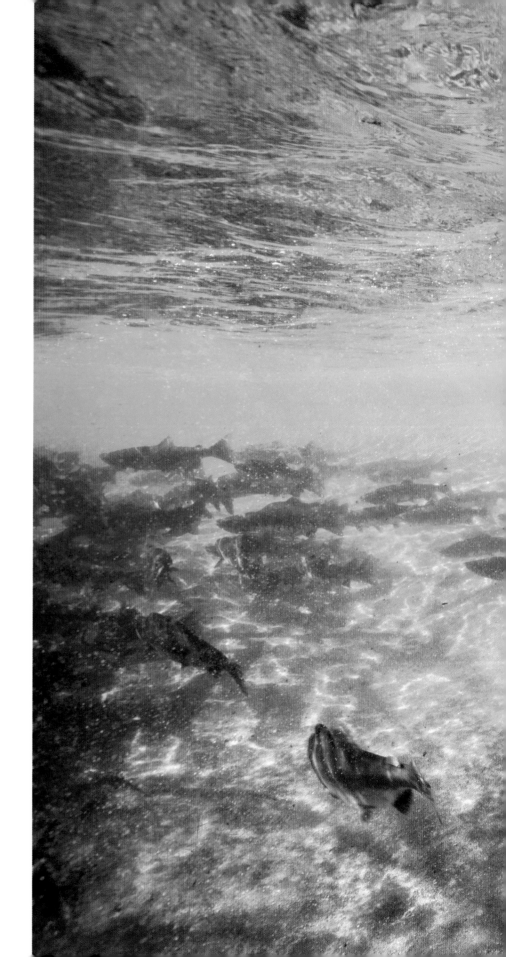

## Salmon swipe

**RUNNER-UP**

## Paul Souders

USA

'I set out to show a salmon's-eye view of a swimming bear swiping at a fish with its huge paws,' says Paul. The location he chose was Katmai National Park in Alaska, and he arrived in time for the late-summer runs of red and chum salmon heading upstream to spawn. Grizzly bears cluster around good fishing spots on the rivers to gorge on salmon, in preparation for the long winter. At shallow points, they wade into the water to try to grab the fish. 'I found an accessible pool,' says Paul, 'just below a steep set of river rapids, where the salmon rested before the difficult climb upstream.' He submerged his camera on a ballasted tripod, and with a radio-controlled remote trigger sat across the river and waited – for four days. Bears turned up with different hunting strategies – sprinters and splashers, stalkers and swimmers. This adult female was one of the best hunters, using all the techniques and eventually providing the action Paul was after.

**Canon EOS-1Ds III + 16-35mm lens; 1/250 sec at f10; modified housing; radio remote-control.**

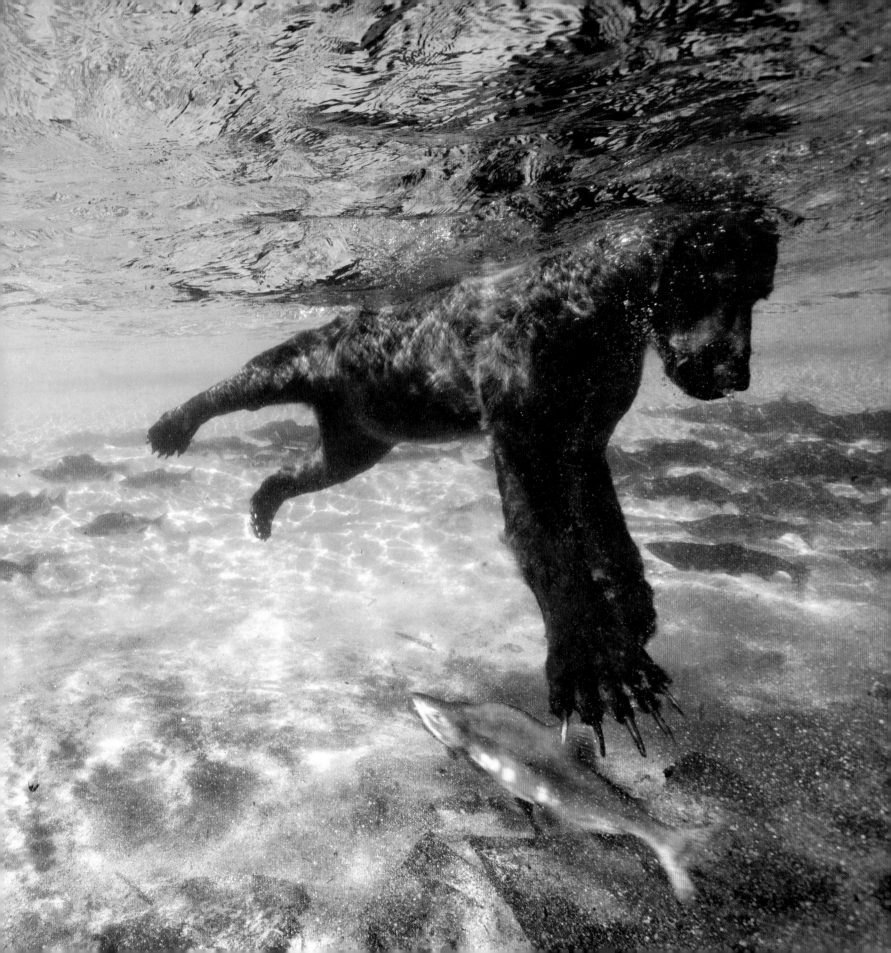

# False killers, disguised dolphin

SPECIALLY COMMENDED

## Clark Miller

USA

The arrival of a pod of false killer whales scuppered any plans Clark had of observing sperm whales. Even though the false killers are a mere 4.5 to 5.5 metres long (15–18 feet) compared to a sperm whale's enormous size, the pod spooked the sperm whales, which left, never to return, at least during Clark's trip to Dominica. To make the most of the time left – and the special permit he'd organized – Clark turned his attention to the false killers. 'They're normally very cautious,' he says, 'and seldom approach divers,' which is why close-up photos are rare. But these individuals found something fascinating about Clark, buzzing him and coming ever closer, stopping only just a couple of metres (six or so feet) away, all eyes on him. This time it was Clark who was nervous. Then in the mélange, he saw the dolphin – and realized he had the chance of a very special shot. Scientists have long known that bottlenose dolphins sometimes associate with false killer whales, but this is almost certainly the first time the relationship has been photographed.

**Canon EOS 7D + Tokina 10-17mm lens at 13mm; 1/100 sec at f8; ISO 320; Nautican housing + Zen dome port.**

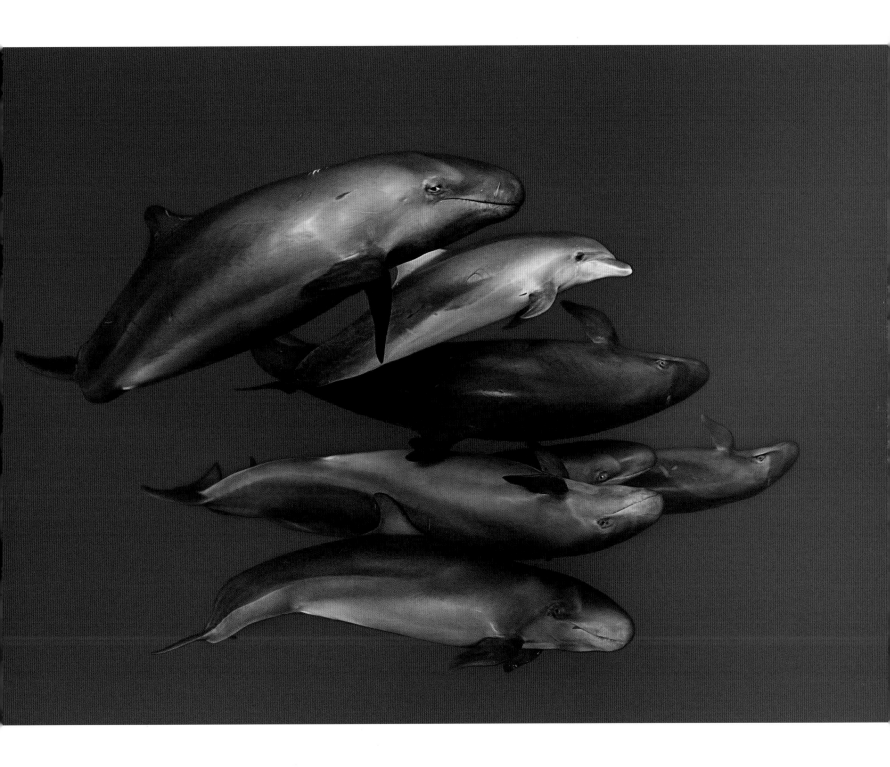

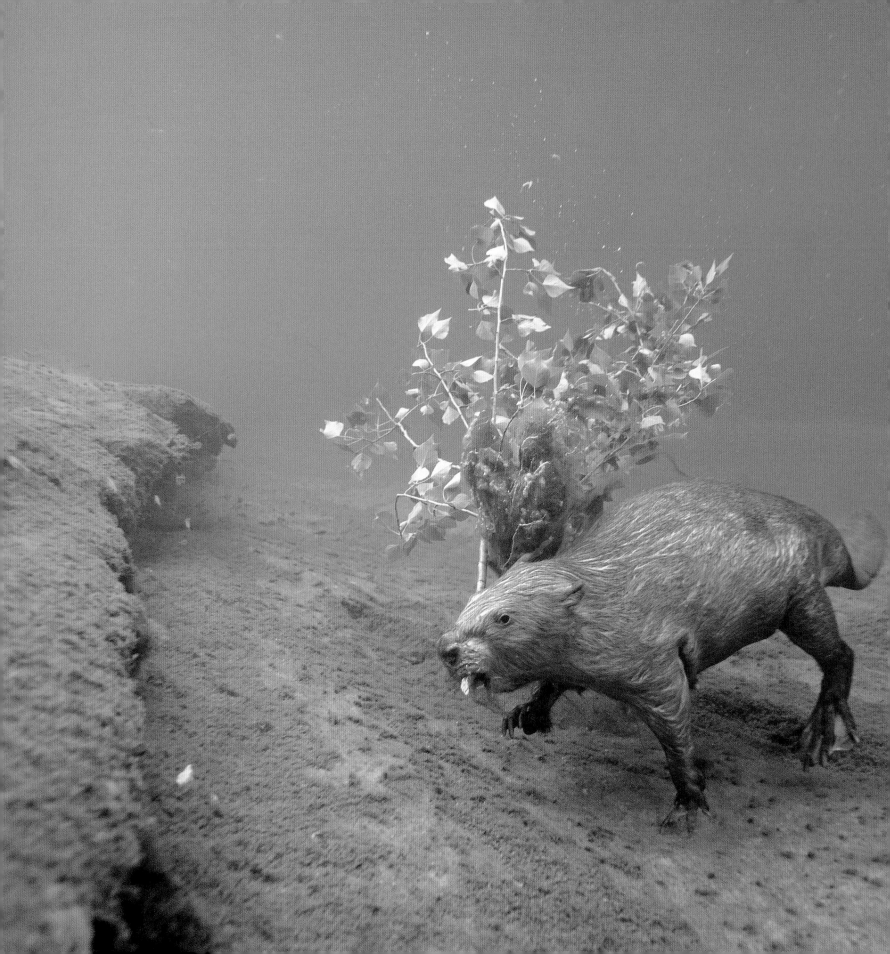

# Beavering

**HIGHLY COMMENDED**

## Louis-Marie Préau

FRANCE

'I have never forgotten,' says Louis-Marie, 'the first time I saw a European beaver under water delivering a branch to its family.' He is passionate about beavers and has returned each season for the past four years to the same spot on the Loire River in France to try to photograph what he saw that first time. Last summer, wearing snorkelling gear, Louis-Marie eventually got lucky. Using weights so he could lie on the river bottom, being careful not to move and frighten the beavers, he finally photographed this adult dragging a poplar branch back to the dam for its kits. 'It looked like hard work,' says Louis-Marie, 'a long journey and a long time holding its breath.'

**Canon EOS 5D + 16-35mm lens; 1/125 sec at f4; ISO 800; Ikelite housing.**

# Night sharks

**HIGHLY COMMENDED**

## Thomas P Peschak

GERMANY/SOUTH AFRICA

Light shining into the depths of the lagoon of Bassas da India, a remote atoll in the Mozambique Channel, reveals a gathering of juvenile Galapagos sharks. The light is from a spotlight on a research boat above, which is being used to illuminate the reef so that the divers can see what's going on. Thomas was part of the expedition to census the population of this vulnerable species. 'Not having to use underwater strobes or a flash,' he says, 'meant it was possible to convey a sense of the nocturnal scene.' This lagoon is one of the few places where the Galapagos shark is found beyond the Pacific and is the only known ocean nursery for it, with schools of 50 or more occurring.

**Nikon D700 + 16mm f2.8 lens; 1/125 sec at f6.3; ISO 1250; Subal housing.**

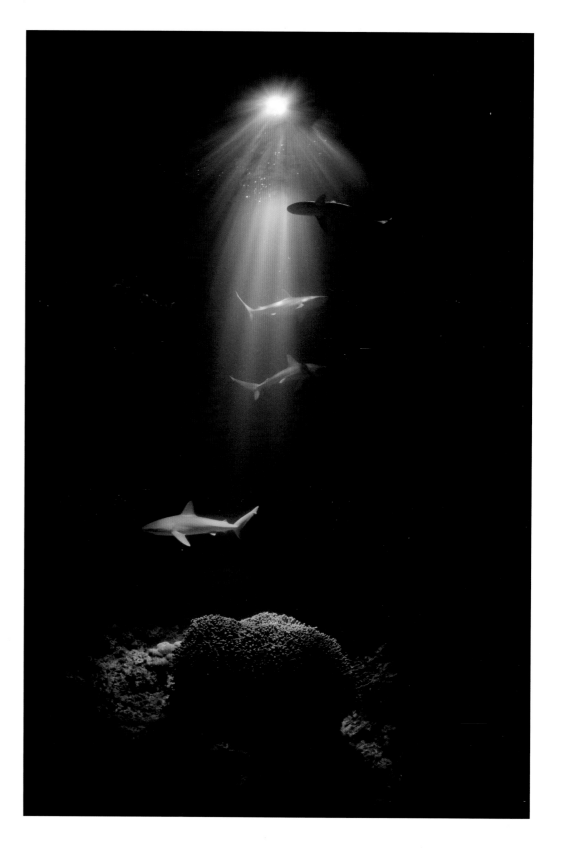

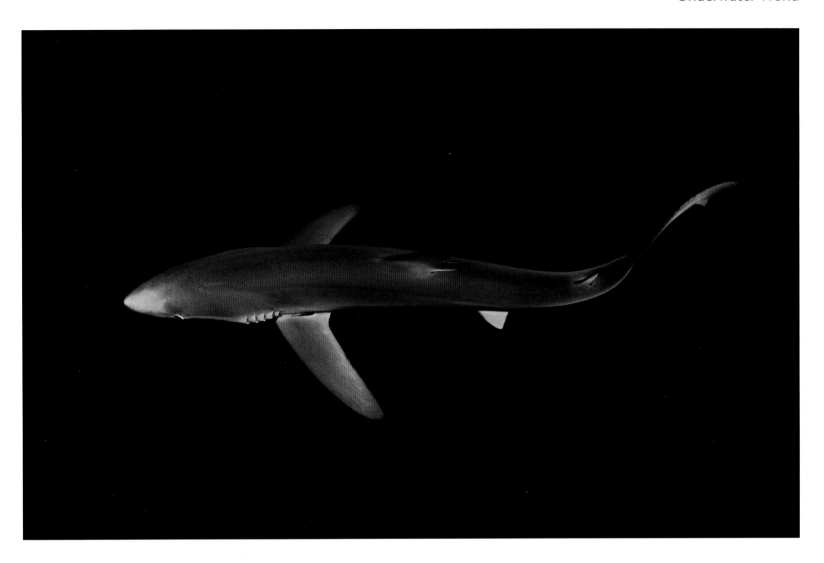

## Racing blue

**HIGHLY COMMENDED**

Nuno Sá

PORTUGAL

Within minutes of lowering a container of bait into the sea, 'a torpedo-shaped shark shot up from the deep blue below,' says Nuno, alerted by the movement as well as the smell. Nuno's boat was over a seamount off the coast of Faial Island in the Azores, being used by a research team from the University of the Azores studying the importance of such seamounts as possible mating areas for blue sharks. Nuno's aim was to illustrate the beauty of this top predator, built for speed. Though supposedly abundant, an estimated 20 million blue sharks are caught annually, either as bycatch or for their fins to supply the Asian food market. The likelihood is that the population is in fast decline.

**Canon EOS 7D + Tokina 10-17mm lens; 1/250 sec at f9; ISO 160; Aquatica housing; Ikelite 160 strobes.**

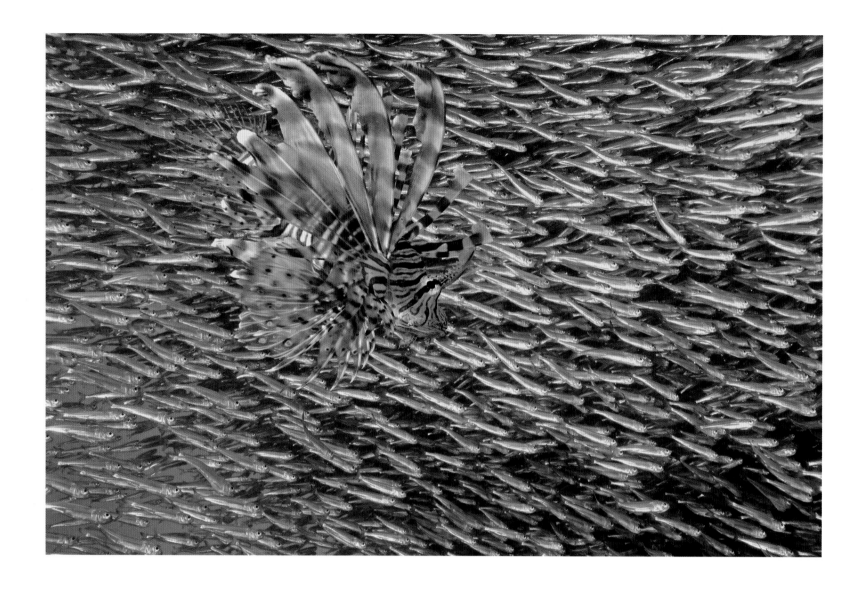

# Lion among the shoal

**HIGHLY COMMENDED**

## Alex Tattersall

UK

At the end of a shore dive at Marsa Nakari, Egypt, Alex encountered a huge shoal of baitfish. Sensing a photographic opportunity, he rushed out of the sea, got a fresh tank of air and re-entered the water 'The shimmering ball of fish,' says Alex, 'swallowed up my next three hours.' Local predators soon arrived, including a common lionfish, which lunged at the baitball, picking off individuals. Alex concentrated on highlighting the contrast between the striking, venomous lionfish and the silvery shoal. 'This photograph,' says Alex, 'represents a turning point in my life because that trip motivated me into setting up my own underwater-photography company.'

**Canon 500D + 10-22mm lens; 1/64 sec at f11; ISO 100; two Inon Z240 strobes; Patima housing.**

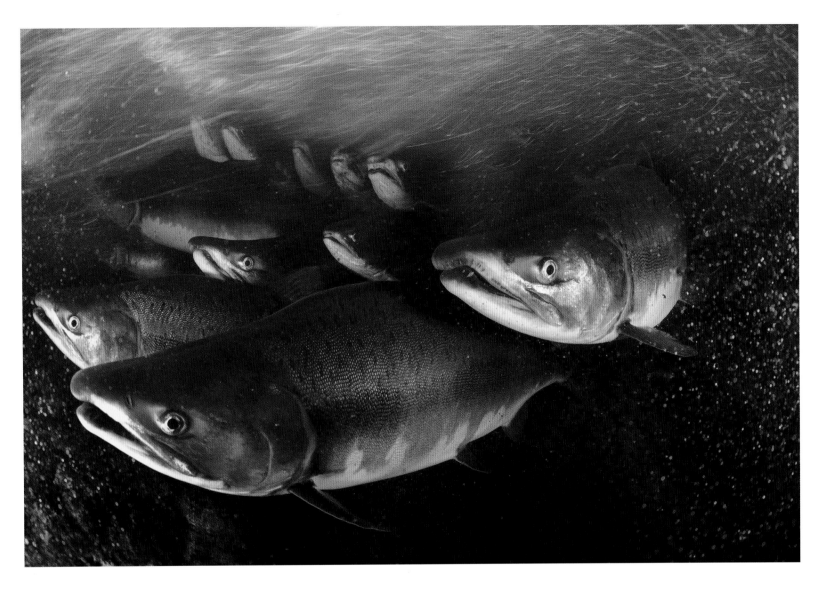

## The salmon jam

**HIGHLY COMMENDED**

## Thomas P Peschak

GERMANY/SOUTH AFRICA

Backing up in a pool at the base of the waterfall were hundreds of pink salmon, waiting for the right moment to leap up the fall and continue their journey upriver to their spawning grounds in the Great Bear Rainforest, British Columbia, Canada. Thomas wedged himself into a crevice under the fast-flowing water and for more than two hours hung there waiting for the moment when the salmon were bunched up sufficiently to fill the frame. Salmon are an integral part of the temperate rainforest ecosystem, returning to spawn and die where they were born. Not only do they feed seals, bears and wolves, but their discarded remains also fertilize the trees of the surrounding forest.

**Nikon D700 +16mm f2.8 lens; 1/10 sec at f11; ISO 640; Subal housing; two Inon Z220 strobes.**

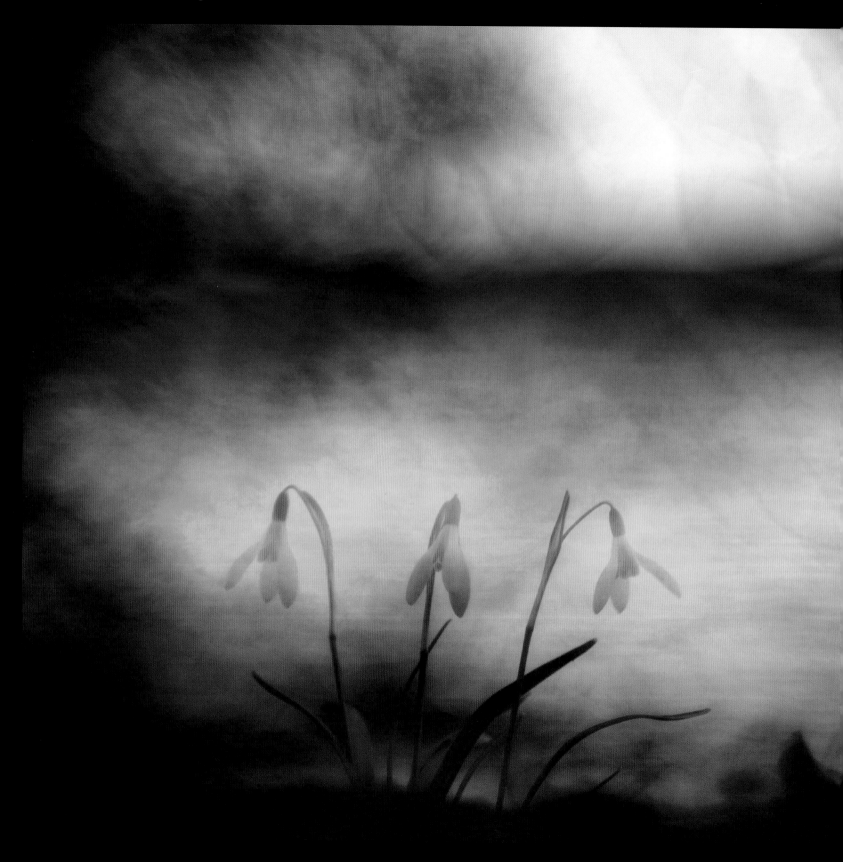

# In Praise of Plants and Fungi

The aim of this category is to showcase the beauty and importance of flowering and non-flowering plants and fungi, whether by featuring them in close-up or as part of their environment. Without them, there would be no animals.

## Harbinger of spring

**WINNER**

### Sandra Bartocha

GERMANY

'My favourite time of the year is when the first snowdrops appear – the harbingers of spring,' says Sandra. 'When I see them, the air suddenly smells fresher and the sun feels a little warmer.' Sandra found this delicate group in a marshy area on the shore of Lake Tollensesee in Mecklenburg, Western Pomerania, Germany, overhung with a criss-cross mass of leafless tree branches. 'The setting sun created a beautiful orange reflection on the water behind, and I could hear great crested grebes calling. I took an in-camera double exposure image, with one sharp exposure and then one much softer one, so the scene would appear as dreamy as it felt.'

**Nikon D700 + Meier Görlitz Trioplan 100mm f2.8 lens; 1/50 sec at f2.8; ISO 200.**

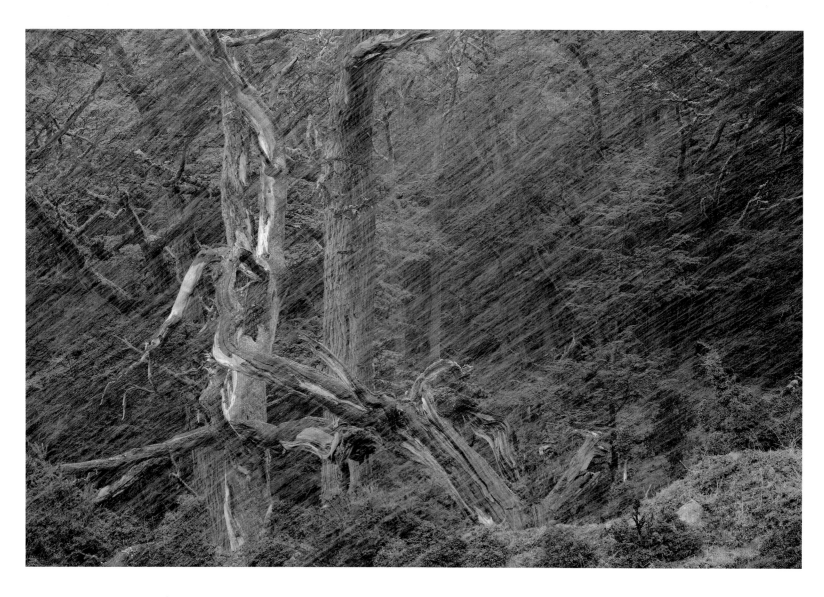

## Patagonian woodscape

**RUNNER-UP**

## Daniel Jara

SPAIN

It had been snowing nearly all day, and Daniel was heading back to base after a trek across the Perito Moreno Glacier in Argentina's Los Glaciares National Park. He became fascinated by the colours and textures of the sub-Antarctic woodland that surrounds the glacier. It's the world's most southerly woodland and includes lenga and Antarctic beech. But it was the contrast of the grey skeleton trees against the autumn colours that made Daniel stop and set up his equipment. And it was the blur of the windswept snowflakes against the tapestry of colour that added the final touch to the picture.

**Nikon D300 + 70-200mm f2.8 lens; 1/10 sec at f16 (-1.0 e/v); polarizing filter; ISO 200; Gitzo G1258 tripod.**

# Tongue orchid and hare's-tail

**HIGHLY COMMENDED**

## Sandra Bartocha

GERMANY

For Sandra, the lure of the Gargano peninsula in southern Italy was its orchids. At least 69 different species grow here, and the location is famous for them. Choosing the light of early morning and early evening, Sandra searched for subjects on the slopes of Monte Sacro in the Gargano National Park. Finding a tongue orchid growing among hare's-tail and quaking grasses, she used an in-camera double exposure to keep the softness of the scene, focusing on the two different layers within the frame – the orchid and the hare's-tail. The light is purely that of the setting sun.

**Nikon D200 + 105mm f2.8 lens; 1/250 sec at f3.3; polarizing filter; ISO 100.**

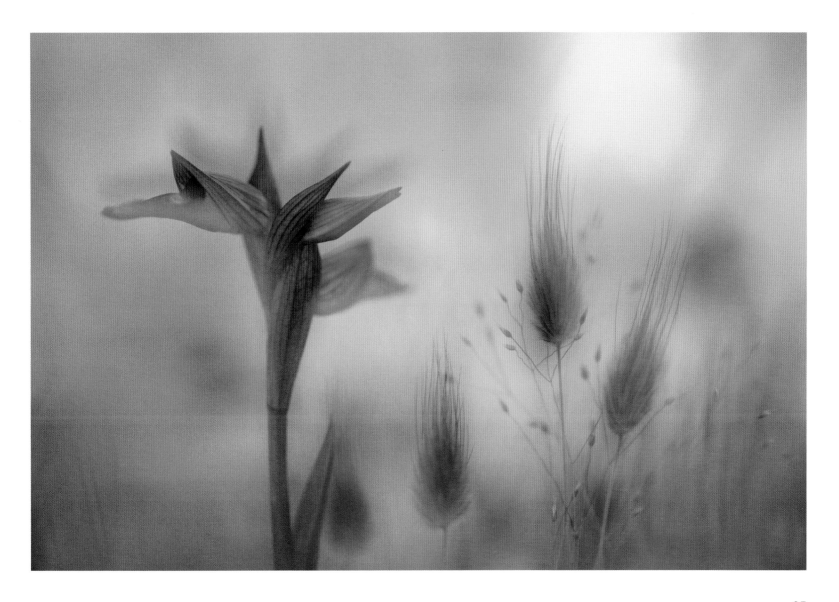

## Fading beauty

**SPECIALLY COMMENDED**

## David Maitland

UK

On a car-park embankment near David's home in Wiltshire, a mass of poppies appeared one day. 'I love poppies,' he says, 'and I can't resist photographing them. It's hard to think of another plant that's so fleetingly beautiful . . . But when poppies flower en masse, it's almost too much, and it's hard to capture the ephemeral nature of their beauty.' For a week he checked on the patch every day, looking for a particular grouping. 'I wanted an image of simplicity – mostly of spent seedheads, with just a few poppies still in full bloom,' he explains. From a prone position, he shot them against an overcast sky to create an architecture of stems 'with little flashes of brilliance'. Three days later, someone 'weed-killered the lot,' he says. 'Most hadn't set seed. So there'll be no poppy meadow there next year.'

**Canon EOS 5D Mark II + 70-200mm f2.8 lens; 1/160 sec at f11; ISO 50.**

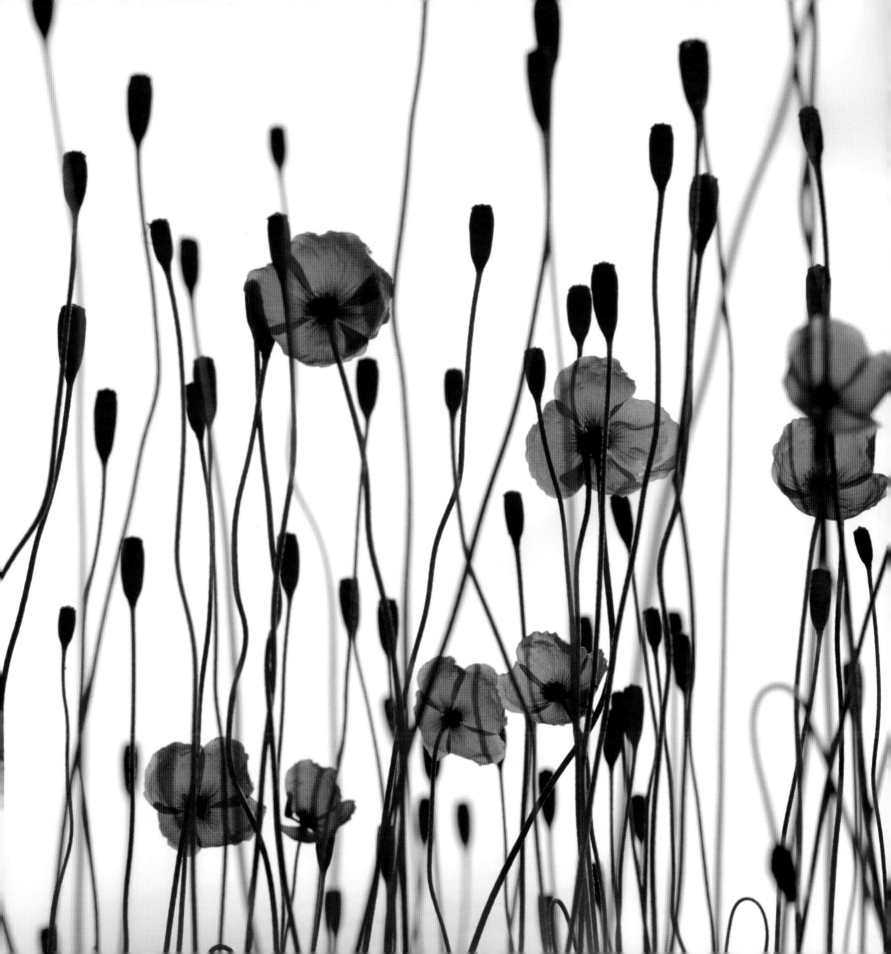

# The grove

HIGHLY COMMENDED

## Bob Keller

USA

Bob is a 'tree devotee'. He spends as much time as possible in the coastal temperate rainforest near his home in Yachats, Oregon. On a misty winter day in the Cummins Creek Wilderness, he wandered through a grove of red alders, searching for a place to set up his tripod. The trunks were covered with a mosaic of crustose lichens and draped with mosses. One tree had died and lost its bark, revealing the red wood beneath and the reason for the trees' name. The trunks were set against an understorey backdrop of spruce and hemlock. Bob specializes in 9:4 panoramic images – in this case, made from two stitched photos. 'The format is ideal to communicate how it feels to stand among these enchanting trees,' he says. 'It takes me right back to the peace and solitude of the grove.'

**Canon EOS 5D Mark II + 24-70mm f2.8 lens; 1/2 sec at f13 (-0.3 e/v); circular polarizer; ISO 200; Benro tripod + cable release.**

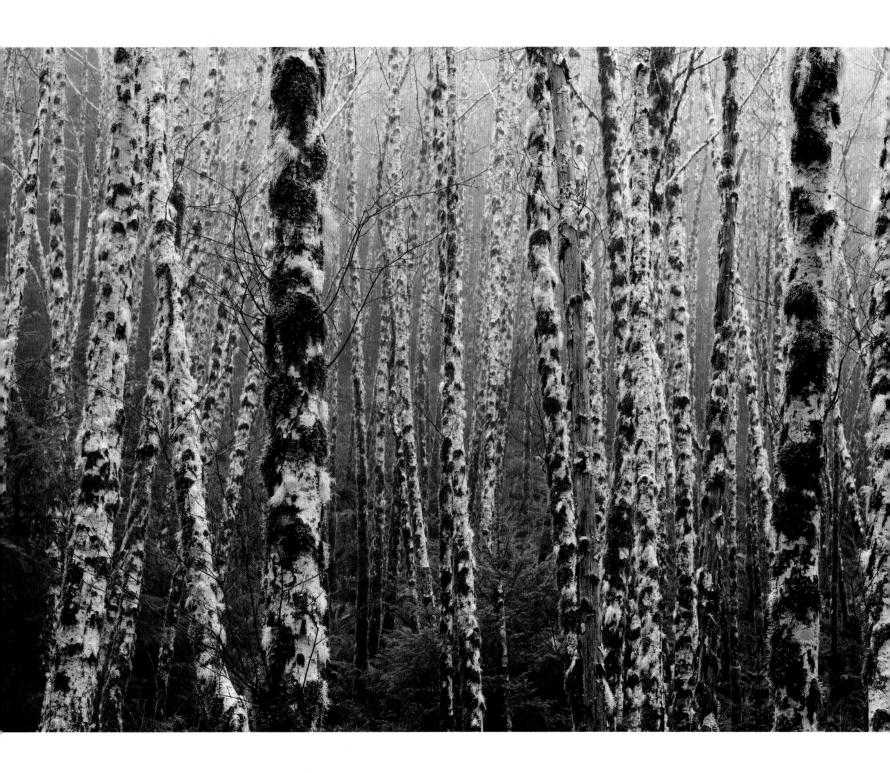

# Animals in Their Environment

A winning photograph must create a sense of place and mood, and convey a feeling of the relationship between an animal and where it lives.

## Snow hare

WINNER

### Benjam Pöntinen

FINLAND

Benjam always keeps his 300mm lens handy, just in case. And one day in March it paid off. Overnight, a storm had covered Ostrobotnia in thick snow. It was still snowing heavily, with big flakes. Benjam set out to look for short-eared owls, driving slowly and scanning the white surroundings. 'The thick snow muted all sounds, so everything was utterly silent,' he says. 'As I passed the hay barn, I suddenly saw movement. Then I saw the picture. I had just enough time to open the window, focus and take the shot before the hare vanished into the white. I knew then it was going to be my picture of the year.'

**Canon EOS-1D Mark II N + 300mm lens; 1/6000 sec at f8 (+1 e/v); ISO 500; beanbag.**

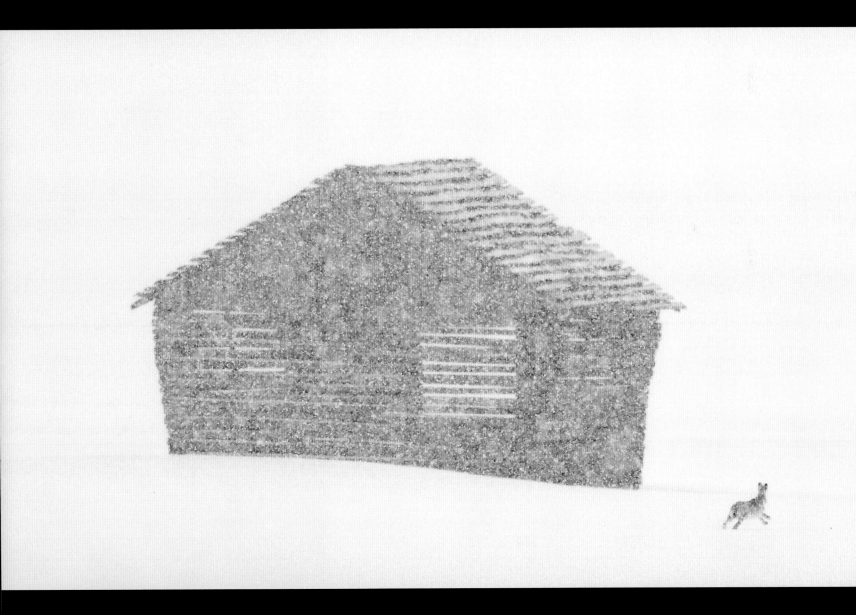

# A wave of waders

RUNNER-UP

## Erlend Haarberg

NORWAY

In spring, thousands of red knots stop off in Iceland, on their way from Western Europe to their breeding grounds in Canada and Greenland. From the windy top of a cliff in Snæfellsnes, on the west coast of Iceland, Erlend watched the feeding flock and planned his picture. 'Everything was moving. The birds were scurrying to and fro, and powerful waves were crashing in,' says Erlend. He wanted to show the power of the sea and the resilience of the birds, and over seven evenings, he experimented with different shutter speeds and perspectives, trying to keep the tripod from being blown over. He needed three things: high tide, so that any birds would be corralled up the shore rather than scattered; waves big enough to create a graphic pattern but not so big that the knots would fly off; and early-morning or late-afternoon light so he could use a long shutter speed and capture the movement of the waves. His planning paid off.

**Nikon D700 + 24-70mm f2.8 lens; 1/6 sec at f7.1; ISO 400; Gitzo tripod.**

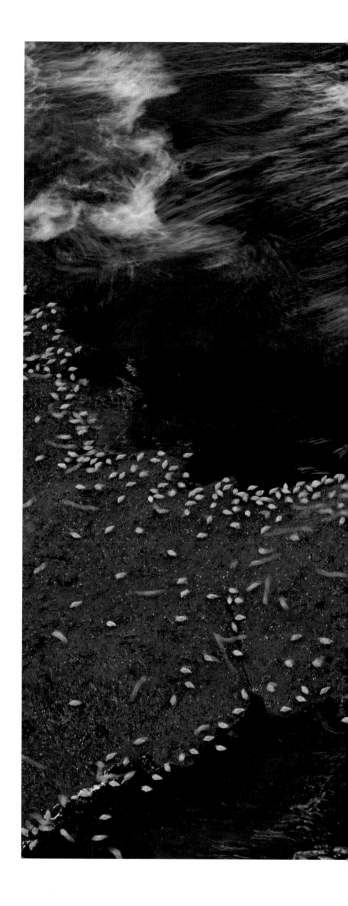

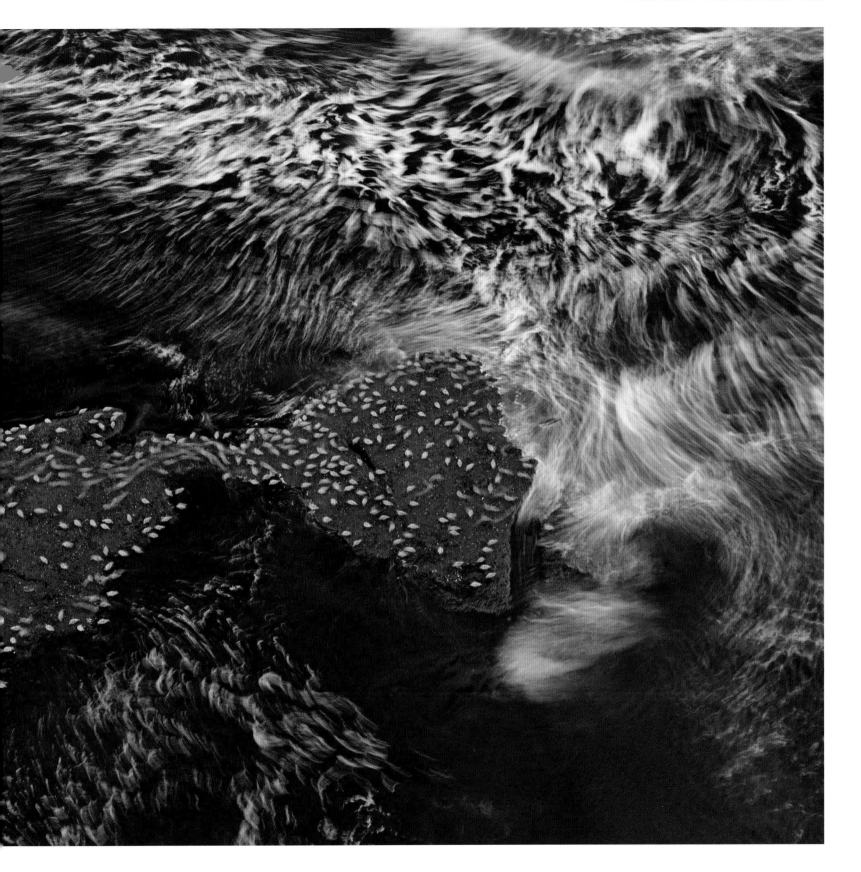

## Tiptoe lark

**HIGHLY COMMENDED**

## Henrik Lund

FINLAND

With the snow lying thick on the ground, Henrik headed out into the fields near his home in southern Finland in search of grey partridges sheltering in burrows in the snow. As he scanned the snow, a tiny horned lark ran past in search of food. When it found a few seeds, 'it kept stretching up to try to reach them,' says Henrik, 'and then jumping if it couldn't.' Low cloud cover and therefore dull light allowed Henrik to use the snow as a white backdrop for the unusual little visitor, and the simple geometry of the yellow stems provided the compositional architecture. Then all Henrik had to do was capture the lark on its toes in the moment before it jumped.

**Canon EOS-1D Mark IV + 500mm f4 lens + 1.4x II extender; 1/800 sec at f6.3; ISO 800.**

# Snow kings

**SPECIALLY COMMENDED**

## Ole Jørgen Liodden

NORWAY

The blizzards came about every 15 minutes. 'There would be a break in the wind, perhaps a ray of sun, then wham, another flurry of snow would hit,' says Ole. Not that this took him by surprise: it was his fourth trip to Antarctica, so he knew what to expect and the atmosphere he was looking for. This group of about 15 king penguins were heading back from fishing and up the beach to their colony on South Georgia to feed their chicks. Ole crouched down in the driving wind and waited for them. 'I used a comparatively slow shutter speed to catch the near-horizontal streaks of snow,' he says, as the penguins waddled by, taking no notice of him and pausing merely to shake the snow off their flippers.

**Canon EOS-1Ds Mark III + 24-70mm f2.8 lens; 1/320 sec at f11; ISO 400.**

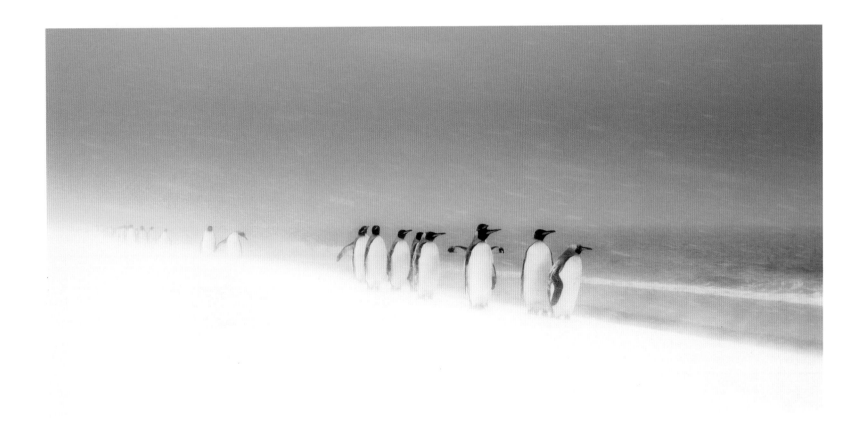

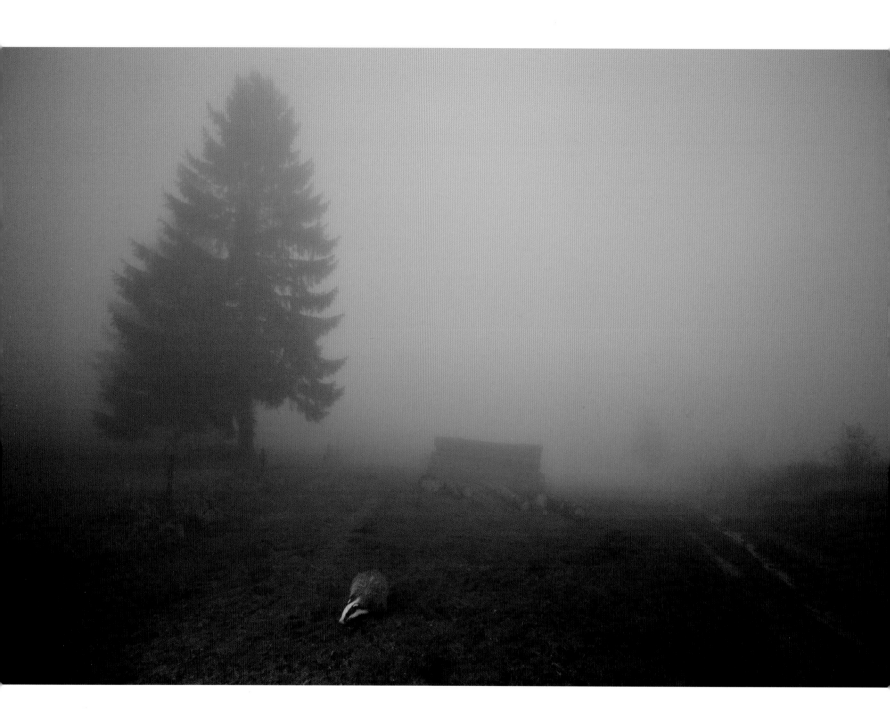

# Worming at dusk

**HIGHLY COMMENDED**

## Klaus Echle

GERMANY

It had been raining all day. There was no one else around, and Klaus knew this improved his chances of seeing a badger before nightfall. Most badgers on Mt Schauinsland, in southern Germany, have their setts on the forested lower slopes, but they venture up the mountain to forage for worms in the more open, cultivated areas. 'There is an endemic worm that lives here, which can grow to 60 centimetres (2 feet) in length, which may be one food they forage for,' says Klaus. Here an adult emerges from the misty twilight, foraging along a well-worn badger track. Klaus specializes in photographing the animals around his Black Forest home and uses his pictures to encourage people to respect the animals they share the land with.

**Canon EOS 5D Mark II + EF 17-40mm f4 lens; 1/100 sec at f5; ISO 500; flash; tripod; remote control.**

# Forest fox

**HIGHLY COMMENDED**

## Klaus Echle

GERMANY

The foxes that Klaus sees in the Black Forest near his home in Freiburg usually keep their distance, even though they are not hunted. One day he came across a vixen who seemed surprisingly relaxed in his presence. Gradually, they got to know each other. Klaus would make a point of going into that part of the wood on wet or misty days. 'The light is so special then,' he explains. 'Sometimes I wouldn't see the vixen for weeks. But when our paths did cross, she would tolerate my presence.' Gradually she allowed Klaus to follow her, often for long periods. Klaus says that his aim with this image was to create the impression of what it's like to be in the forest, to show how the fox was one with its environment.

**Canon EOS 5D Mark II + EF 17-40mm f4 lens; 1/80 sec at f4; ISO 1000; tripod.**

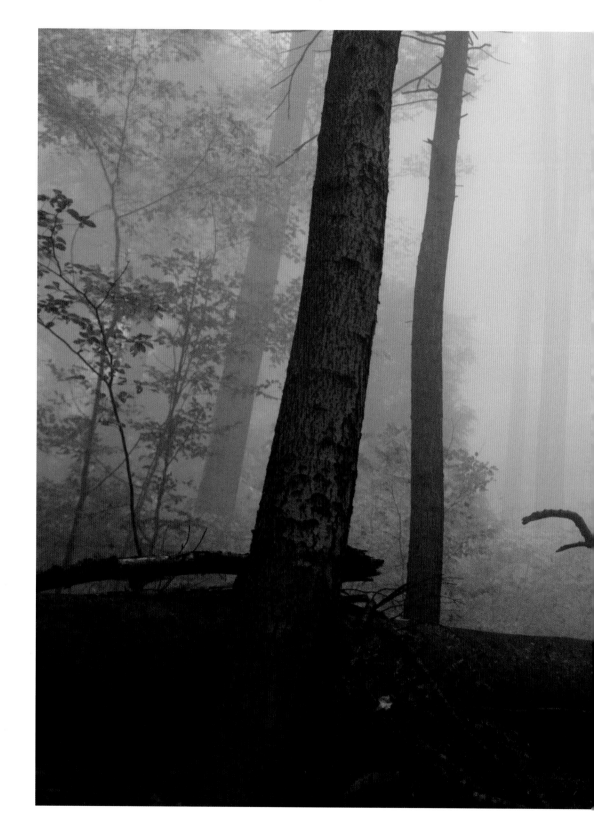

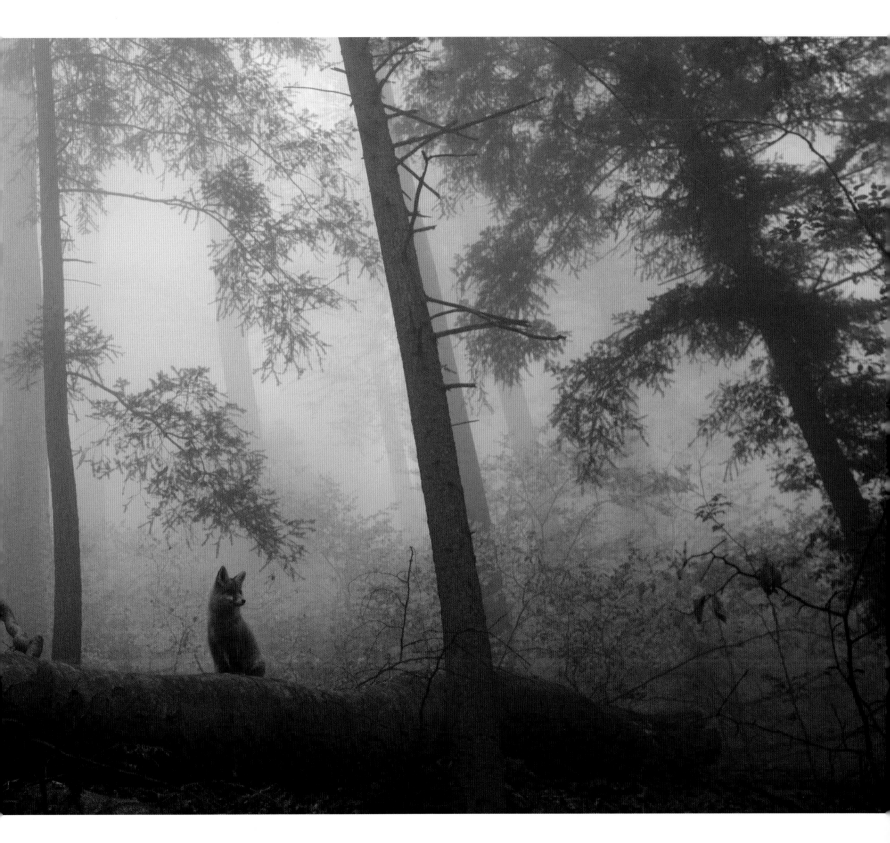

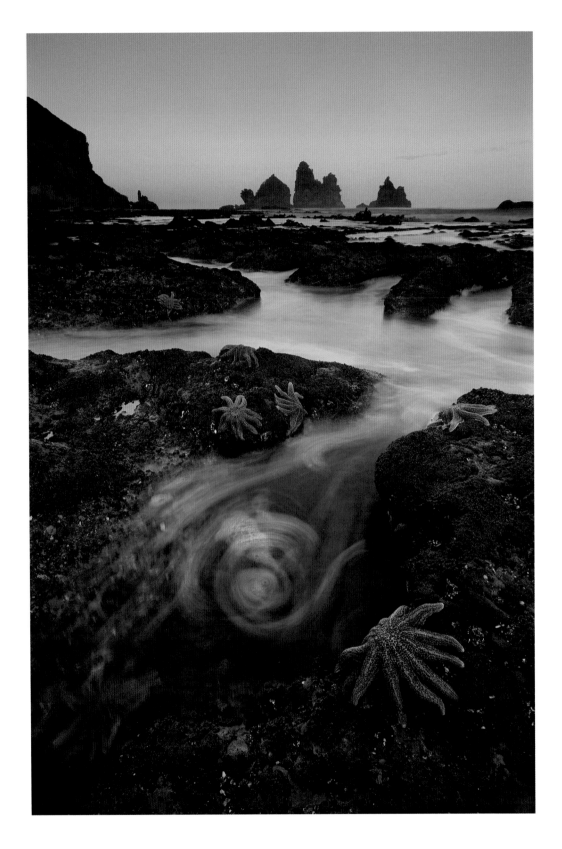

## Dawn stars

**HIGHLY COMMENDED**

## Kah Kit Yoong

AUSTRALIA

'Of the many beaches I have photographed in the world,' says Kah Kit, 'this one is my absolute favourite.' He had gone to Paparoa National Park, on New Zealand's South Island, with a particular composition in mind, drawn to the multicoloured rocks and stacks that make the coast so distinctive and hoping to photograph them lit up at dawn. But the blazing sunrise he had envisaged didn't happen. Instead, while exploring the beach as the tide went out, he found another source of colour. Set against the blue of the early morning light, the reef starfish almost glowed. 'A long exposure captured the swirl of an eddy in the rock pool, suggesting some primordial world from which these strange creatures had emerged.'

**Canon EOS 5D Mark II + 16-35mm f2.8 lens; 4 sec at f13; polarizing filter + neutral-density graduated filter; ISO 100; Gitzo Explorer tripod.**

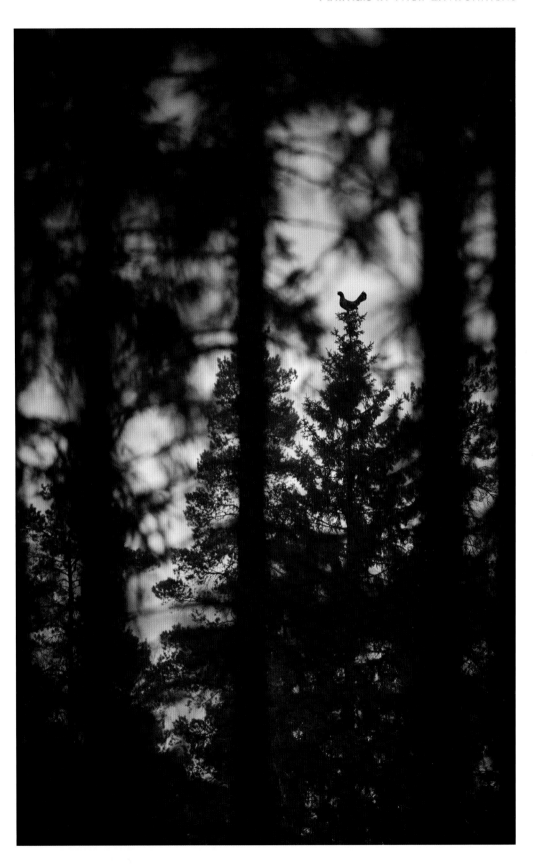

## Top spot

**HIGHLY COMMENDED**

### Janne Heimonen

FINLAND

When he woke up in his hide in the woods near Toivakka, central Finland, Janne's heart sank. He thought he'd be facing a capercaillie lek – the display arena of a male, where he shows off to potential mates. But he'd pitched his hide facing the wrong direction, and there wasn't a male in sight. Giving up his hopes of photographing displaying capercaillies that day, Janne was about to sneak a bit closer to where he knew the birds might be, to work out the best spot to move to that night, when a movement to one side caught his eye. 'It was a flying capercaillie. It landed on top of the fir tree, right in front of me, and started displaying – calling and shaking his head, with his tail spread.' Janne had just a minute or so to frame the shot and capture the mood of the moment. 'It turned out not to be such a bad morning after all.'

**Nikon D700 + 300mm f2.8 lens; 1/600 sec at f2.8; ISO 3200.**

# Wild Places

This is a category for landscape photographs that convey a true feeling of wildness and create a sense of awe.

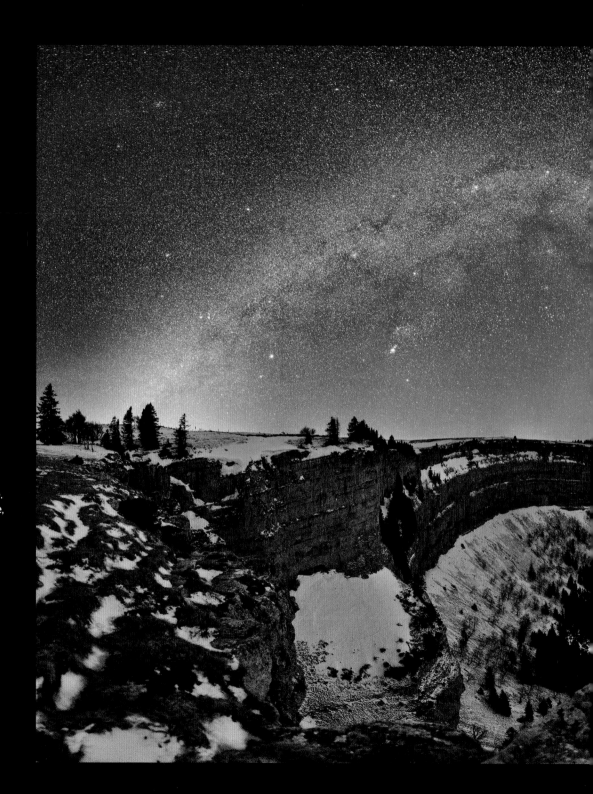

### Celestial arch

**WINNER**

## Stephane Vetter

FRANCE

It took Stephane two hours to walk to Creux du Van in western Switzerland, laden with heavy equipment. He had chosen this natural rocky amphitheatre as a grand backdrop to showcase what he was hoping to photograph – the Milky Way. The temperature was -15°C (-5°F) by the time he arrived, but the sky was clear and there was no wind. He set up camp in the dark beside the ravine, his tripod balanced on the edge. 'The sky moves surprisingly quickly,' says Stephane, 'and I needed to be ready for the moment the Milky Way was right above the Creux du Van.' The clouds on the horizon were a blessing as they blocked stray light from towns and villages. 'Gazing at the myriad of stars and constellations,' adds Stephane, 'it's fascinating to think that some of that light set off towards Earth millions of years ago.' He took 24 images of the vista. These were then 'stitched' to create a panoramic view, showing the celestial curve of the Milky Way complemented by the terrestrial curve of the ancient rock. He describes the result as the 'synthesis' of his work.

**Nikon D3 modified with Baader IR cut filter + 24mm f1.4 lens; 20 sec at f1.8; ISO 4000; Bilora C283 tripod + Ninja Nodal 5 panoramic head.**

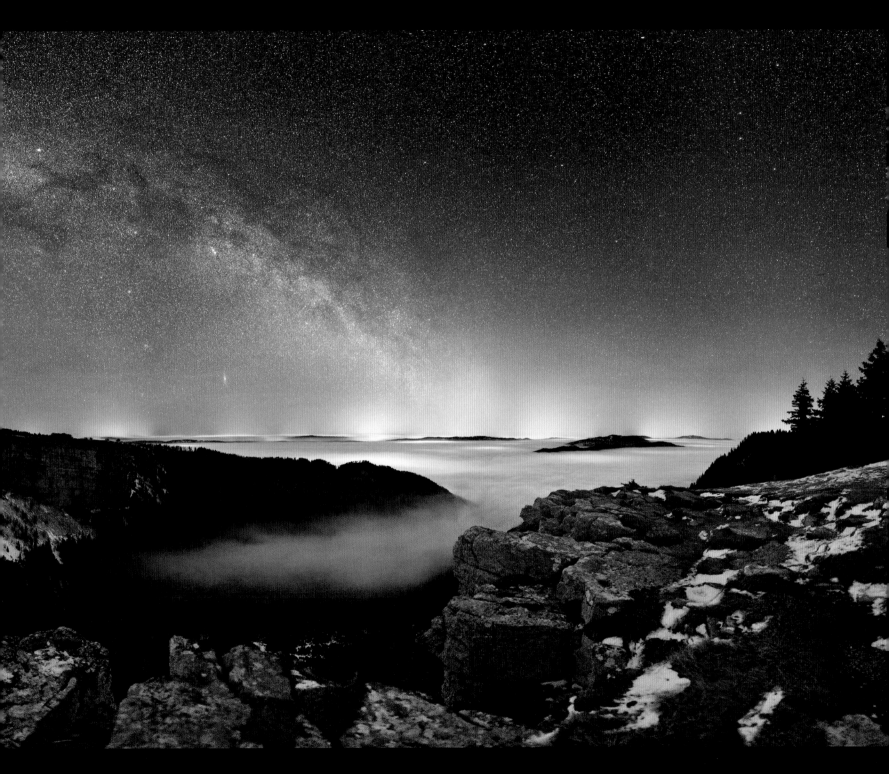

# In the Valley of Giants

**RUNNER-UP**

## Denis Budkov

RUSSIA

In December 2009, Kljuchevsky erupted and continued to belch fire and brimstone for a year. It's the highest active volcano in Eurasia and one of a belt of volcanoes on Russia's Kamchatka Peninsula, where Denis lives. Indigenous people believe that, when the raven god Kuth created Kamchatka, this was the handle, the point where he held it, which is why the mountain remains unsealed. Denis spent five days below the volcano in what he calls the Valley of Giants. On his arrival, after nightfall, he heard 'a great roaring and saw that there was a massive flame coming out of the crater'. After this, magma spurted out like a gigantic sparkler and began to flow down the volcano's flanks as crimson lava. The next day, the sky was thick with clouds of ash up to 2 kilometres (more than a mile) high. Denis took this image of the thick lava streams glowing in the dusk two days later, with a lenticular cloud hovering overhead. 'To be there during such a big explosion and see the volcano in all its glory was something I will never forget,' he says.

**Canon EOS 500D + 18-55mm lens; 20 sec at f8; ISO 100; Manfrotto 190xPROB tripod.**

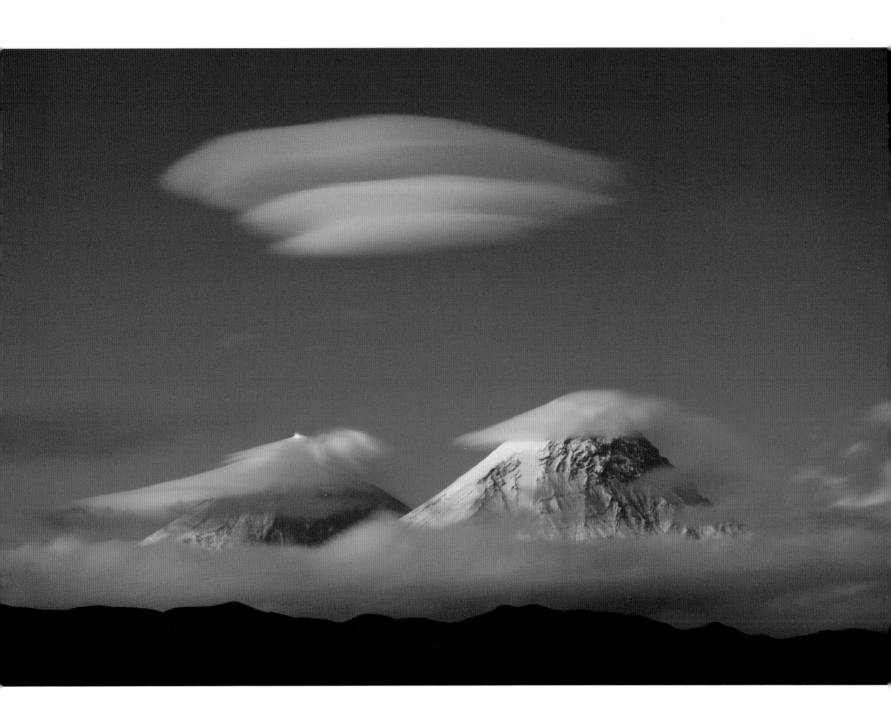

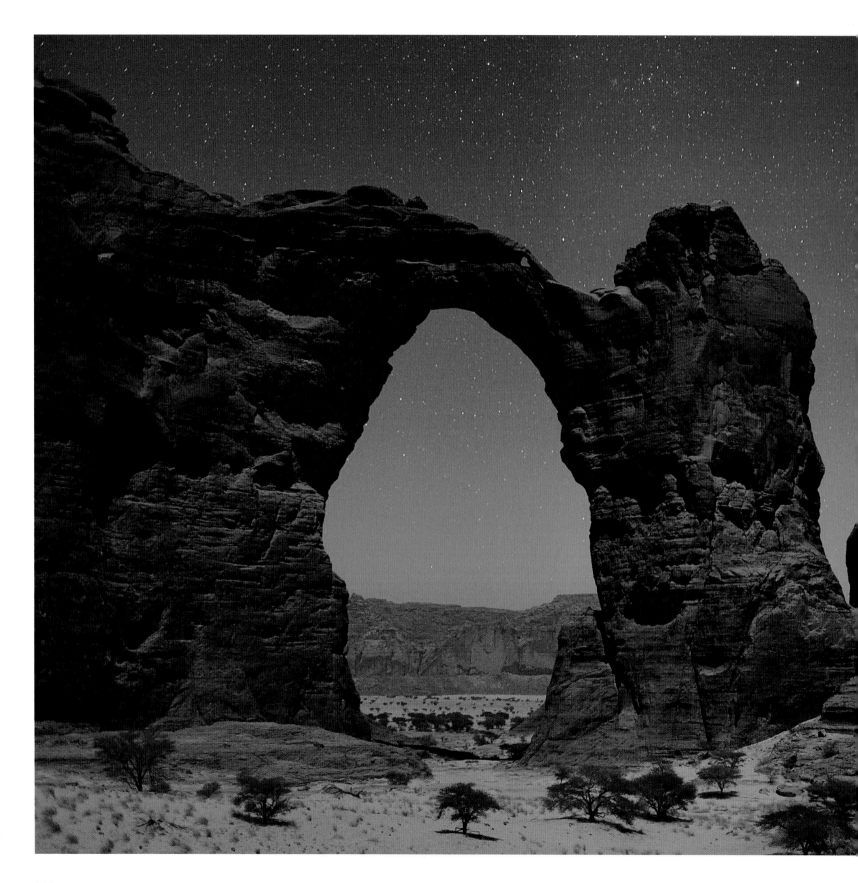

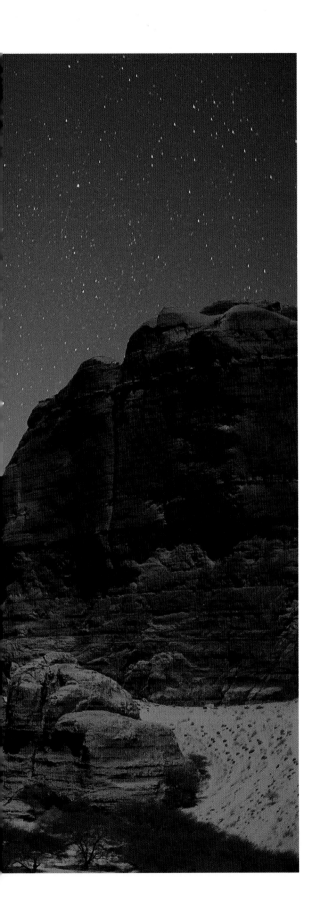

## Moonlight over Aloba

**SPECIALLY COMMENDED**

## Marsel van Oosten

THE NETHERLANDS

The Aloba Arch, on the Ennedi Plateau in northeastern Chad, is one of the most magnificent rock arches in the world. And with an elevation of 122 metres (400 feet), it is one of the highest, too. But its remote location means it's also one of the more seldom seen. Travel to this area can be particularly difficult because of the lack of facilities, political unrest and highway banditry, but Marsel decided to go there anyway. The plateau is, he says, 'a sandstone bulwark in the middle of the Sahara, assailed by the sands on all sides, with a geology similar to the Colorado Plateau and a number of similar landforms.' He wanted to photograph the arch in a way that would create 'a feeling of awe and wonder,' choosing a night shoot, with enough moonlight for a light source but not so much that the stars wouldn't be visible. 'The clear night sky,' says Marsel, 'made this wild place look almost otherworldly.'

Nikon D3S + 24-70mm f2.8 lens; 15 sec at f2.8; ISO 2500; Markins ballhead; Gitzo tripod; cable release.

# Gobi oasis

**HIGHLY COMMENDED**

## Alessandra Meniconzi

SWITZERLAND

China is second home to Alessandra. She's travelled the country since childhood, visiting the most remote and wild corners, often cycling or hitch-hiking to get there. During a trip to Inner Mongolia, Alessandra travelled to the Alxa Desert Geopark in the Gobi Desert, which has the world's highest stationary dunes and more than 140 spring-fed lakes, and is a centre for the study of desertification. Climbing the highest dune, the oasis scene below took her breath away. 'I have never seen scenery like this: thousands of small, wind-moulded dunes sunk into one huge one, the scene doubled in size by the reflection in the lake, so that I felt lost in the middle of a huge ocean of sand. The only sounds were the soft whistle of the wind and early-morning birdsong. I felt regenerated.'

**Canon EOS-1Ds Mark III + 70-200mm f2.8 lens; 1/20 sec at f8; ISO 100; Giotto tripod.**

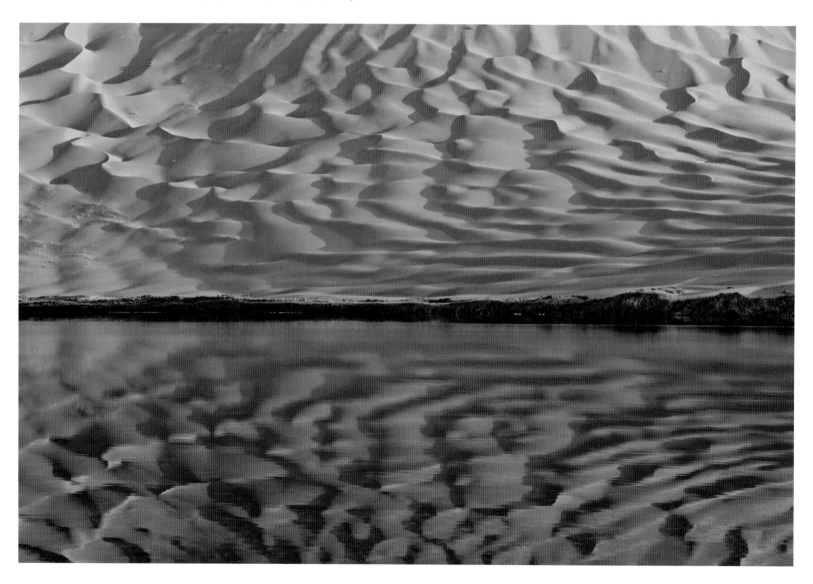

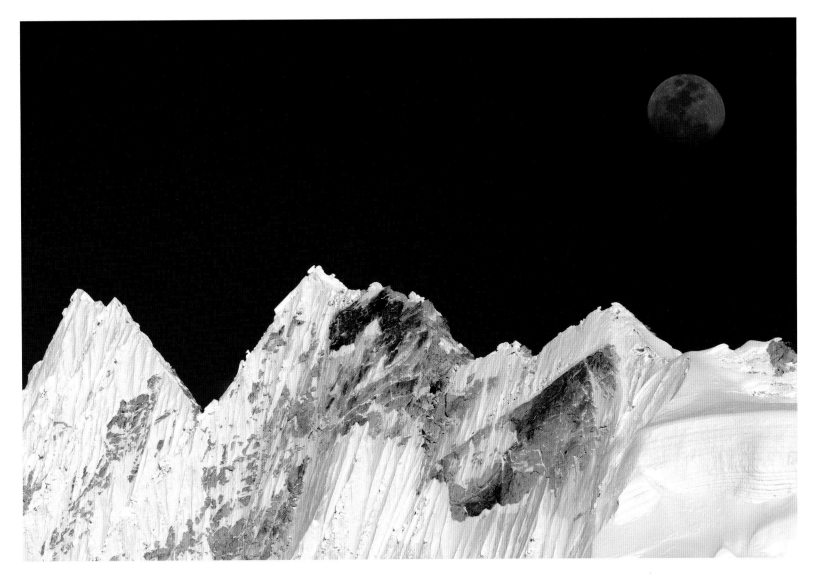

## Moonrise over Nuptse

**SPECIALLY COMMENDED**

### Patrik Bartuška

CZECH REPUBLIC

After six days of heavy cloud, fog and almost zero visibility in Gorak Shep, Nepal, the skies finally cleared and the south ridge of the mighty Nuptse was revealed. Having climbed to about 5,200 metres (17,000 feet) on the Khumbu Glacier, Patrik began taking photographs of the massive ridge. Checking the shots he had taken in the viewfinder, he noticed a dot in the frame. It was the moon, rising fast. Quickly changing to a more powerful lens, he focused on the peaks and the moon, to catch 'the cold beauty of this truly wild place.'

**Canon EOS 5D Mark II + 400mm f5.6 lens; 1/800 sec at f8 (-0.3 e/v); ISO 100; Gitzo tripod.**

# Storm painting

HIGHLY COMMENDED

## Joel Sartore

USA

'It was one of the most thrilling rides I've ever had,' says Joel. The violent wind tossed the little Cessna plane around 'like a cork on the ocean'. Struggling not to break his nose on his camera, he focused on the tempestuous raincloud emptying itself over Uganda's Lake Albert. His aim was to capture an image that spoke of the seasonal rain cycle in the Albertine Rift but also the drama of the moment. 'We could smell the rain as we bounced in and out of pockets of cold air,' says Joel. It was only later, once the plane had landed, that the pilot revealed how tricky it had been keeping the plane in the sky against the force of the down-draughts, some pushing down at 1,000 feet per minute.

**Nikon D3 + 14-24mm f2.8 lens; 1/5000 sec at f6.3 (-1.3 e/v); ISO 1000.**

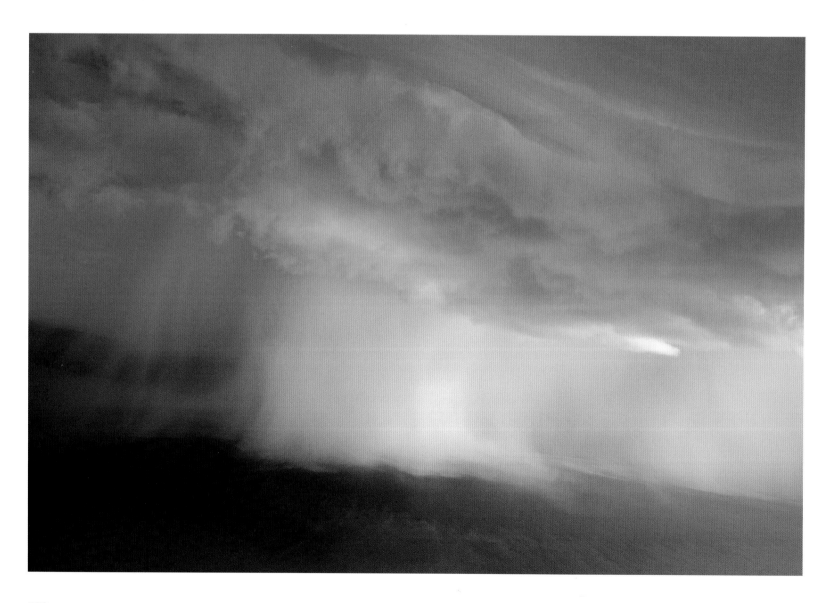

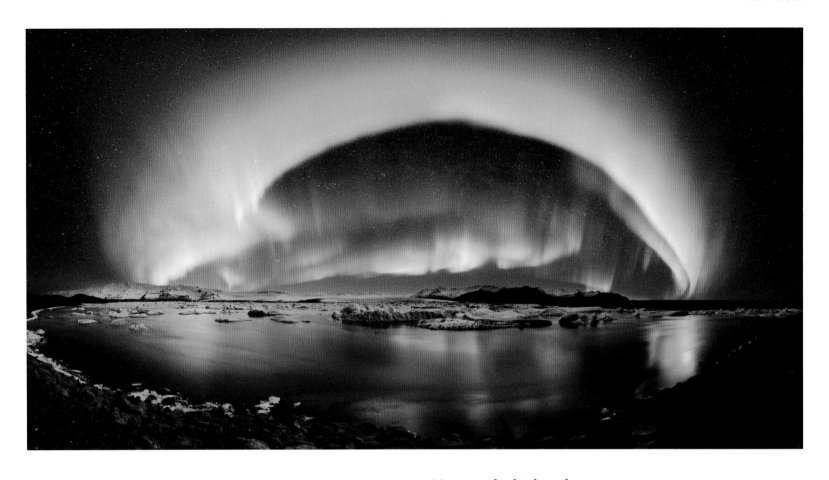

## Heavenly light show

**HIGHLY COMMENDED**

## Stephane Vetter

FRANCE

A major peak of solar activity in March triggered spectacular auroras over Jökulsárlón, the largest glacier lake in Iceland. 'Auroras are highly dynamic, and the lights move very quickly,' says Stephane. 'So you need long exposures to smooth out their beautiful draperies.' He waited for four hours in the bitter cold for the light show to begin, his tripod weighed down to prevent it blowing over in winds of 40kph (25mph). 'The aurora stretched all the way from the southwest to the northeast and up to the zenith, draping itself right over the Milky Way.' Using long exposures, he created a series of eight photographs that he could then assemble into a single stitched image to recreate the magical scene. 'Another gift from heaven.'

**Nikon D3S + 14-24mm f2.8 lens at 14mm; 15 sec at f2.8; ISO 3200; Bilora C283 tripod + Ninja Nodal 5 panoramic head.**

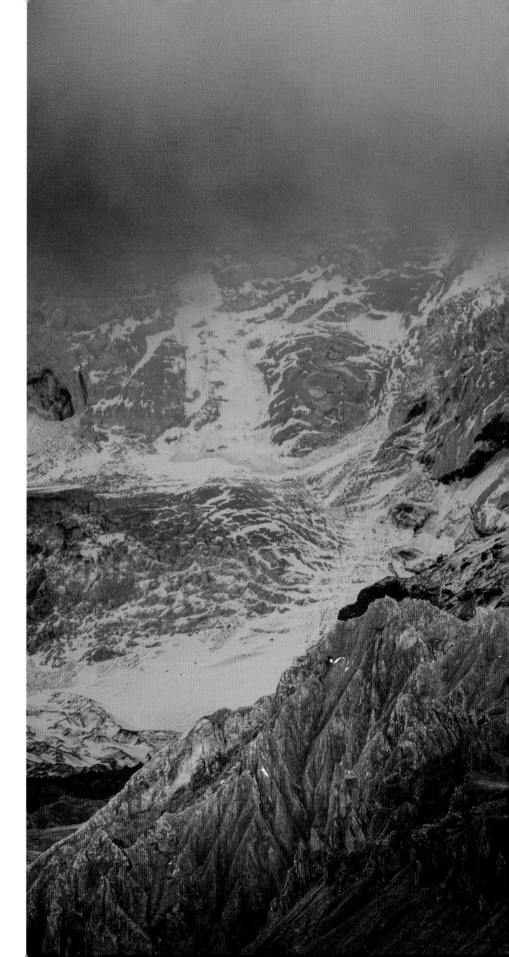

# Land of fire and ice

**HIGHLY COMMENDED**

## Erlend Haarberg

NORWAY

Erlend arrived in Iceland on 12 April 2010, two days before the Eyjafjallajökull volcano began to erupt from under the ice cap. Though the explosion was relatively small, it tore a fissure down the ice cap, and the ash plume it produced was huge. On the first clear evening after the eruption began, Erlend climbed a nearby mountain and began to photograph the plume – a plume that was to cause massive disruption to international air travel. Pausing for a moment, he turned around to look at the mountain ridge behind him. The shaded snow-covered slopes of Thórsmörk were tinged blue by the low-lying clouds, but the lower slopes and the clouds above were lit by the setting sun. 'For the ten minutes that the light lasted, I completely forgot about the volcano,' says Erlend. 'Everything was magical that evening – the powerful volcano, the light and the atmosphere – a once-in-a-lifetime experience. I felt very small beside the overwhelming power of nature.'

**Nikon D700 + 500mm f4 lens; 1/160 sec at f7.1; ISO 200; Gitzo tripod.**

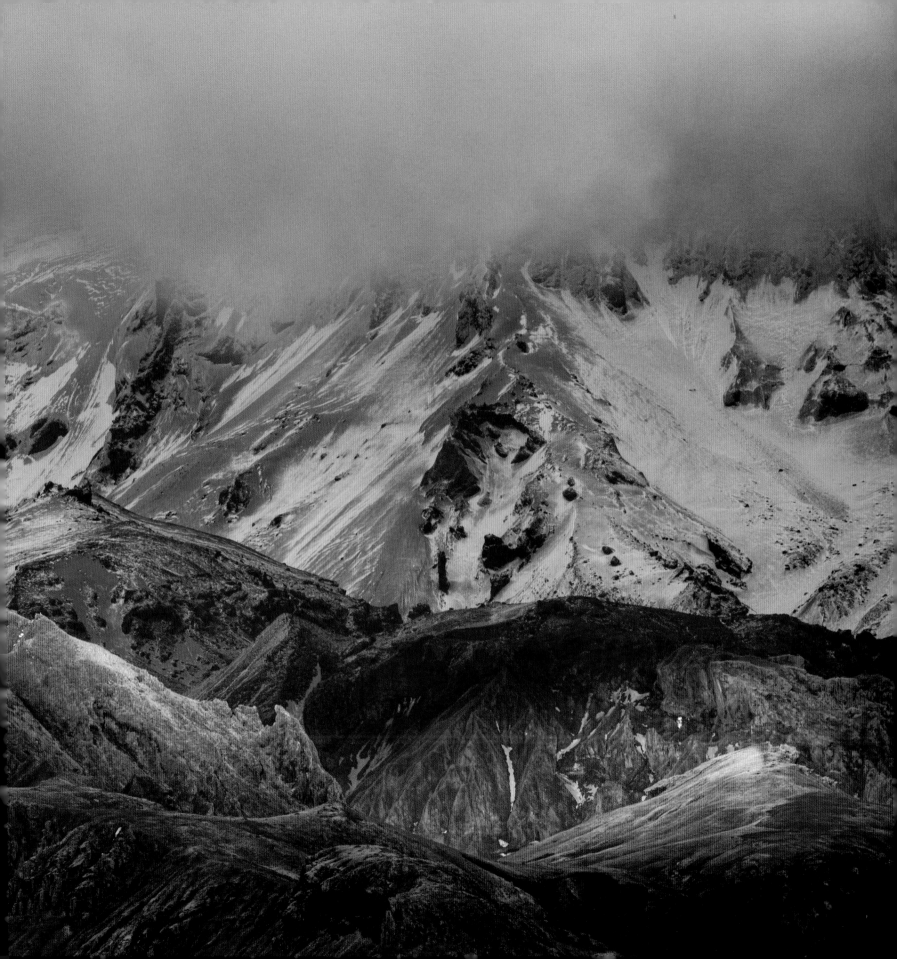

# Urban Wildlife

These pictures must show wild plants or animals in a human environment, with the human presence very much part of the picture.

## Boy meets nature

WINNER

### Alexander Badyaev

USA

Each year, on a few warm late-summer evenings, satin moths flutter at the windows of Alex's cabin deep in the Montana wilderness. Introduced to North America with timber shipments from Europe in the 1920s, they emerge over just a few days in August and are attracted by lights. In turn, they are irresistible lures for the neighbourhood long-legged myotis bats, otherwise restricted to feeding mostly on mosquitoes and caddisflies. 'It took a couple of summers before I figured out how to photograph the scene without overpowering the warm glow from the window lamp or disturbing predators and prey,' says Alex. 'By the time I'd mastered the technical side, my 13-month-old son Victor's love of bat-watching completed the tableau. Here he's standing on his bed, spellbound by the scene unfolding before him.'

Canon EOS-1D Mark IV + EF 24-105mm lens at 35mm; 1/200 sec at f14; ISO 320; remote flashes.

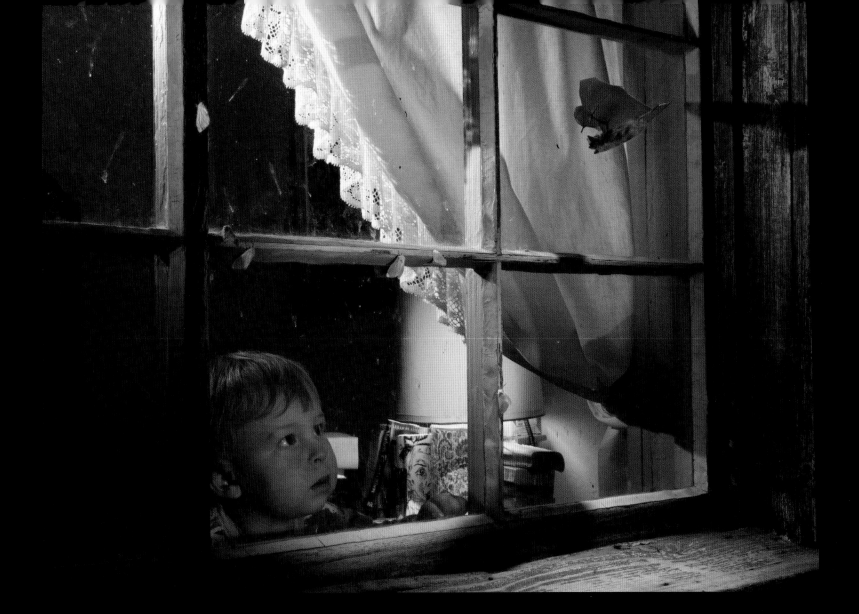

# Window on new life

**RUNNER-UP**

## Thomas P Peschak

GERMANY/SOUTH AFRICA

This window looks out onto Malgas Island, once a thriving mining site. In the nineteenth century, the island was covered in a deep layer of droppings from centuries of occupation by seabirds – guano that was dug up and taken to mainland South Africa for sale as fertilizer. Abandoned since the end of the 'white gold' rush in the 1850s, the settlement has been reclaimed by the birds, and the island is now part of South Africa's West Coast National Park. Thomas took his shot from inside a derelict house overlooking the Cape gannet colony that now dominates the island. A feral pigeon from a flock that roosts in the roof space – hangers-on from the days when people lived on the island – is attempting to perch on the window, symbolic of the crossover between the urban world of humans and the lives of wild creatures.

**Nikon D700 + 70-200mm f2.8 lens; 1/1000 sec at f16; ISO 320.**

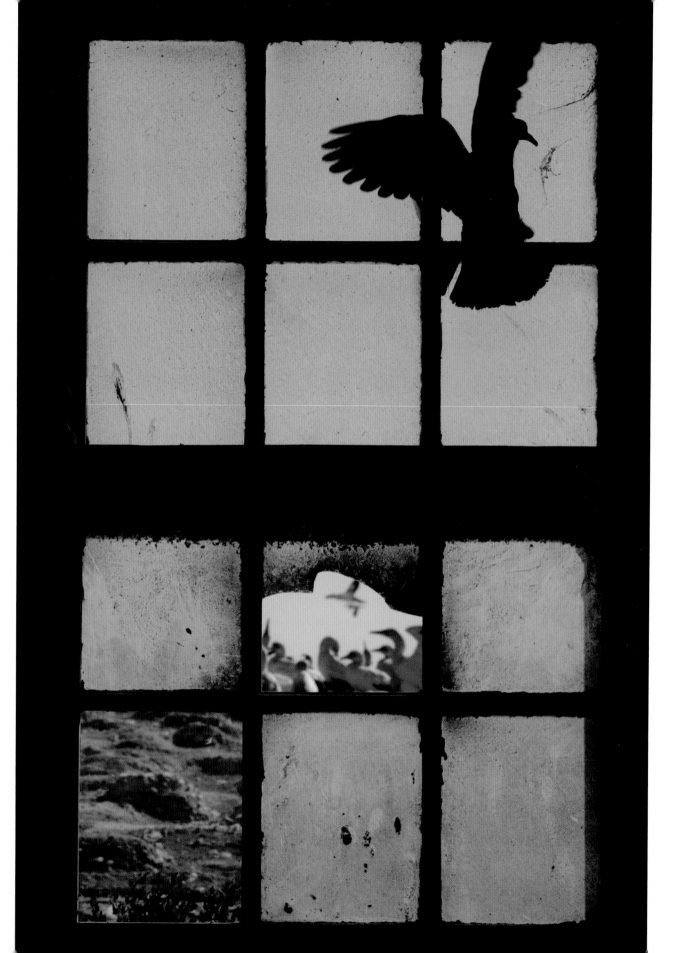

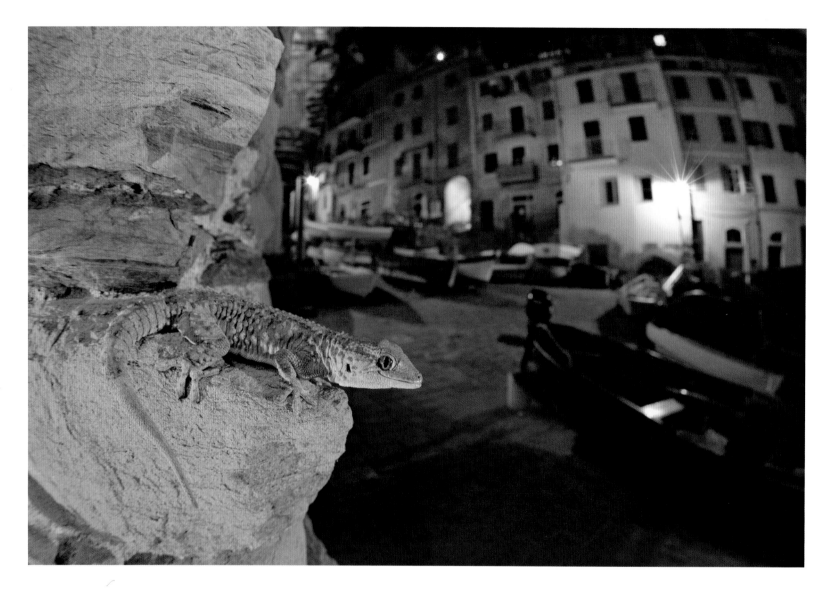

# Night prowler

**HIGHLY COMMENDED**

## Emanuele Biggi

ITALY

Riomaggiore, a village on the Italian Riviera and within the Cinque Terre National Park, is a popular tourist destination. Emanuele wanted to use it as the setting for a picture that would show how nature can coexist with humans. 'I'd been searching all day and much of the evening for that perfect picture,' says Emanuele. 'Only when walking back up the beach to go to bed did I find it.' He set up his tripod and flashes and angled the shot to show the alert little hunter against the backdrop of the sleeping village. 'Some people think Moorish geckos are ugly and even dangerous,' he says, 'but they are our friends, eating tons of insects each night, including mosquitoes.'

**Nikon D3S + Sigma 15mm f2.8 lens; 2 sec at f10; ISO 400; SB-R200 macro speedlight; tripod.**

# On the tracks of a coyote

**HIGHLY COMMENDED**

## Martin Cooper

CANADA

This stretch of railway track in Burnaby, British Columbia, is Martin's favourite spot for photographing local wildlife. And autumn, with its beautiful, mellow light, is his favourite season to be there. One October dawn, while Martin was sitting on the embankment waiting for a beaver to reappear from a culvert, a coyote came out of the undergrowth a short distance down the track and started sniffing around for signs of rodents. 'At that moment, I knew the backlit shot I wanted,' says Martin. Slowly moving onto the track, he lay down on the ballast and waited, pressing the shutter as the coyote turned its head to look up at the sky.

**Nikon D300 + Sigma 120-400mm f4.5-5.6 lens; 1/1250 sec at f7.1; ISO 200.**

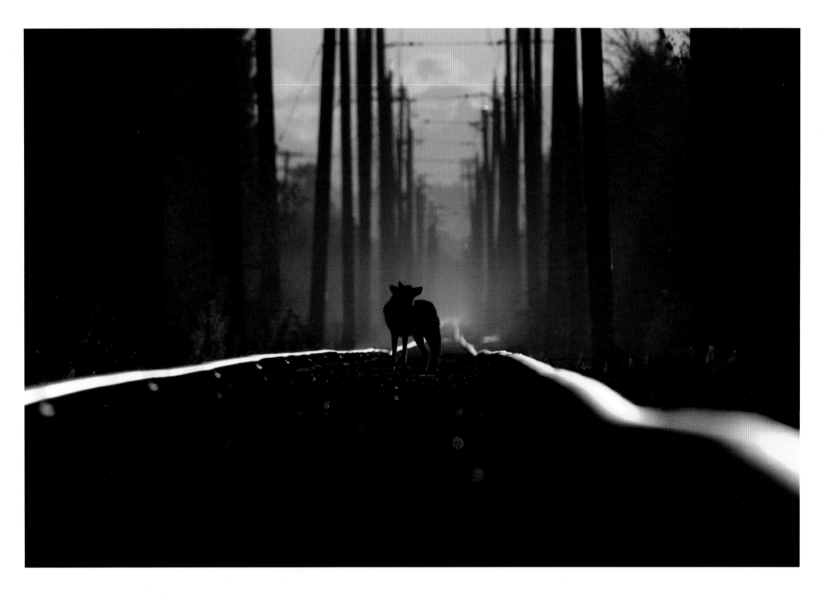

# Gerald Durrell Award
# for Endangered Wildlife

The subjects featured here are species officially listed on the IUCN Red List
as critically endangered, endangered, vulnerable or near-threatened,
and the purpose of the award is to highlight, through photographic
excellence, the plight of wildlife under threat.

## Taking off

**WINNER**

## Peter Chadwick

SOUTH AFRICA

With space at a premium, the normally territorial
African black oystercatchers on Malgas Island,
South Africa, are forced to congregate when
feeding on the rocky shore. It's a time of intense,
high-pitched, raucous social interaction, different
breeding pairs flying in to claim their turn at the
seaside table, prising shellfish off the rocks both to
eat and to take back for their chicks. All the while,
among the greetings and the squabbles, they keep
an eye on the waves. 'They usually know exactly
when to run from a crashing wave,' says Peter,
'but this wave seemed to take them by surprise.'
Found only along the coastline of southern Africa,
the charismatic species is the subject of
a conservation success story. Back in the 1980s,
the African black oystercatcher had declined
to some 4,500 birds, mainly because its breeding
beaches are also where humans with their dogs
and off-road vehicles go, resulting in the death
of many of the chicks. But though the species
remains near-threatened, protection from
disturbance in the breeding season has resulted
in an increase in numbers to about 6,000.

**Nikon D300S + 500mm f4 lens; 1/1600 sec at f8; ISO 640;
Manfrotto tripod.**

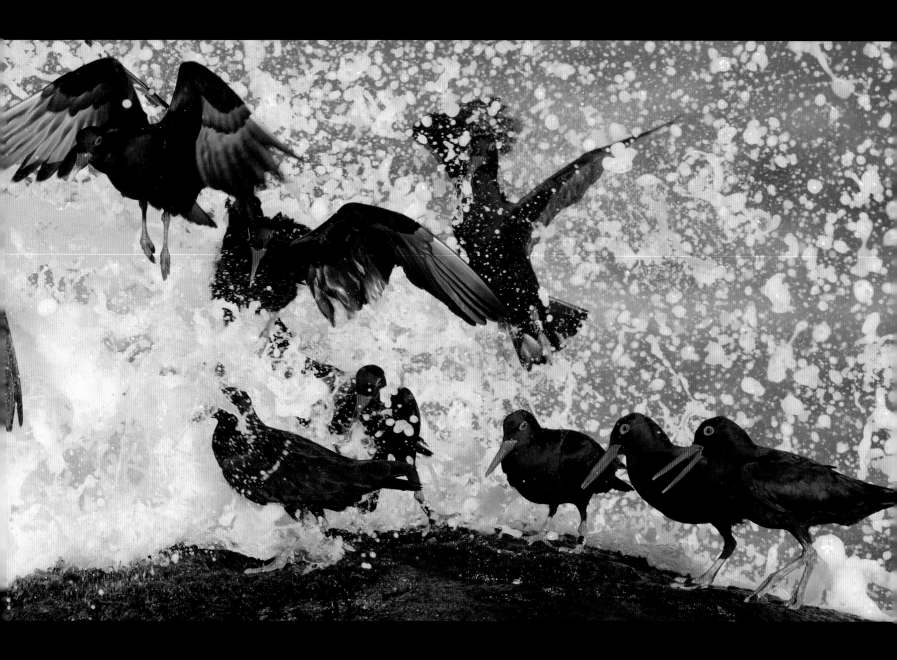

# Apollo at rest

**HIGHLY COMMENDED**

## Valter Binotto

ITALY

Every summer, just as he has done for the past 20 years, Valter visits a colony of 50–100 Apollo butterflies in the pre-Alps in the Veneto region of Italy. He keeps the location secret, for fear of butterfly collectors (the species is classified as vulnerable). 'I admire this butterfly as if she were a queen. When it flies, it's a show of natural beauty,' he says. 'Each butterfly has its own night shelter, and when I go up in the morning, I often find the same butterfly in the same spot.' On this day, low cloud covered the meadow, and the Apollos were sheltering among the grasses, waiting for the sun to warm them up. 'It gave me the chance to take a shot to show their beauty, elegance and fragility.'

**Nikon D300 + 300mm f2.8 lens + converter; 1/250 sec at f4.8; ISO 320; Gitzo tripod; flash.**

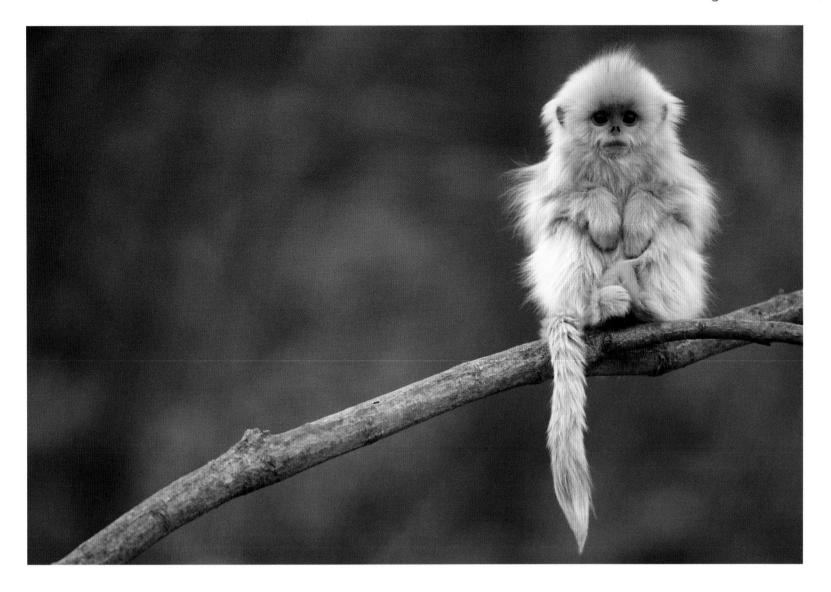

## Tiny warm-up

**RUNNER-UP**

Cyril Ruoso

FRANCE

Folded up into a fur-ball, this youngster is warming its extremities in between bouts of play and feeding. He is part of a band of about 70 or so Qinling golden snub-nosed monkeys living high up in China's Qinling Mountains, surviving on lichen, leaves, bark and buds. 'If mother is not around to cuddle up to, then sitting like this is the best way to keep warm in the extreme winter cold,' says Cyril. Sitting apart from its mother also makes such a little monkey vulnerable to attack by goshawks or golden eagles. The species is endangered, and this subspecies probably numbers no more than about 4,000. The total population of all races of golden snub-nosed monkeys is estimated at only 8,000–20,000.

**Canon EOS-1Ds Mark III + 400mm f2.8 lens; 1/200 sec at f2.8; ISO 400.**

# Eric Hosking Award

The aim of this award is to encourage talented young photographers aged 18 to 26. It is given for a portfolio of six images representing a collection of the photographer's best work.

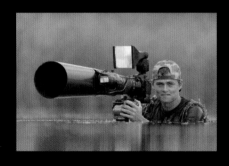

### Bence Máté

**The award goes to Bence Máté from Hungary. He was the overall winner – *the* Wildlife Photographer of the Year – in 2010, aged just 25, and this is the fourth time he has won the Eric Hosking Award. Bence started his photographic career aged 12, with a very basic camera, earned enough money himself to upgrade his equipment and began winning prizes with his imaginative work. He built his first tailor-made viewing hide at the age of 14, and with a picture taken from his hide won the Young Wildlife Photographer of the Year Award in 2002. He is now an expert creator of hides, which he uses in conjunction with the photography tours he now runs.**

## Pelican perspective

From his kitchen table, Bence planned the way he would photograph Dalmatian pelicans. He wanted a water-level perspective of them. So he designed and constructed a catamaran-style floating system, incorporating an underwater camera housing and specially positioned lights and flashes, and set off for Lake Kerkini in northern Greece. 'It was a huge buzz,' says Bence, 'to find that the contraption actually worked.' Using cables, Bence took photos from a distance away on a boat, monitoring the scene on a screen and altering the settings with the ever-changing light. The fish-eye lens gave the unusual perspective of the pelican's pouch as it caught a fish thrown back into the lake by a fisherman.

Nikon D300S + Tokina 10-17mm f3.5-4.5 lens; 1/160 sec at f16; ISO 500; Subal housing; three linked SB-800 flashes; floating remote-control system.

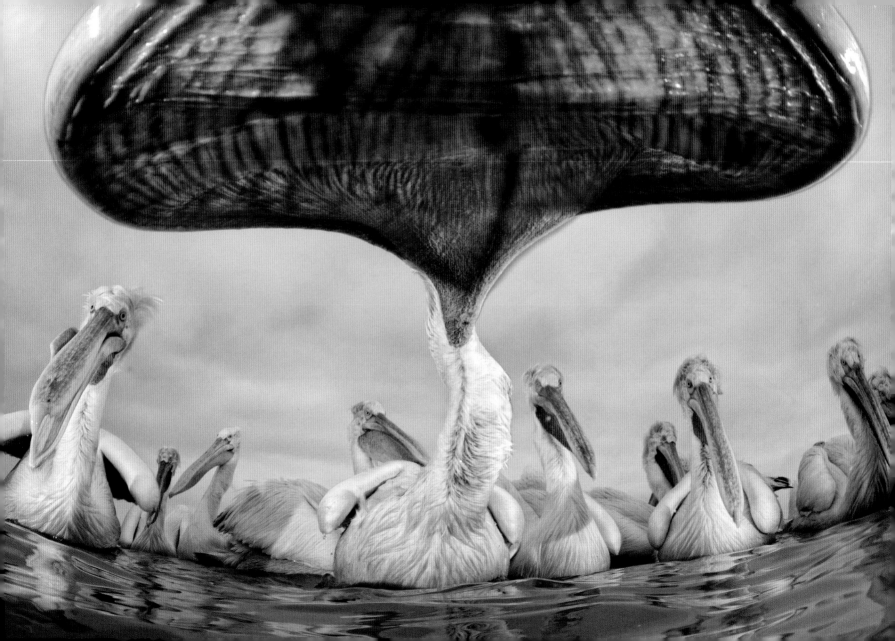

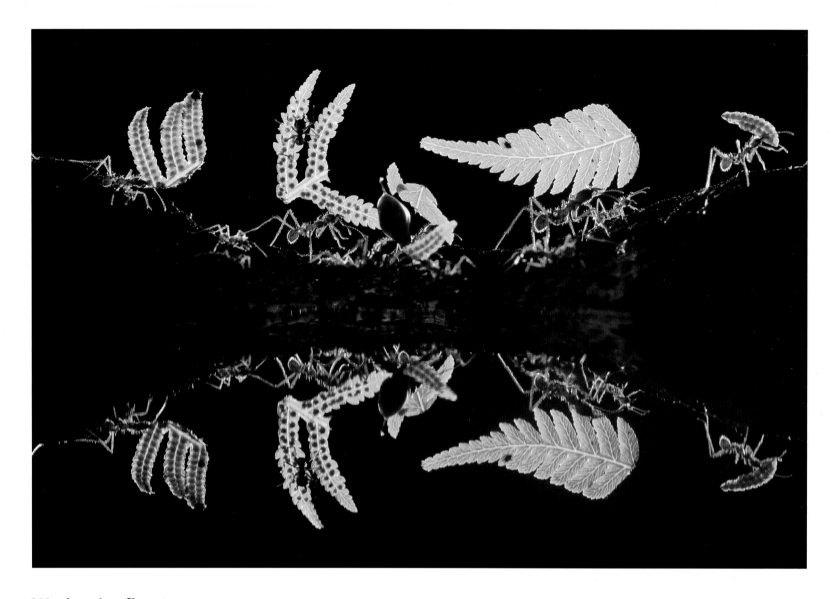

## Workers' reflections

This line of fern-laden ants and their guards, their dainty bodies reflected in
the water below, belies how resilient leaf-cutter ants are. The female workers
transport leaves to their nest from a radius of more than 100 metres (330 feet).
Each load is chewed up and used as compost for cultivating fungi, the food
they grow in their indoor garden. Earlier in the year, a tornado flattened the
trees in the Costa Rican rainforest where Bence was photographing the ants,
but their nest survived. And, as Bence witnessed one night, torrential rain did not
stop them, though it washed many of them away. As soon as the rain stopped,
the ants resumed their work, bypassing the potholes as they toiled to and fro.

**Nikon D700 + 28-105mm lens; 1/250 sec at f13; ISO 200; two SB-800 flashes; Gitzo tripod.**

# Great catch

Camping on his home-made floating hide on the city lake in Szeged, Hungary, Bence was intent on photographing little bitterns. To catch the best light for photography – just before sunset and just after sunrise – he was sleeping in his motorized hide. The reward was some unexpected behaviour. Early one morning, he witnessed a great reed warbler swooping down and scooping up a fish. Even more surprising to Bence was that the warbler took the fish to its nest, presumably to feed its chicks something other than the more normal beakful of insects. It was luck that gave Bence the shot, but luck self-made by his being in the right position at the right time.

**Nikon D700 + 28-300mm lens; 1/160 sec at f9; ISO 250; three linked SB-800 flashes; floating hide.**

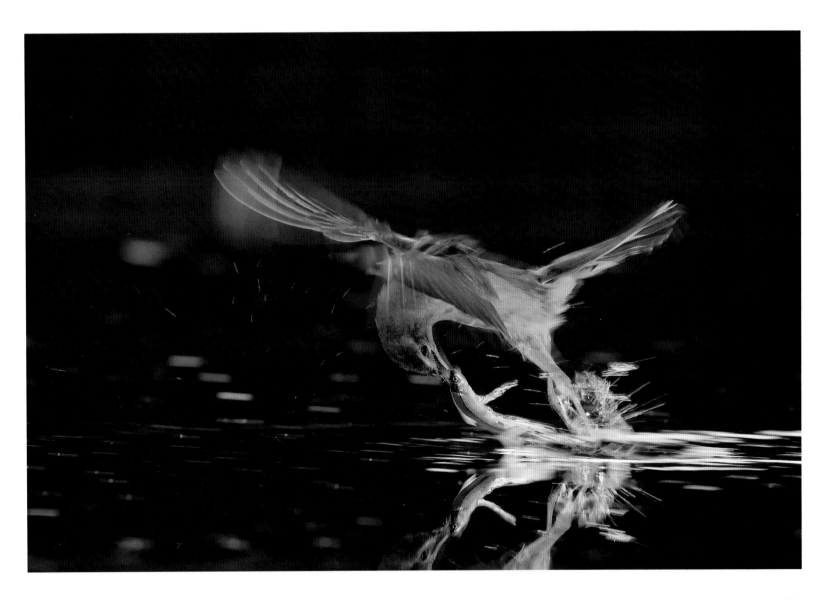

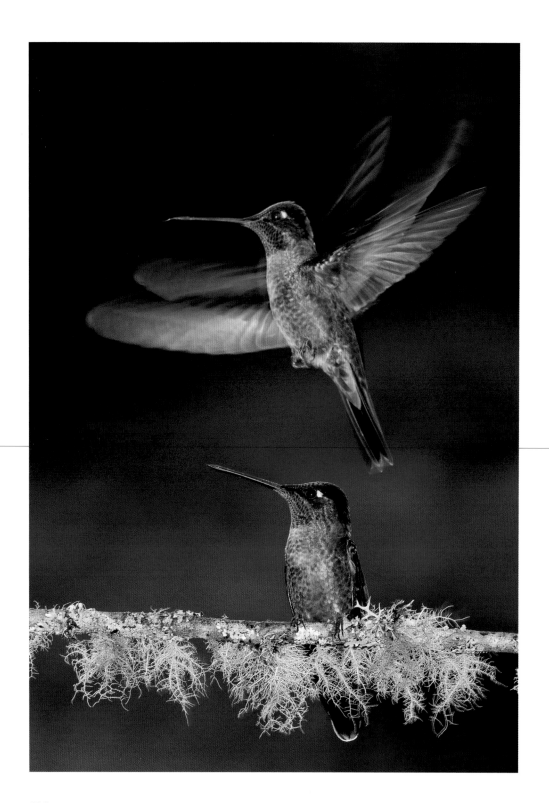

## Brilliant show

Once these male green-crowned brilliant hummingbirds arrived at the feeder, it was a race against the sun for Bence. The feeder was in the grounds of a Costa Rican lodge, which was in a valley, providing a mountain backdrop for the illuminated scene. 'The dawn light was perfect,' says Bence, 'but it was intensifying all the time.' To filter the increasingly strong light, he put up a curtain between the sun and the birds queuing up to feed and used a flash to highlight the hummingbirds' glittering colours.

**Nikon D700 + 28-300mm lens; 1/30 sec at f13; ISO 100; two SB-800 flashes; tripod.**

# The lost supper

Great egrets breed at Lake Csaj in Hungary's Kiskunsági National Park, and some of the hardier among them stay at the lake throughout the bitter winter. In January, the lakes are frozen hard, except for small areas kept ice-free by flowing water. Birds congregate around these prime fishing areas, among them gulls, some of which become adept at robbing other birds of their meals. Here a black-headed gull is about to grab a fish carelessly dropped by the egret, catching it even before it landed on the ice. With the same speed, Bence caught his image.

**Nikon D700 + 28-300mm lens; 1/1000 sec at f4; ISO 1000; hide.**

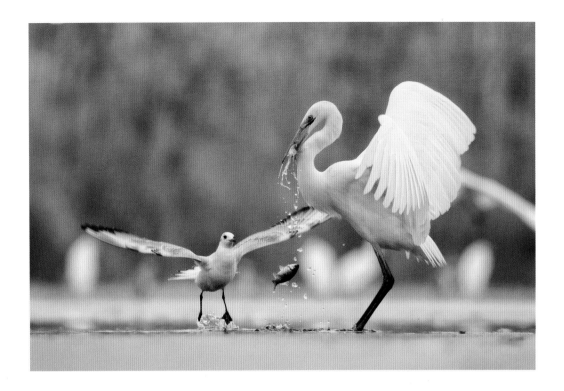

# Flight of the hoopoe

Hoopoe numbers on the Continent have declined over the past 20 years. To encourage his local Hungarian population to breed, Bence has for some years made and erected concrete nestboxes – substitutes for the hollow trees that they would normally choose. They seem to favour these nestboxes over more classic wooden ones, giving Bence the opportunity to photograph their breeding habits. If conditions are right, hoopoes around his home will breed twice a year and raise up to nine chicks, keeping their parents busy feeding them. This image of a hoopoe leaving its nest was the result of careful planning. 'I used synchronized flashes, together with a long exposure to use as much of the natural light as possible,' explains Bence, 'plus a grey filter to counterbalance the amount of light.' The result is a mesmerizing impression of the hoopoe swimming through the air.

**Nikon D700 + 28-300mm lens;1/4 sec at f9; ND filter; ISO 100; two SB-800 flashes; Gitzo tripod; hide.**

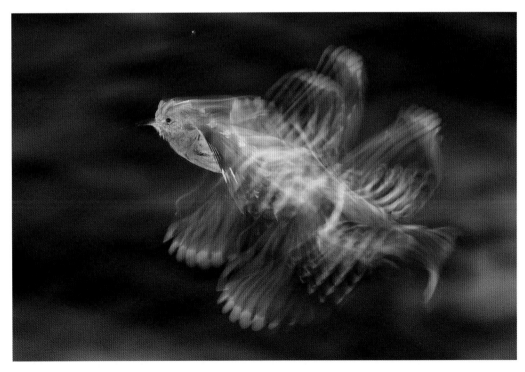

# The Veolia Environnement
## Young Wildlife Photographer
## of the Year Award

The title Veolia Environnement Young Wildlife Photographer of the Year 2011, a cash prize and a masterclass with a professional photographer go to Mateusz Piesiak – the young photographer whose image has been judged to be the most memorable of all the pictures by photographers aged 17 or under.

### Mateusz Piesiak

POLAND

**Mateusz took his first pictures, of lapwings, when he was six years old and on holiday with his great-grandmother. Since then, bird photography has been his passion. 'It allows me get away from the city,' he says, 'away from everyday life, and provides me with many unforgettable memories.' When taking photographs, he rises before sunrise, either goes to a hide or puts on camouflage gear so he can stalk the birds. He credits Polish ornithologist Tadeusz Drazny for inspiring him and teaching him how to identify birds and their songs. Mateusz took his winning picture when aged 14. 'Wildlife photography is difficult,' he says, 'but it gives me a lot of satisfaction.'**

### Pester power

**YOUNG WILDLIFE PHOTOGRAPHER OF THE YEAR and WINNER (11–14 YEARS)**

Mateusz wrapped his camera in a waterproof sack, dropped onto his belly and began to crawl along the wet sand. His aim was to get close to a small group of American oystercatchers on a beach on Long Island, New York. The birds were so absorbed in their foraging that they ignored him, sometimes scuttling almost to within arm's length in their search for shellfish. One young oystercatcher kept trying to find its own food. 'As soon as it saw an adult with a morsel,' says Mateusz, 'it would run over with loud, begging *queep queep* cries and try to snatch it from them. Sometimes the adult would give in. At other times, there would be a noisy quarrel.' Mateusz spent so long watching this pester power at work that he didn't notice the tide coming in until a big wave washed over him. 'I managed to hold my camera up high,' he says. 'I was cold and wet, with sand in my clothes, hair and ears, but I had my shot.'

**Canon EOS 40D + 400mm f5.6 lens; 1/800 sec at f5.6 (-1.3 e/v); ISO 400.**

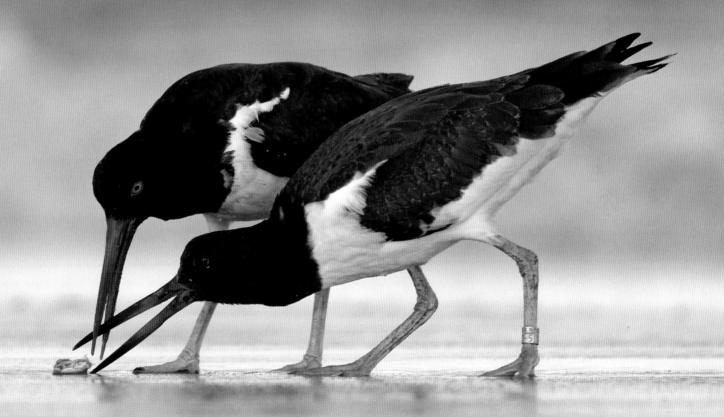

# Lure of the bee

**WINNER (15–17 YEARS)**

## Jack Salzke

AUSTRALIA

Jack was experimenting with macro-photography in his garden in New South Wales, using extension tubes he'd had for his birthday. Then he spotted the honeybee entering the great white cup of the magnolia flower. But there were challenges: 'Extension tubes made the depth of field tiny. So I had to use a high ISO, which introduced grain into the shot. Also, the bee was moving so fast that my camera's autofocus was too slow.' Using manual settings, he took several pictures before the bee exited. The result? A beautiful experiment, he admits.

**Nikon D5000 + 55-200mm f3.5-5.6 lens at 200mm + Kenko 12, 20 and 36mm extension tubes; 1/500 sec at f5.6; ISO 800.**

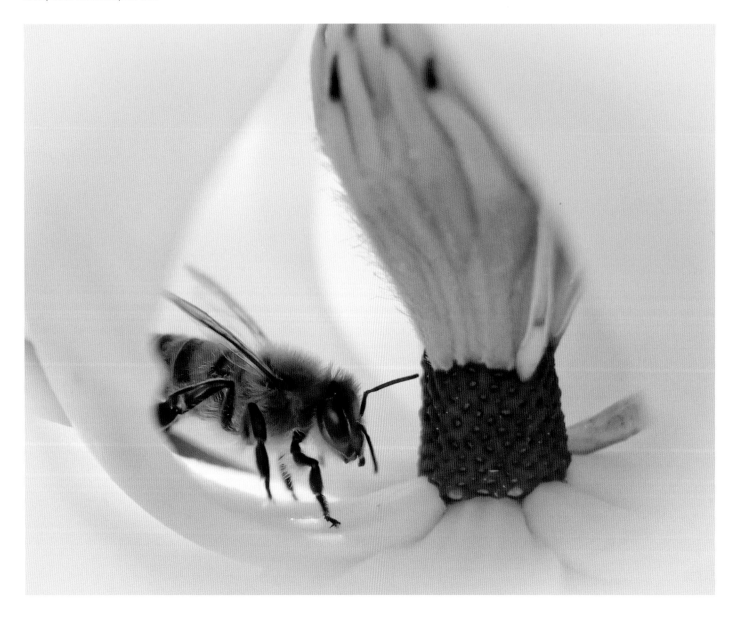

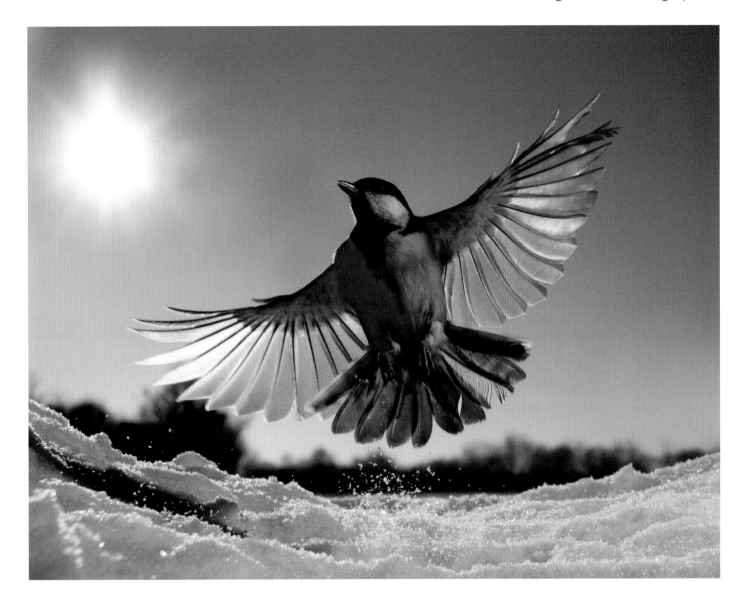

# Frozen in flight

**RUNNER-UP (15–17 YEARS)**

Jamie Unwin

UK

It was Christmas morning when Jamie set up his shoot in his back garden.
He had experimented with flight shots the previous winter and so knew what he
wanted: '. . . a bird in flight, precisely centred with the sun top left, which meant
that I had to take the picture between 11am and noon.' That gave him an hour to
get the shot. He placed grain on the snow in a precise spot and waited. 'I didn't
know I'd captured this great tit lifting off until I took the camera inside to thaw
out.' It was everything Jamie had been working towards – the only picture he
took but the one he wanted – a spectacular winning action shot.

**Sony A350 + Sigma 18-125mm f3.5-5.6 lens; 1/4000 sec at f9; ISO 400; Minolta 5600HS flash.**

# A new dawn

HIGHLY COMMENDED (15–17 YEARS)

## Damian Bednarz

POLAND

Damian set off in the middle of the night, along with his uncle, to climb to the summit of Three Crowns in the Pieniny Mountains, southern Poland. Once at the top, he set up his camera and waited for dawn and the view to unfold. 'It was as though we were sitting above the Earth,' says Damian. 'All we could see were rolling banks of fog. Then gradually the world began to emerge below us.' As the cloud shifted, first to emerge was a line of treetops far below. Damian took his picture before the mist dispersed and the sense of mystery melted away.

**Canon EOS 400D + Sigma 70-300mm lens; 1/6 sec at f4; ISO 100; GoldPhoto YH324C tripod + YH430 ballhead.**

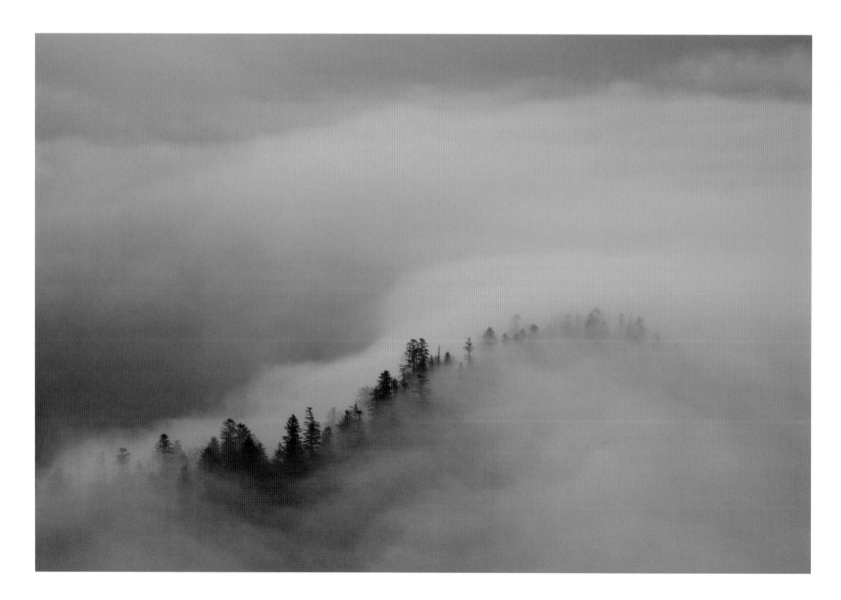

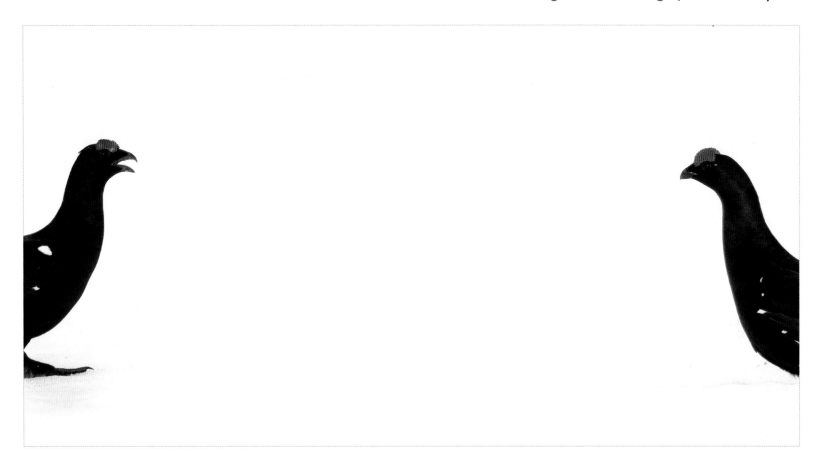

## The duel

**HIGHLY COMMENDED (15–17 YEARS)**

## Aleksander Myklebust

NORWAY

Aleksander spent 10 nights inside a hide to get this shot – his personal interpretation of lekking (displaying) black grouse. The lek takes place every spring near his home in Ringsaker in Norway. The male black grouse, large chicken-sized birds, set up camp in small territories and, in the early morning, display to females, who come to watch and judge. That requires photographers to be in their hides before dawn. Neighbouring grouse often spar, and these two cocks were approaching over the snow, preparing to fight, one 'yelling' at the other. Aleksander deliberately framed the picture in a way that would symbolize the birds' sense of territory.

**Canon EOS 40D + 300mm f4 lens + 1.4x converter at 420mm; 1/1000 sec at f5.6 (+1.3 e/v); ISO 800.**

## Pasque flower at sunset

**HIGHLY COMMENDED (15–17 YEARS)**

### Marton Schaul

HUNGARY

Each spring Marton likes to photograph greater pasque flowers, always looking for fresh ways to show them in their natural habitat. He goes to the forest of Szárhalom, in Hungary, where he knows lots of them will be in flower in the mountain meadows. In 2011, there were a series of spectacular sunsets, which gave Marton an idea for a new picture. He didn't use any special techniques, just lay down on the ground as the sun went down and positioned it exactly where he wanted it in the frame.

Sony Alpha A200 + Sigma 70-300mm f4-5.6 lens at 200mm; 1/80 sec at f5; ISO 100; Vanguard tripod.

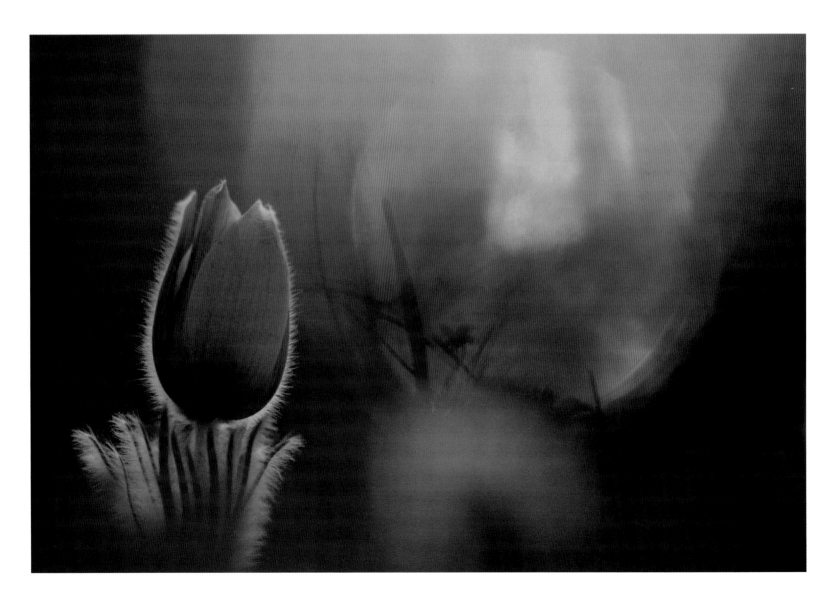

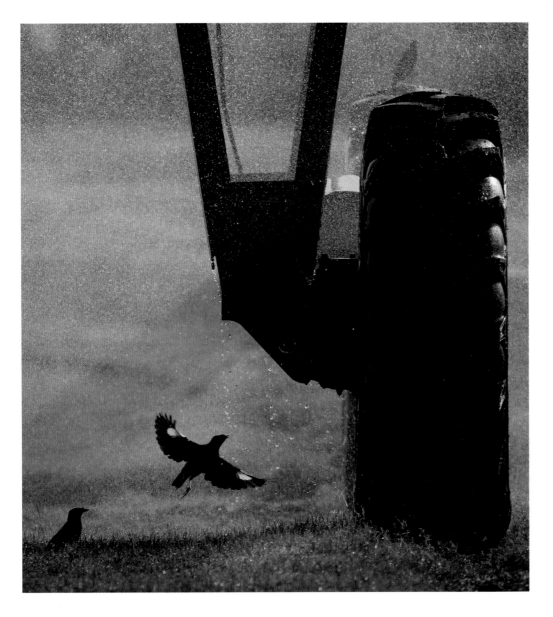

## Mynas cooling off

**RUNNER-UP (11–14 YEARS)**

### Sander Broström

SWEDEN

Photographically, things didn't look promising. The midday sun was beating down on the fields near Dubai City in the United Arab Emirates, and the light was just too intense. 'It was so hot that I had to drink constantly,' remembers Sander. Looking around for inspiration, he spotted a mobile irrigation plant at work away in the fields, drenching the ground with water. What caught his attention were the hundreds of birds flying around the machine, including a lot of bank mynas. As he approached, he could see that, like him, 'the birds were also really hot and needed to cool off and get a drink.' Then he saw it – in black and white – the graphic combination of machine, mynas and mist.

**Canon EOS 7D + 300mm f2.8 lens + 1.4x II converter; 1/1600 sec at f6.3; ISO 250.**

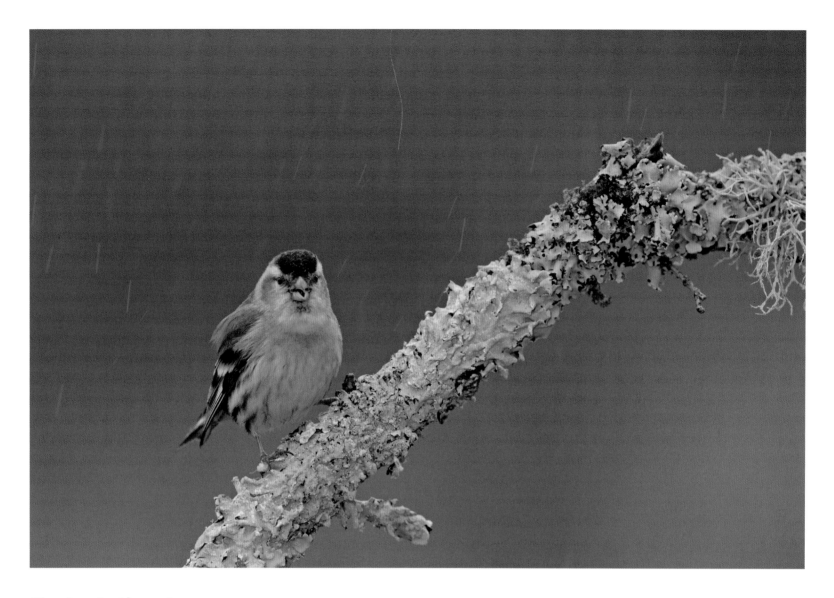

## Singing in the rain

**HIGHLY COMMENDED (11–14 YEARS)**

### Maud Graillot Denaix

FRANCE

Every winter, Maud and her family put out food for the birds in their garden in Aquitaine, France. They also set up a hide that they use for photography. Maud spends a lot of time in the hide, particularly on rainy days: 'When the weather is sunny, I can only get good pictures in the early morning. But when it's raining, I can take great shots all day long.' On one such perfect drizzly day, Maud settled into the hide specifically to photograph greenfinches. And when this little siskin landed nearby, she ignored it. 'I'd already taken lots of photographs of siskins.' But then it began to sing a lovely high-pitched song. 'I just couldn't resist it,' she says.

Canon EOS 5D Mark II + 500mm f4 lens; 1/200 sec at f7.1 (-0.3 e/v); ISO 400; tripod; hide.

# Spirit of the Badlands

**SPECIALLY COMMENDED (11–14 YEARS)**

## Joe Sulik

USA

Something was moving along the perimeter of the prairie-dog town. At first, Joe couldn't identify it. Then he realized that the creature was one of the Badlands' most elusive: a bobcat. Thrilled at this brief sighting, Joe spent the next three days in South Dakota's Badlands National Park trying for another. 'Sometimes I spent more than six hours searching for it, only to get just a short glimpse,' he says. 'On my last day in the park, just as the sun was setting, I finally saw the bobcat catch a prairie dog far out across the grassland.' Watching carefully to see which way the bobcat went, Joe was then privy to a wonderful moment. 'Two cubs appeared from behind a rocky bluff and came to greet their mother. After a short moment of reunion, all three cats disappeared over the bluff.'

**Nikon D90 + 500mm f4 lens; 1/350 sec at f11; ISO 400.**

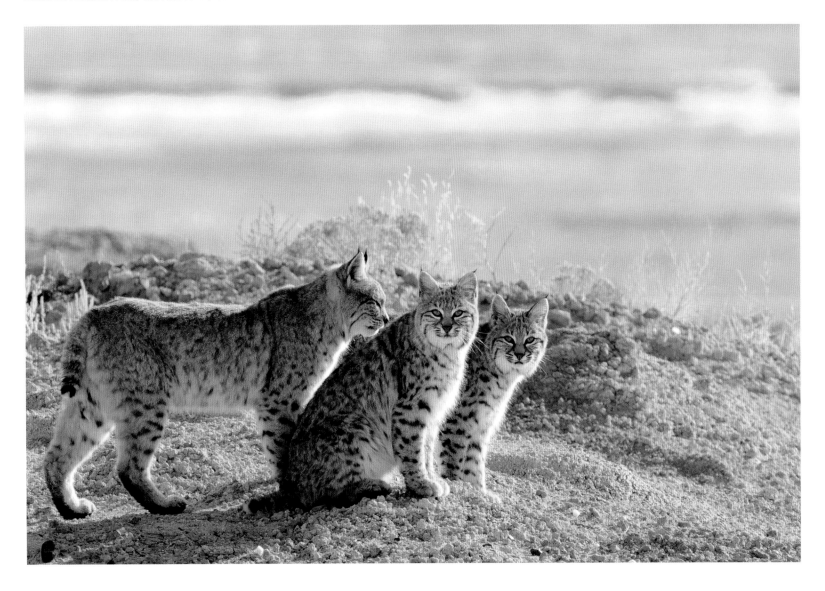

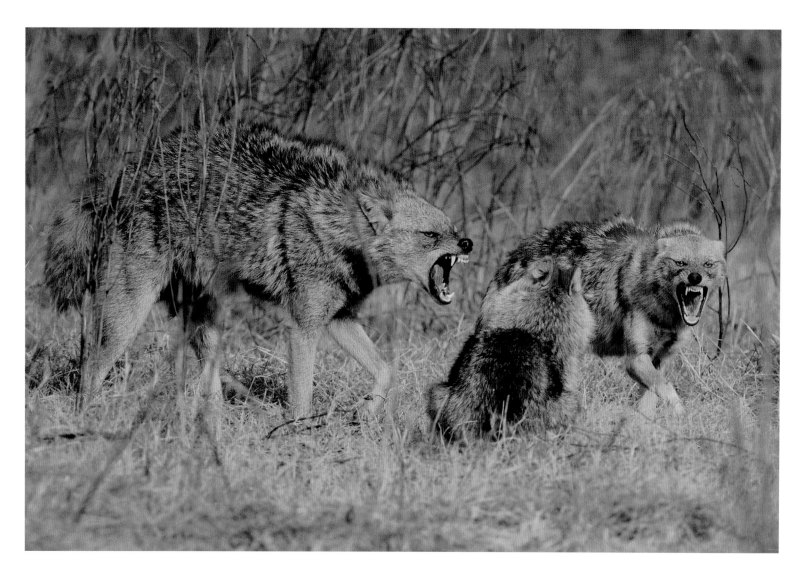

# The warning

**HIGHLY COMMENDED (11–14 YEARS)**

## Gaurav Ramnarayanan

INDIA

An Indian jackal slunk out of the bushes, glancing nervously behind.
Clearly something was going on. Gaurav, who was on a safari in Keoladeo Ghana
National Park in Rajasthan, leapt out of his rickshaw and quickly set up his tripod.
The angle was very narrow, with branches on either side, and Gaurav didn't
have long to think about his shot as, seconds later, a pair of jackals emerged from
the bushes, teeth bared. The first jackal had no intention of putting up a fight.
'It crouched submissively for a moment as the pair emphasized their
warning, and then they parted,' without any injury being inflicted.
'To see such behaviour was a once-in-a-lifetime opportunity,' Gaurav says.

**Nikon D300S + 300mm f2.8 VR lens + TC-17E II 1.7x teleconverter at 500mm;**
**1/800 sec at f9 (-0.3 e/v); ISO 400; tripod + Benro ballhead.**

# Tern style

**HIGHLY COMMENDED (11–14 YEARS)**

## Ilkka Räsänen

FINLAND

In the summer holidays, Ilkka often goes fishing on the shores of Lake Saimaa. He has been photographing common terns here since he was seven years old. 'They're not shy and come really close,' he says. What fascinates him most is the way they fly. 'They have long wings, which make it look as though their body springs up when their wings go down. They dive at high speed, sometimes so deep that they go right under the surface. I love photographing the action and the way the light sparkles through the water drops.' Ilkka shares the guts from his fishing catch with the terns. The rest he takes back to the cottage for his family's favourite summer supper: fresh fish fried in butter.

**Nikon D700 + AF-S 300mm f2.8 lens; 1/5000 sec at f5.6; ISO 2500.**

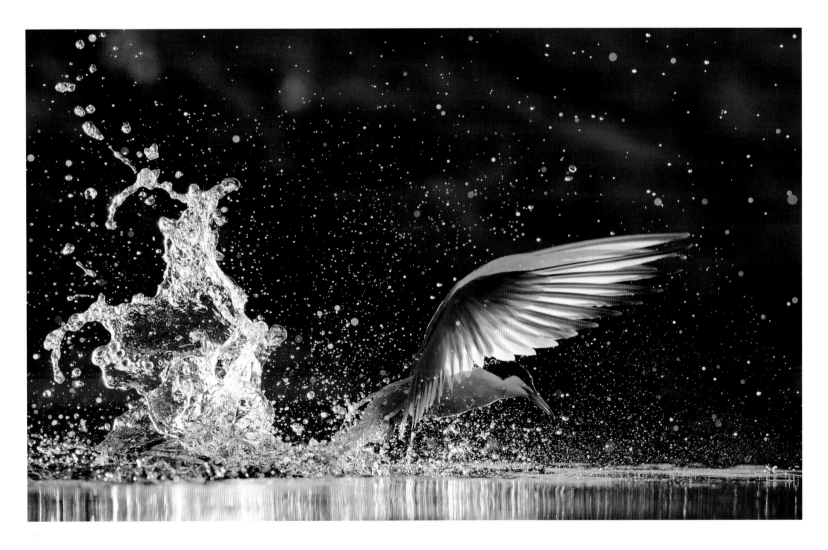

## Mist rising at sunset

**HIGHLY COMMENDED (11–14 YEARS)**

Sander Broström

SWEDEN

Last winter, Sander was photographing at Höje Creek near Knästorp
in southern Sweden when great banks of mist began to rise up.
The sun was setting, and he knew he had the chance of a very special shot.
'Luckily I was close to home,' he says, 'because I had time to run back to get
my 70-200mm lens.' By the time he returned, the creek below was covered
in a blanket of mist, now lit by a spectacular sunset. 'What I really wanted,'
says Sander, 'was for a bird to fly across the sky, but that was just too much
to wish for.' But then, as though on cue, a cormorant entered from stage left,
and Sander took his last few shots before the bird and the sun disappeared.

**Canon EOS 7D + 70-200mm f2.8 lens; 1/1600 sec at f8; ISO 400.**

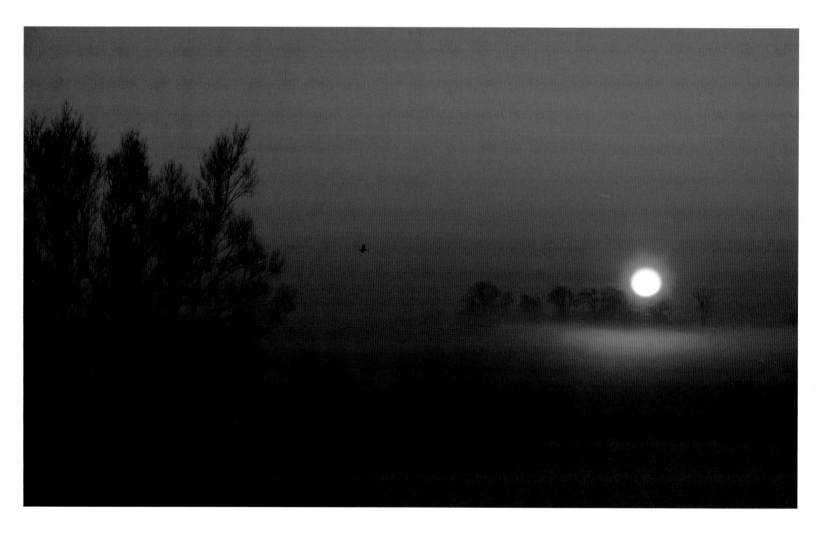

## Alien

**WINNER (10 YEARS AND UNDER)**

## Hui Yu Kim

MALAYSIA

Hui Yu photographed this imposing portrait of a tropical flat-faced longhorn beetle on a family photography trip to a tropical rainforest at Gunung Jerai in Malaysia. A light bulb in a mosquito net attracted local invertebrates during the night, and in the morning there were lots of them to look at. Hui Yu is keen on macro-photography and chose the most colourful animal to take a portrait of. 'It had a strange look, like an alien, but it wasn't angry. It sat still on the branch all the time,' she says. 'I want people to know that all creatures, even small ones, count. So don't destroy the forest.'

**Nikon D300 + 105mm f2.8 lens + extension tube; 1/80 sec at f5.6; ISO 400; cable release; tripod; light reflectors.**

# The sunbird brood

**HIGHLY COMMENDED (10 YEARS AND UNDER)**

## Hui Yu Kim

MALAYSIA

The olive-backed sunbirds had their work cut out feeding their growing clutch
of babies. Hui Yu counted them coming to the nest five times in ten minutes.
The mother had built the nest in Hui Yu 's back garden in Sungai Petani, Malaysia.
She had threaded spiderwebs among the other materials, including bits of
string, so the nest could stretch as the babies grew. 'After a week,' says Hui Yu,
'the babies' heads poked out of the nest, and we could watch them being fed.'
The parents would fly in so quickly that Hui Yu's camera's autofocus was
no use. So with her parents' help, she set her camera on a tripod, on manual,
and focused on the centre of the nest, finally getting the shot she wanted.

**Nikon D300 + 70-200mm f2.8 lens; 1/1000 sec at f4; ISO 400; cable release; tripod.**

# Great tit poised

**RUNNER-UP (10 YEARS AND UNDER)**

## Corentin Graillot Denaix

FRANCE

Corentin took this picture of a great tit in his garden. Each winter, his father sets up a hide there so that they can watch the birds that come to the bird feeders. Corentin uses it every weekend. 'About 10 species visit,' he says. 'Several land on nearby branches, but when it's a blue or a great tit, it stays on the perch a very short time. So you have to take the picture very fast.' On this day, Corentin tried hard to concentrate and focus on where the birds were landing. His determination paid off as he got his shot, sharp and perfectly poised, of a great tit perched on a lichen-covered twig.

**Canon EOS 40D + 300mm f4 lens + 1.4x extender; 1/500 sec at f7.1; ISO 400; tripod; hide.**

# Index of Photographers

**124**
**Alexander Badyaev** (USA)
abadyaev@email.arizona.edu
www.tenbestphotos.com

**65**
**Kevin Barry** (USA)
kbarryphoto@aol.com
www.flickr.com/photos/kevin_barry

**92, 95**
**Sandra Bartocha** (Germany)
info@bartocha-photography.com
www.bartocha-photography.com
Agent
www.naturepl.com

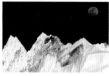

**119**
**Patrik Bartuška**
(Czech Republic)
pbartuska@gmail.com
www.bartuska.eu

**61**
**Gregory Basco**
(USA)
greg@deepgreenphotography.com
www.deepgreenphotography.com

**144**
**Damian Bednarz** (Poland)
damian2000@vp.pl
www.damianbednarz.w.of.pl

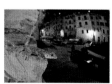

**14-21**
**Daniel Beltrá** (Spain)
daniel@danielbeltra.com
www.danielbeltra.com

**128**
**Emanuele Biggi** (Italy)
ebiggi@anura.it
www.anura.it

**60**
**Adithya Biloor** (India)
adithyabiloor@gmail.com
www.lensandtales.com

**132**
**Valter Binotto** (Italy)
binoval@alice.it
www.valterbinotto.it

**147, 152**
**Sander Broström** (Sweden)
info@sanderbrostrom.com
www.sanderbrostrom.com

**114**
**Denis Budkov** (Russia)
ratbud@mail.ru
www.budkovdenis.ru

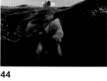

**44**
**Joe Bunni** (France)
joe.bunni@wanadoo.fr
www.joebunni.com

**24**
**Robert Cave** (UK)
robertcave@me.com
www.flickr.com/bobcav

**130**
**Peter Chadwick** (South Africa)
wildlifex@iafrica.com
www.peterchadwick.co.za

**68**
**Marco Colombo** (Italy)
oryctes@libero.it
www.calosoma.it

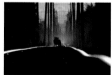

**129**
**Martin Cooper** (Canada)
mjcooper@sfu.ca
www.martincooperphotography.ca

**42**
**Nilanjan Das** (India)
dasbappa@gmail.com
www.nilanjandasphotography.com

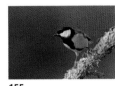

**78**
**David Fettes** (UK)
david.fettes49@btinternet.com
www.davidfettes.com

**155**
**Corentin Graillot Denaix**
(France)
corentin.graillot.denaix@wanadoo.fr

**34**
**Thomas Hanahoe** (UK)
t.hanahoe@ntlworld.com
www.hanahoephotography.com

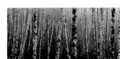

**94**
**Daniel Jara** (Spain)
dtjara@yahoo.es
www.danieljara.com

**58**
**Peter Delaney** (Ireland)
delaneypl@yahoo.com
www.peterdelaney.co.za

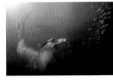

**43**
**Gennady Fedorenko** (Russia)
mydive@yandex.ru
www.mydive.sitecity.ru

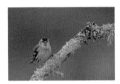

**148**
**Maud Graillot Denaix** (France)
maud.graillot.denaix@wanadoo.fr

**111**
**Janne Heimonen** (Finland)
Janne.heimonen@gmail.com
www.janneheimonen.net

**70, 106, 108**
**Klaus Echle** (Germany)
echle.alpirsbach@t-online.de
www.echle-naturfoto.de
Agent
www.naturepl.com

**67**
**Andrew George**
(The Netherlands)
a.george@chello.nl
www.agfoto.nl
Agent
www.fotonatura.com

**41, 50**
**Paul Goldstein** (UK)
psgoldie@blueyonder.co.uk

**55**
**Marcel Gubern** (Spain)
marcel@oceanzoom.com
www.oceanzoom.com

**102, 122**
**Erlend Haarberg** (Norway)
erlehaar@frisurf.no
www.haarbergphoto.com
Agents
www.naturepl.com
www.samfoto.no

**46**
**Richard Herrmann** (USA)
rbherrmann@cox.net
www.richardherrmann.com
Agent
www.mindenpictures.com

**76**
**Ross Hoddinott** (UK)
info@rosshoddinott.co.uk
www.rosshoddinott.co.uk
Agent
www.naturepl.com

**98**
**Bob Keller** (USA)
info@bobkellerphoto.com
www.bobkellerphoto.com
Agent
www.wavegallery.org

**153, 154**
**Hui Yu Kim** (Malaysia)
kim.hui.yu@gmail.com

**38**
**Tim Laman** (USA)
tim@timlaman.com
www.timlaman.com
Agents
www.nationalgeographicstock.com
www.naturepl.com

**25, 105**
**Ole Jørgen Liodden** (Norway)
post@naturfokus.no
www.naturfokus.com
Agent
www.naturepl.com

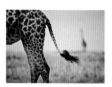

**62**
**David Lloyd**
(New Zealand)
david@kanzu.com
www.davidlloyd.info

**104**
**Henrik Lund** (Finland)
henrik.lund@lundfoto.com
www.lundfoto.com

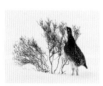

**39**
**Ron McCombe** (UK)
ron@wildlife-photography.uk.com
www.wildlife-photography.uk.com

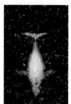

**27, 72**
**Marc McCormack** (Australia)
panomack@bigpond.com
www.marcmccormack.com

**96**
**David Maitland** (UK)
david@davidmaitland.com
www.davidmaitland.com
Agents
www.gettyimages.com
www.naturepl.com

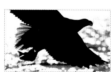

**40**
**Roy Mangersnes** (Norway)
roy@wildphoto.no
www.wildphoto.no
Agent
www.naturepl.com

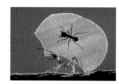

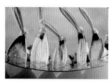

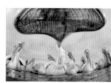

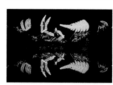

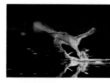

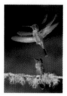

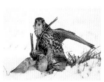

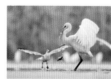

**57, 74, 134-9**
**Bence Máté** (Hungary)
bence@matebence.hu
www.matebence.hu
Agent
boglarka@matebence.hu

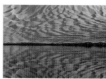

**118**
**Alessandra Meniconzi**
(Switzerland)
alex.photo@mac.com
www.alessandrameniconzi.com

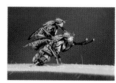

**56**
**András Mészáros** (Hungary)
andras@meszarosandras.com
www.meszarosandras.com

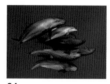

**84**
**Clark Miller** (USA)
clark@aquaterraimagery.com
www.aquaterraimagery.com

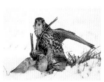

**32**
**Steve Mills** (UK)
steve@birdwing.eu
www.stevemills-birdphotography.com

**54**
**Dmitry Monastyrskiy** (Russia)
dlm@aaanet.ru
http://mit-lj.livejournal.com

**31**
**Arthur Morris** (USA)
birdsasart@att.net
www.birdsasart-blog.com

**145**
**Aleksander Myklebust** (Norway)
aleksander-myklebust@hotmail.com
www.almyfoto.com

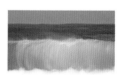

**30**
**Laurence Norton** (USA)
laurence.norton@gmail.com
www.laurencenorton.com

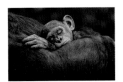

**79**
**Xavier Ortega** (Spain)
xaviortega1@wanadoo.es
www.xavierortega.net

**26**
**Antti Partanen** (Finland)
anttipar@gmail.com
http://personal.inet.fi/luonto/antti_partanen

**88, 91, 126**
**Thomas P Peschak**
(Germany/South Africa)
Thomas@thomaspeschak.com
www.thomaspeschak.com

**48**
**Eric Pierre** (France)
eric_ep_pierre@yahoo.fr
www.boreal-lights.com

**140**
**Mateusz Piesiak** (Poland)
matipiesiak@tlen.pl
www.mateuszpiesiak.pl

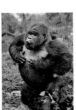

**100**
**Benjam Pöntinen** (Finland)
benjam@pontinen.fi
www.pontinen.fi

**86**
**Louis-Marie Préau** (France)
photo@louismariepreau.com
www.louismariepreau.com

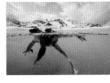

**150**
**Gaurav Ramnarayanan**
(India)
gaurav10298@yahoo.co.in

**151**
**Ilkka Räsänen** (Finland)
ilkkao.rasanen@pp.inet.fi

**51**
**Andy Rouse** (UK)
andyrouse@mac.com
www.andyrouse.co.uk
Agent
www.naturepl.com

**52, 133**
**Cyril Ruoso** (France)
cyril.ruoso@wanadoo.fr
www.cyrilruoso.com
Agent
www.mindenpictures.com

**89**
**Nuno Sá** (Portugal)
fotonunosa@gmail.com
www.photonunosa.com

**142**
**Jack Salzke** (Australia)
salzke@fadedfocus.com
http://fadedfocus.com

**49, 120**
**Joel Sartore** (USA)
sartore@inebraska.com
www.joelsartore.com
Agent
www.nationalgeographicstock.com
akeating@ngs.org

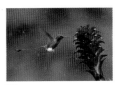

**146**
**Marton Schaul** (Hungary)
schaulmarci@gmail.com
www.schaulmarci.fw.hu

**36**
**Petr Simon** (Czech Republic)
p.simon@cmail.cz
www.photosimon.cz

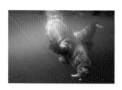

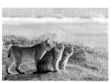

**80, 82**
**Paul Souders** (USA)
paul@worldfoto.com
www.worldfoto.com
Agents
www.corbisimages.com
www.gettyimages.com

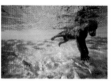

**149**
**Joe Sulik** (USA)
joseph.sulik@me.com

**90**
**Alex Tattersall** (UK)
alex@uwvisions.com
www.uwvisions.com

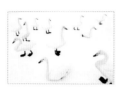

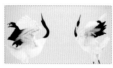

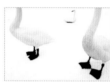

**22, 66, 73**
**Stefano Unterthiner** (Italy)
info@stefanounterthiner.com
www.stefanounterthiner.com
Agent
agent@stefanounterthiner.com

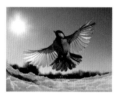

**143**
**Jamie Unwin** (UK)
fromnatureseye@gmail.com
www.jamieunwin.com

**64**
**Wim van den Heever**
(South Africa)
wim.vandenheever@gmail.com
www.wimvandenheever.com

**35**
**Jan van der Greef**
(The Netherlands)
jan.vandergreef@tno.nl
www.insightintonature.com
Agent
www.buiten-beeld.nl

**116**
**Marsel van Oosten**
(The Netherlands)
marsel@squiver.com
www.squiver.com

**112, 121**
**Stephane Vetter** (France)
stephane.vetter@wanadoo.fr
www.nuitsacrees.fr
Agent
www.novapix.net

**110**
**Kah Kit Yoong** (Australia)
kahkityoong@magichourtravel
scapes.com
www.magichourtravelscapes.com

**28**
**Sven Začek** (Estonia)
sven@zacekfoto.ee
www.zacekfoto.ee
Agents
www.fotonatura.org
www.naturepl.com
www.osf.co.uk